MW01025835

THE UNSEEN PHOTOS OF

STREET GANG

HOW WE GOT TO SESAME STREET

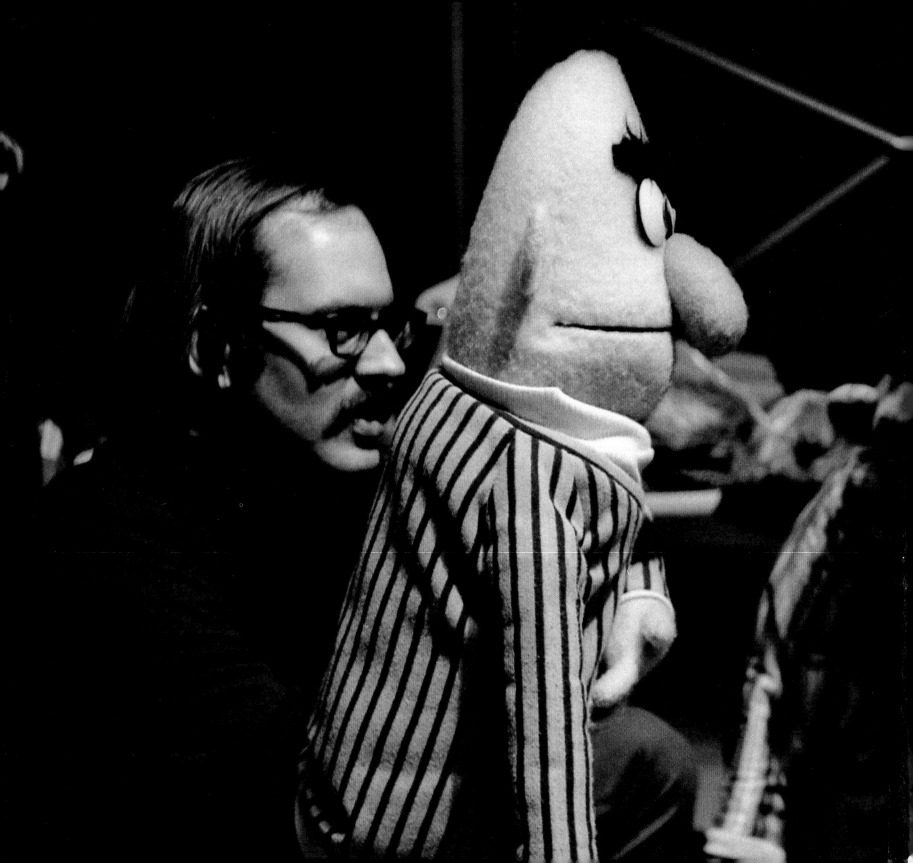

THE UNSEEN PHOTOS OF

STREET GANG

HOW WE GOT TO SESAME STREET

By Trevor Crafts
Photographs by David Attie

Preface by Eli Attie
Foreword by Michael Davis
Afterword by Sonia Manzano

ABRAMS, NEW YORK

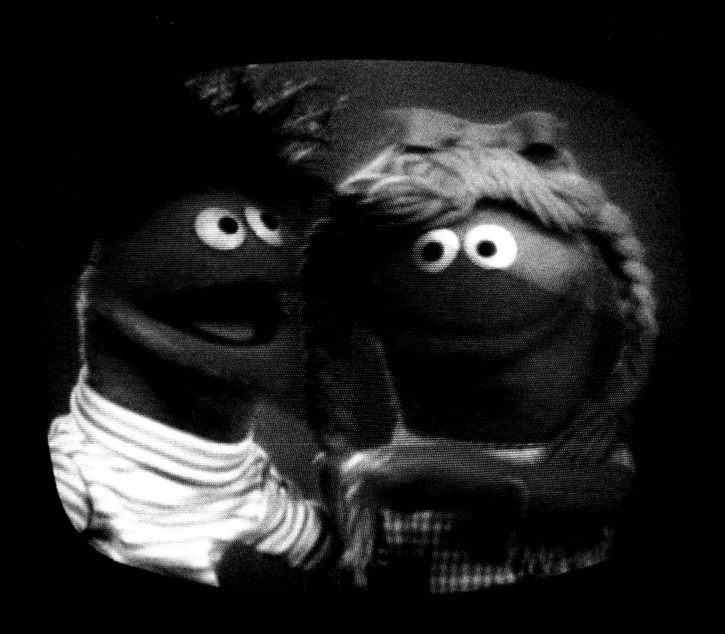

INTRODUCTION: THE BEGINNING

Trevor Crafts

————————

"Could you make that into a documentary?"

I hadn't really thought about it before, at least not like that. It was a question asked of me in the spring of 2015 by my friend Stephen Christy, with whom I'd formed an instant bond over our shared love of Muppets creator Jim Henson. I wasn't sure if it was possible to make a documentary about *Sesame Street*. I was pretty sure that the topic had been covered. I mean . . . it's *Sesame Street*. Who doesn't know about *Sesame Street*?

I had read the book *Street Gang: The Complete History of Sesame Street* by Michael Davis out of a fascination with Henson as one of the great cinematic worldbuilders of modern media. I am, undeniably, a *Sesame Street* kid. Like so many people, I had grown up on the same street where Ernie annoyed Bert, Oscar's best friend was a little orange-and-yellow worm, and Super Grover consistently crashed into the very thing he was trying to help.

As I read through the first few pages of the paperback edition of *Street Gang*, I could tell that this was a story that we, as a society, didn't really remember. Maybe we knew it at one point, but after fifty years we had clearly forgotten what it took to breathe life into this experiment. As I dove into the history I thought I knew, I was introduced to so many people that I had never heard of before. People like Jon Stone, the original director and creator of the "street" itself. I learned that Sesame Workshop founder and *Sesame Street* creator Joan Ganz Cooney poured years of her life into researching the original idea of the show.

I marveled that Frankie Biondo, the original cameraman who filmed the pilot, still films the show today. The list goes on and on. These architects of a kids show made a meteoric impact on our collective global society. I knew it was a story that had to be retold; I needed to reintroduce everyone to the forgotten heroes of our childhood and our society. I needed to reintroduce the Street Gang.

The initial spark of a project often holds the most excitement and power for filmmakers. For me, I feel that spark as a tightness in my center. It's like the moment right before a kiss, or when you hear an amazing piece of music, or when you finally return home after a prolonged absence. That spark acts like a compass. When I follow the tug of its needle toward something great, and don't let the shadows of doubt get in the way, that's when little bits of magic can occur.

Follow the compass, get to greatness. Sounds very easy when it's put that way. The truth, as I'm sure you can guess, is anything but.

If you were to ask a random person on the street, "What's it like to be a filmmaker?" you would probably get a slew of similar answers. You would hear things like "You get to hang out with movie stars," or "You get to go to exotic places," or "You make lots of money." People will never say, "You have to have the patience of Job from the Bible." And I'm not even sure that "patience" is a strong enough word. "Tolerant," "stoic," and "pertinaciousness" might be a better combo. Sometimes the waiting lasts for years and years: From the time that I picked up Michael's book to the time the final film was in theaters took a little more than six years.

Right off the bat, obtaining the rights to turn Michael's book into a film proved harder than expected. Maybe it was an early omen of the odyssey that was yet to come. To me it seemed odd that in 2014, when I started the search, with the power of a high-tech, global information network at my fingertips, I couldn't locate the author of a *New York Times* bestselling book. As a general rule in business, I don't take a "no" at face value but look for a way to turn

Pages 2–3 Frank Oz and Jim Henson delight a young fan with Bert and Ernie.

Opposite Bob McGrath with Oliver Attie.

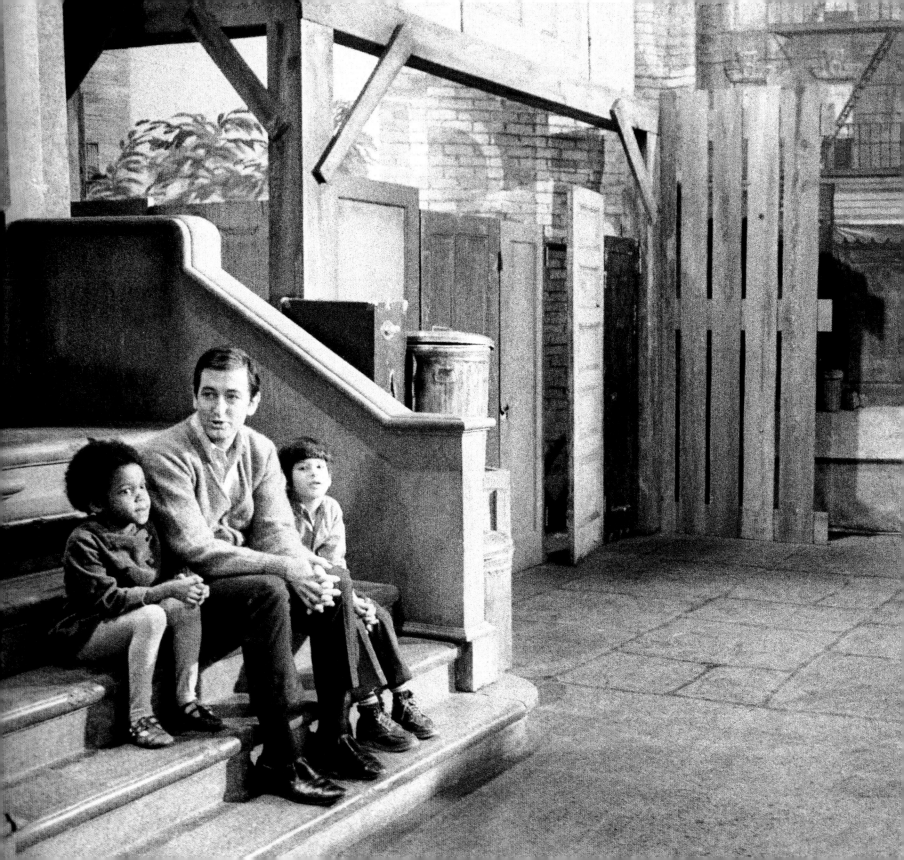

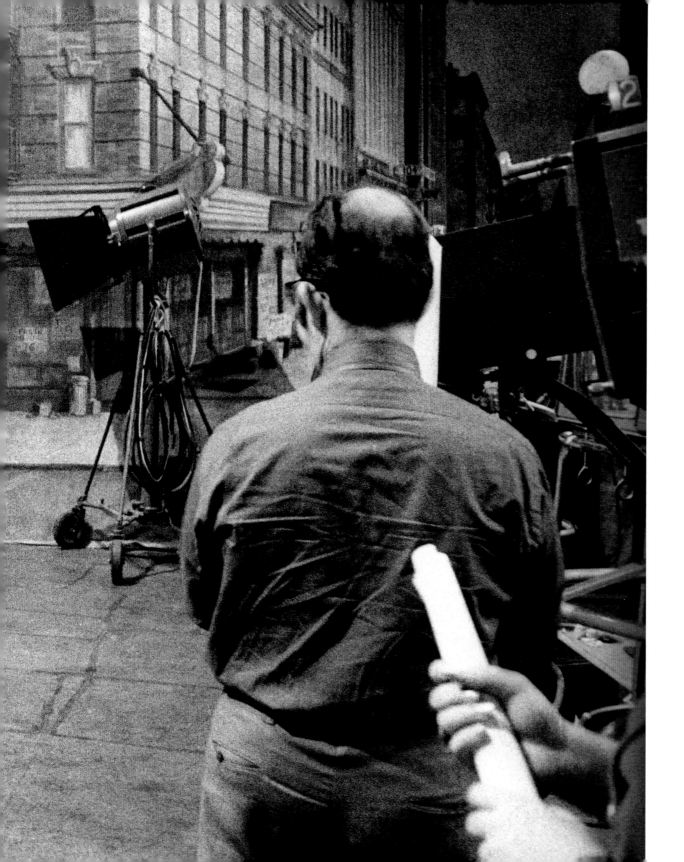

McGrath with the
Sesame Street kids
and crew on the stoop.

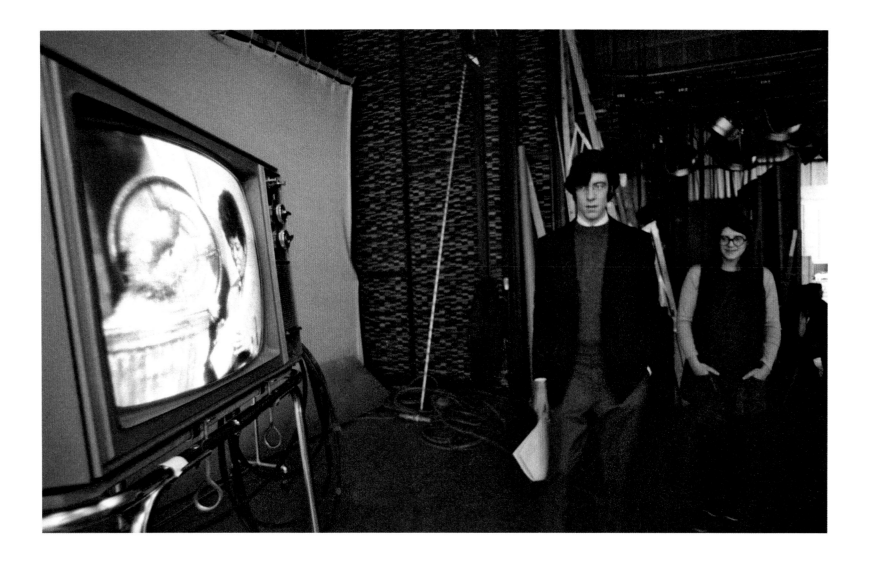

"no" into "yes." I turned to social media, reached out to the Twitterverse, and combed the web looking for a valid email address that might not bounce back as undelivered.

Weeks went by, and I had found nothing on my own. Even my entertainment lawyers, who also represent the parent company of the publisher, couldn't find him. Facing an early defeat, I finally called Stephen and told him the bad news. "Sorry, can't find him, no documentary, no deep dive into the Street." "Give me a day, I think have an idea," he said. Stephen is the kind of person who is instantly likable. I first met him at San Diego Comic-Con in 2013, and as we walked the expansive floor of the convention together, we were frequently interrupted by people coming up to hug him. Just seeing that, I knew he was the kind of person I could be friends with for a long time.

The next day Stephen called me back with Michael's cell phone number. I was shocked at how quickly he got something that had eluded me for months. "I asked Brian Jay Jones, and he happened to have it." Brian Jay Jones wrote *Jim Henson*, a fantastic biography of Jim Henson's life. The world is a very small place, as they say. Especially between authors who write about the history of Muppets.

Sesame Street executives watch Loretta Long, as Susan, chatting with Oscar the Grouch.

I knew what was next: Call Michael Davis and say, "Hello, you don't know me, but I have an idea to tell your story."

During this "waiting" time, I had been working on the pitch that I would present to Michael, or to anyone who might be involved in this film. The film needed a core idea, something that would be an anchor but also provide the narrative drive necessary to propel the story forward.

For me, it all came down to the people that built *Sesame Street*. This film wouldn't be about the Muppets, it would be about the people. It would be about Joan Ganz Cooney, and Jim Henson, and Jon Stone. They would represent the three pillars that Sesame would be built upon: The Idealist, the Magician, and the Visionary.

I wanted to make sure that I didn't ruin anyone's childhood with this film. I was going to make a film that instilled in others the same feelings that I got reading the book: that imagination and creativity with purpose can change the entire world for the better. That every time someone asks a question that starts with "could," there are limitless possibilities to answer the call.

I finalized my pitch and sent it over to Michael. Having been a graphic designer for more than twenty-five years, I knew that without a "look" that would support my idea, I couldn't properly communicate the intent for the film. A picture really is worth more than a thousand words in the real world.

I had planned it all out—the vision and the execution, what partners we would need, and how much it would cost. Every page of the pitch book was filled with iconic, vintage images of the series, timelines of the events, summaries of the film's story arc, and as many behind-the-scenes photos as I could get my hands on. It was the entire movie spelled out on paper.

When Michael and I finally connected on the phone, I could hear something special in his voice—the sound of someone, bursting with passion for an idea, who knew that so many more people needed to hear the story. If that sounds a little touchy-feely, well—it was. We formed a bond that was immediate and strong, mostly because he heard the same thing in me. I wanted everyone to know

that creativity wins; it moves the immoveable and lifts us all. So after a few short weeks, it was done. I had the rights to *Street Gang*.

Now, one could certainly make a movie about the history of *Sesame Street* without the support of the people who make *Sesame Street* . . . but it wouldn't be very good. Somewhere along the line, someone at Sesame Workshop heard that Michael had sold the rights to his book, and since I hadn't immediately reached out to them, everyone was very curious about my intentions. About two months after I had closed the deal with Michael, I was scheduled for a call with Jeff Dunn, then CEO of the Workshop, and the executive team. I paced around my office in Los Angeles looking out of the window, on hold on the conference line waiting to have another variation of a conversation that had become familiar: "Hello, Jeff. You don't know me, but I have an idea to tell your story."

So I told my story, and the story of the documentary. I told them what was in my head and heart: that *Sesame Street* was responsible for the happiness of so many people, and that we all, as a society, needed to remember where all of that came from. *Sesame* is an institution, but it didn't start that way. We needed to know that a creative group of rebels can change the world, with the intent to make it a better place. I told them that I wanted the focus to be on the origin story of the show, and more precisely about Joan, Jon, and Jim, and that I wanted to interview the people who made it happen. I wanted more than to show what it was like to make a TV show for kids; I wanted people to feel what it was like to make *Sesame Street* and be part of the gang.

The question that started *Sesame Street* was "Could television be used to teach young children?"

"Could you make that into a documentary?" is the question that started *Street Gang*.

As the production got started in 2016, there were many days when "Could you?" turned into "Can you?" Making movies is hard. No other way to say it. Long days and sleepless nights can wear down even the most seasoned professional. Add the word "independent" to the word "movie," and you've reached a whole new level of

difficulty. Without a big studio backing your production, you end up holding all of those proverbial hats, trying to figure out which one to wear next, or more accurately, how many you can wear at once.

At some point during the production of this film I played the role of producer, writer, editor, director, financier, production assistant, grip, designer, postproduction supervisor, counselor, and janitor. I'm sure there are lots more roles I haven't mentioned. And the crew you hire also very likely will need to do more than just their job. With independent film, a strong crew isn't a "nice to have"; it's as essential as the oxygen you breathe.

Working on a project like *Street Gang*, you quickly realize who your friends are, who really has your back. You see the people that will go to bat for you against all odds. Making movies has been likened to a skirmish on a battleground. There is a lot of waiting around, and then, for a short period of time, everyone is deep in it, surrounded by big equipment, crouched in uncomfortable positions, making the best of a very difficult situation. But in those moments, like the band of brothers (and sisters) from the St. Crispin's Day fight that Shakespeare so eloquently put to words, these people that "fight" with you become your family.

It was through work that I met my wife Ellen. Irrespective of our marital connection, Ellen is one of the greatest producers that I have ever known. A big part of any project, in any medium that uses teams of creative professionals, is making sure that "everyone feels safe and smart," as she likes to say. There is a profound wisdom in that statement. Because of the volume of production tasks that face filmmakers every day, no one person can know everything that is happening. Producing is making sure that every part of a film is moving along smoothly. But what often isn't talked about is that the job is also making sure that all of the people who are working on the film are also moving along smoothly. This is where Ellen is a master at the art of producing. Managing the complexities becomes a high-stakes game when you are producing a film. You hope the risk will give you reward, but there are no guarantees in life, love, or filmmaking. The volume of phone calls and personal meetings she took, and as of this writing still takes, from all of the partners on the film is staggering.

We were lucky enough to start off our interviews for the film with Sonia Manzano. Ellen was there for the shoot at Sonia's home in NYC. Though we hadn't met Sonia before, we all knew her as Maria from *Sesame Street*. She had been interviewed many times, so we needed our shoot to be perfect so she could trust us to be the stewards of her story.

There was an immense amount of complex logistics that Ellen streamlined to achieve that trust. We split the tasks, each working on separate aspects of the shoot. It became the template for how we would handle all our interviews, along with our team. Some say you are crazy to work with your spouse, but for us, there is absolute trust, complementary strengths, and the expediency of unspoken communication that comes from knowing someone so well. I highly recommend it.

I'm sometimes asked, "How do you get an interview like that? Where do you start?"

You start with a phone call. You start by gaining the trust of the other person on the phone. You have to be authentic, and clear about your intent and purpose. And you start by making sure that all of your crew knows that they are supported, because we are all working together.

In the early stages of development for the film, I interviewed a potential director who had worked directly with Jim Henson for many years. He told fantastic stories about those years. I sat next to him totally enraptured by the conversation. Anecdote after anecdote, I was dazzled by the wit, wisdom, and business savvy of Jim Henson. There was one part of our conversation that has always stayed with me. This director made it a point to mention specifically that Jim created a professional environment that was completely without fear. If you worked for him, you were encouraged to try something new and great, and if it didn't work out, you weren't persecuted; you just tried again.

So, Ellen and I created our own crew, our own gang. We brought on key people, like our director Marilyn Agrelo.

While searching for a director, I was mindlessly scrolling through Facebook when a picture of Ernie

Long peers into Oscar's trashcan.

12
—
13

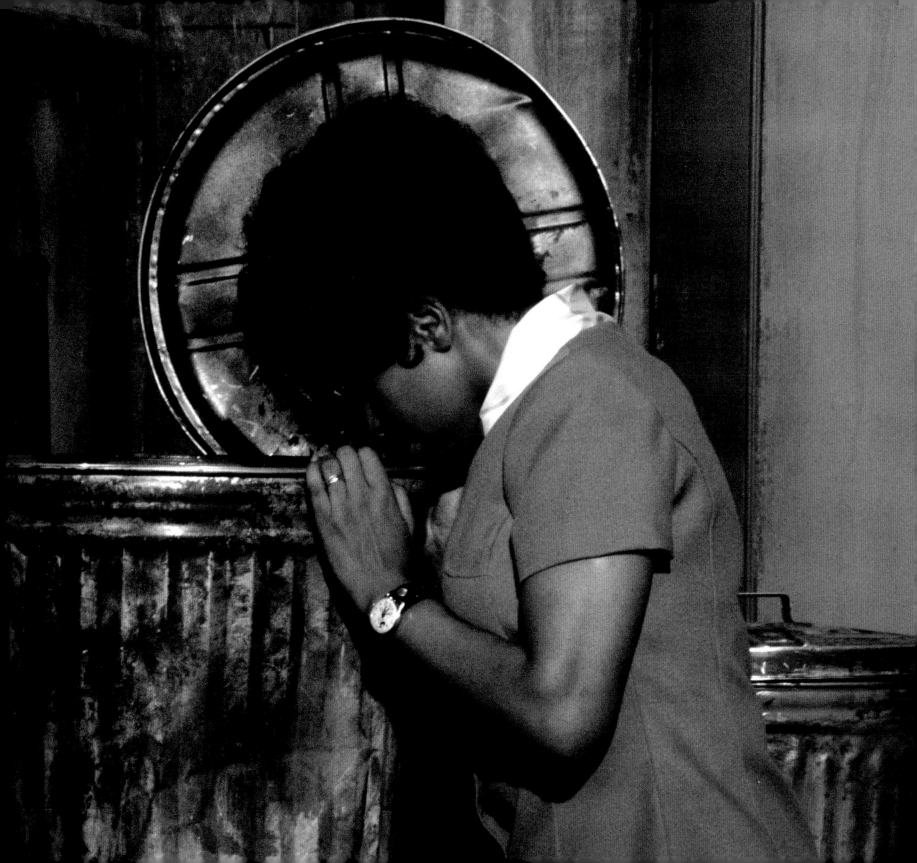

and Marilyn rose from the bottom of my feed. I had known Marilyn for almost twenty years, and of course knew about *Mad Hot Ballroom*, her first documentary film. Marilyn had just directed a music video for *Sesame Street* with Ernie singing "I don't want to live on the moon." It took a picture of her on Facebook with a Muppet for me to connect the dots.

Ellen and I then set about establishing, and maintaining, an environment without fear, so our new creative family could find its way to tell a story that was bigger than all of us.

Joan Ganz Cooney, the creator of *Sesame Street*, once said about the original team that developed and produced the show: "Collectively, we were a genius." And in our own small way that was true for us, too, the little Street Gang we discovered.

Documentary filmmaking is largely about discovery. You have a story that is unknown, at least to yourself, and through countless hours of looking, listening, and sifting, you become one of the lucky few who discover something that is rare and beautiful—something that people need to see. Unlike most narrative films, where you have a script, the story in a documentary often unfolds as you work on it. Sometimes that happens in very unexpected ways.

Five years into making *Street Gang*, we had hit a huge wall. We got external feedback that the movie wasn't good. The film wasn't really resonating. There was a lot of work to be done, much more so than we had expected at that point.

I had the same sinking feeling that you get when you know your tank is empty, but there is so much farther to go: You feel like your lungs are filled with mud and even though you are screaming, no sound comes out. I had also been feeling like much of the film wasn't working at that time. I knew it deep down in my center, but I was hoping that I was wrong. Turns out I wasn't. We were missing one basic element: joy.

A producer's main job is to keep the production on track. But for Ellen and me, the struggle was more acute than just a job. Our production company, Macrocosm Entertainment, was funding the documentary, and our

reputations were on the line. This was the proverbial tipping point. One little shove in the wrong direction, and we would lose it all.

Seated at the end of a conference room table, my mind racing at stress level 100, I was surprised by my first and earliest memory from my childhood, which appeared in my head out of nowhere.

I saw a quick flash, then a soft glow as a TV came to life. It was time for *Sesame Street*. I ran back to the brown fuzzy couch in the basement of my Long Island, New York, childhood home and sat next to my parents. We were all watching the show together, laughing and being silly. That's what *Sesame Street* brings to so many of us—a profound sense of joy. I needed that memory then more than at any point in my life.

Seated at the end of the table, I could see everything laid out in front of me. In that moment I also saw the entire timeline of the project like VHS playing on rewind. That early memory flashed into my head again, and I blurted out to the group, "Kids and Muppets. We are missing kids and Muppets!" I realized that those charming kid/Muppet scenes embody everything that makes up *Sesame Street*: imagination, improv comedy, and a healthy dose of education. For the kids, both in front of the camera and in the audience alike, there was no puppeteer. A Muppet was only ever a colorful monster that they considered a best friend.

I looked at our team and said, "We tried, and it didn't work, but we are going to get this right, and really change the direction of the film." It was one of those very NASA-esque, "Houston, we have a problem" moments.

With joy as our new guiding light, we worked with the team in a conference room for three days, story notes and cards all over the table, all over the walls, and discarded ideas literally lying on the ground. It was messy, it was chaotic, there was plenty of arguing, and sadly a few old poke bowls lying around (that's where my janitor role came in handy). But I knew that without joy, this film wouldn't live up to its potential.

When we were done in the conference room, a new map had been drawn. Luckily for all of us, it showed how

to get to *Sesame Street*. Finally, we were on our way, to where the air is sweet.

In looking back at what it felt like when I was a kid watching the show, I realized that I got so caught up in the business of making movies that I forgot about the joy of watching movies. I forgot what people really want to see. Audiences want to discover, and to laugh, but most importantly, they want to feel. In the end, the amazingly, overwhelmingly positive reception of our documentary tells me that following joy was the right call.

In that conference room, another thing became crystal clear: All of the stories about the creation of the show would never fit into a hundred-minute movie. Inevitably, in any film, there are gems that get cut in the editing process—images that aren't seen and stories that can't be heard. But I wondered why some of the stories and images needed to remain unseen. Why couldn't we create a story world for *Street Gang* and a way that every part of the production could inform the whole larger story? There are, after all, many ways to tell a story, which brings us to the book that you hold in your hands now.

The idea started as a small spark in the summer of 2018 as my fantastic archival producer Rich Remsberg was sitting in our office, furiously scanning negatives. Throughout the production, Rich pulled footage from obscurity and consistently amazed us with what he found. From old footage of Matt Robinson, the first Gordon, hosting the local Philadelphia talk show *Black Book*, to the original *Send your kid to the ghetto* PSA that inspired Jon Stone's vision of the *Street*. If you named it, he could find it.

He was only on the west coast for a few days, coordinating a few different projects that were based in LA. The images he showed us that filled us with a profound awe. Scan after scan, Rich was mining diamonds.

The photos became one of the greatest treasures of the film. They were given to us by Eli Attie, an accomplished television writer (his words found their way into shows like *The West Wing*, *House*, and *Billions*). Eli's father was David Attie, a noted photographer who was very active during the time of *Sesame Street*'s premiere. David captured these never-before-seen photos during a two-week period when some of the most classic Muppet sketches were performed for the first time. It was not only the volume of David's photographs that amazed us, but the uniqueness of the story they told.

It was pure chance that we found Eli Attie. One of those rare cosmic alignments that led one person to another, and then another, and ultimately to us.

We went to meet Eli on the Disney lot in Burbank and carefully accepted boxes of slides and negatives. You could tell the value that these boxes held for Eli. It was like he was handing over platinum bars. And rightfully so. These images are priceless.

David Attie's collection of behind-the-scenes photos chronicled not only the characters that we have come to love and admire for more than fifty years, but also the process of making television in a bygone era.

For me, the photos in this book create a profound sense of joy. They allow us to look deeper into the story of the Street Gang than the documentary alone. They lift the veil on childhood dreams and show us that the wizards behind the curtain are just as wonderful as the magic in front of it. They show us in vivid detail that a gang of rebels created a street where everyone learned from each other, loved each other, and were there for each other, no matter what. The photos show that a street that was plucked from Harlem . . . well, it became the world we all wanted to live in, and because of it, we are all part of the Gang now.

Trevor Crafts is an award-winning producer and filmmaker whose works include *Street Gang: How We Got to Sesame Street* and *Lantern City*, based on his own BOOM! Studios comic-book series. He is the CEO of Macrocosm Entertainment and lives in Weston, Connecticut.

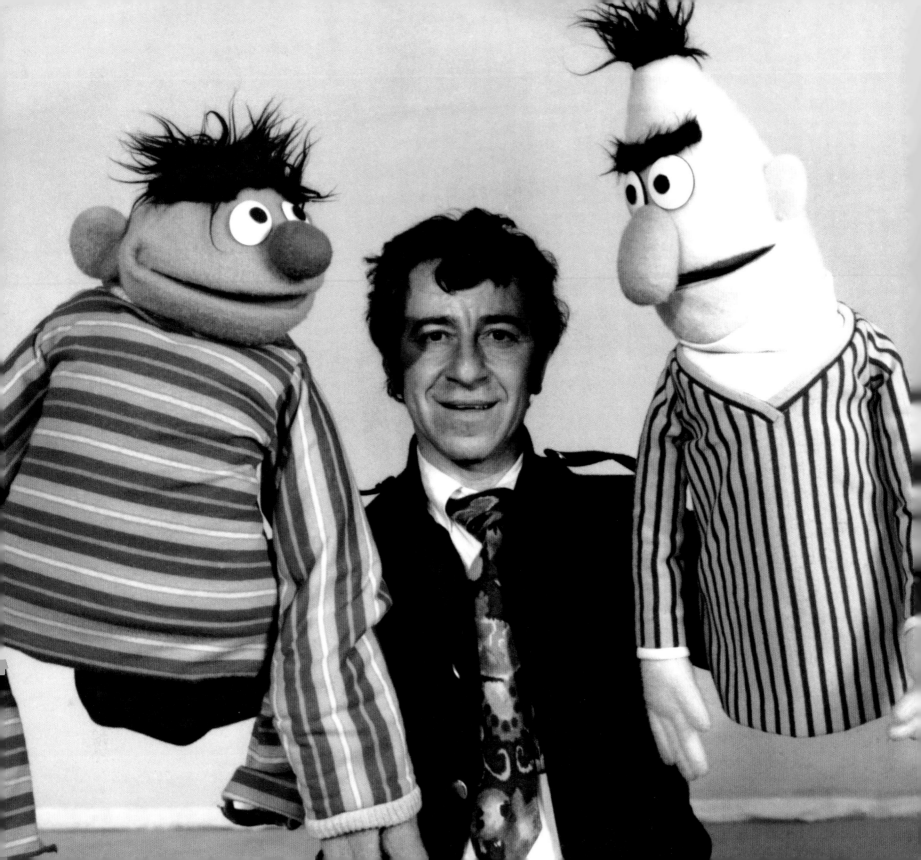

PREFACE

Eli Attie

In all likelihood, David Attie never wanted you to see the photographs in this book.

If that seems implausible to you, maybe even a little crazy, consider these facts: My dad was given total, behind-the-scenes access to the filming of several episodes of *Sesame Street*—already a phenomenon in its very first season. In the months and years to come, the show became much more than a phenomenon; it became a part of our collective consciousness—a signifier of joy and innocence and childhood abandon on par with swing sets and hide-and-seek and Good Humor ice cream.

But only a couple of these images ever appeared in print. And that was fifty-one years ago, in the obscure magazine that commissioned them, available only in the Soviet Union.

The negatives were then stashed in an overcrowded closet, in the brownstone where my father lived and worked. Never printed. Never shown. One leaky pipe away from oblivion.

In case you're wondering, my childhood home had its share of leaky pipes. It also had its share of *Sesame Street* fanatics. My mother, Dotty Attie, an acclaimed feminist painter in her own right, says that in my Manhattan childhood, the show aired on three local public broadcast stations, one after the other. She would sit my brother Oliver and me in front of a TV, in a room next to her painting studio, ducking in to change the channel between broadcasts.

"I wish I could say it was because it was educational," she admits now. "It wasn't. You were transfixed. I could just change the channel, and I was good for another hour."

I should add that Oliver, a brilliant and widely published mathematician, learned to spell from those three-hour blocks of TV.

If *Sesame Street* was good enough for day care, why wasn't it good enough for David Attie's oeuvre?

I'll pose the question another way: Why were these stunning, historic images hidden away for decades, nearly forgotten, instead of being enshrined in our culture, displayed on postage stamps, and exhibited in major museums?

We'll get back to that. But first, let's talk about David Attie. The guy with precarious closets and a poor sense of his own legacy.

My dad never set out to be a photographer. After getting out of the Army, he worked as a commercial illustrator, drawing everything from cigarette ads to the covers of trashy romance novels. By his own account, he was "never outstanding in any way" and "always aware of my inadequacies." But hey, it was a living. Until it wasn't.

By the late 1950s, commercial illustration was dying fast. Magazines and publishing houses were turning to photographs instead of those antiquated, *Mad Men*–era line drawings. Meanwhile, as I've discovered from some personal letters, my dad was going broke. He wanted to start—and somehow support—a family of his own. In his own cheery assessment, "everything seemed to be going downhill." He needed a break.

That's when a friend suggested that he sign up for a photography course with the legendary Alexey Brodovitch, at the New School. Brodovitch was the longtime art director of *Harper's Bazaar* and had already mentored some of the greatest photographers who ever lived, marquee names such as Richard Avedon, Irving Penn, and Diane Arbus. The course was actually held in Avedon's studio.

Now, Brodovitch is considered one of the fathers of modern magazine design; he's credited with inventing the two-page spread—which, let's face it, is a bit like inventing the sandwich. He was a very big deal. He was also a brutally tough teacher. His course was a visual-arts version of

David Attie holding
Bert and Ernie.

the movie *Whiplash*. If he didn't like your work, he'd rip you to pieces.

One night, in his makeshift apartment darkroom on 55th Street, my father was developing the film for his very first assignment—photos of the original Penn Station, before its demolition. He quickly discovered that, in his rookie ignorance, he'd underexposed every single frame. There wasn't one usable image, not one. The class was the next day. In other words, he was toast. And so was the break he needed to, well, create my brother and me. I get anxious just thinking about it. In a desperate panic, he started layering negatives together, just to create some usable images, and in the process, he created moody, impressionistic montages. His life must have been flashing before his eyes—and at the wrong exposure.

Brodovitch loved the montages. He spent the entire class gushing over them. On the final night of the course, he offered my father his first professional assignment: to illustrate a new work by an emerging young writer, Truman Capote. The work was "Breakfast At Tiffany's." It ran in *Esquire*, and the first full page was one of my dad's now-signature montages. Capote was soon gushing over him too, and hired him again. Downhill had become uphill.

Did my father become a rock-star photographer after that? Not exactly. He struggled and he hustled, as any freelancer would. But with "Tiffany's" as his calling card and Brodovitch in his corner, he worked constantly. And he racked up impressive credits: frequent covers and spreads for *Vogue, Time, Newsweek,* and *Bazaar*. Album covers and subway posters. Two books of his own work, 1977's *Russian Self-Portraits* and 1981's *Portrait: Theory* (together with Chuck Close, Robert Mapplethorpe, and others—not the shabbiest company).

Then my dad passed away. Nearly a decade before the Internet. The only footprint he left behind was stashed in those overcrowded closets.

I was extremely close to my dad. He worked from home. He always had time for me and my brother. His darkroom was another playground to us. And then he was gone, when I was still a kid. For years, it was too painful to even think about his death. So, I just moved on. My mom met my stepdad, who's very much a father to me now. We all developed lives and careers of our own. Digging through my late father's closets was the last thing on any of our minds. His work languished, and then it pretty much vanished.

Until about eight years ago. I can't say what motivated me to do this, beyond sheer procrastination from some script I was trying not to write, but I Googled my father's name.

Almost nothing popped up. I don't think I was prepared for how much that bothered me.

So I sprang into action. I took bad iPhone photos of some work of my dad's that was hanging on my mother's walls. I emailed them to a few people in the art world, certain that they would instantly recognize my father's genius and thank me for changing their lives.

Nobody cared.

Actually, that's putting it mildly. I couldn't even get gallerists and curators to take my calls and give me general advice. Hollywood may be a tough town, but at least people will ignore you over coffee.

Finally, a prominent rock photographer, Kate Simon, counseled me: "You need pictures of famous people. Gather any pictures your father took of famous people. That's the only way anyone's ever gonna care."

That's when I opened those overcrowded closets, in search of some celebrity juice. What I found made my jaw hit the floor—W. E. B. Du Bois, stoic and proud in front of a great big painting of Frederick Douglass; Truman Capote, leading my dad around his Brooklyn Heights haunts; Lorraine Hansberry, beaming from behind her IBM Model 01 typewriter; Bobby Fischer, six months before becoming world chess champion, bizarrely being shaved by my dad on eight-millimeter film; portraits of The Band in their Woodstock prime—most of which had never been seen, not even once.

I also found—if I may brag a little here—some of the coolest pictures of the Street Gang that have ever been taken, a creation story in all its hippified glory.

How could such incredible, historic work be shoved in a closet, presumably never to be seen again? I don't think it was an oversight on my dad's part.

An example of Attie's experimental photographic overlay montage technique, featuring Long, Bert, Oliver Attie, Ernie, Jim Henson, and a few lucky kids who got a set visit to *Sesame Street*.

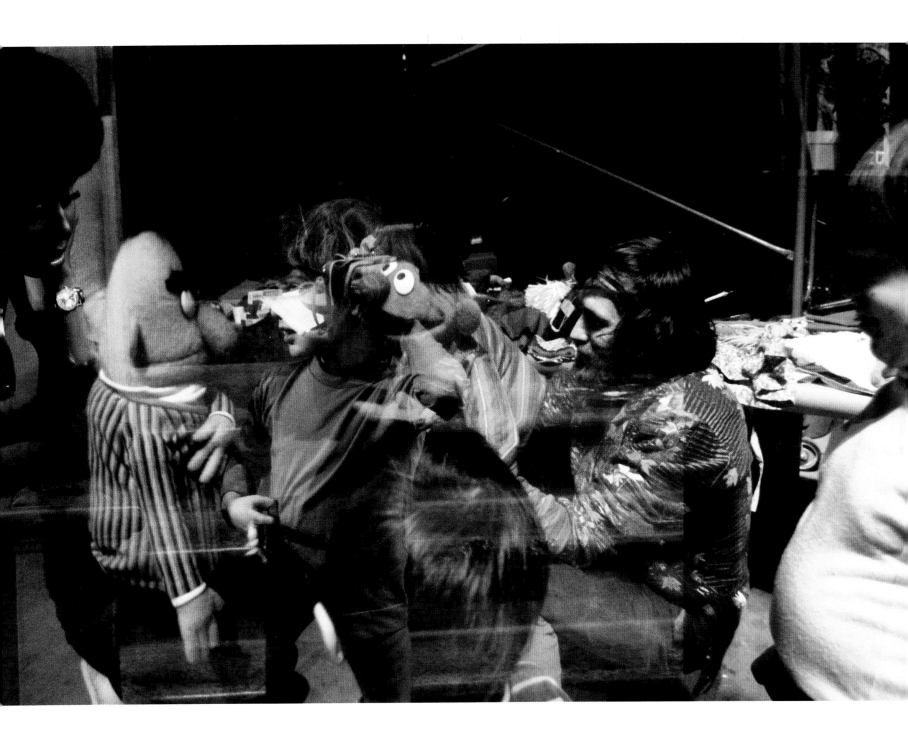

This brings us to the complicated part of the story. My dad always kept the rights to his work, and often licensed his old montages. But he almost never tried to license his celebrity images, even as their subjects rocketed to mega-fame. He wanted to be known for his montages. I don't think he believed the other work was good enough.

My father once wrote that, "my first impulse is to do battle with photography, to produce images that are anti-photographic. I have never made peace with photography in its simplest expression. I feel the need to interfere in some way with the making of a photograph. The ideal photograph for me is one that cannot be seen in a view-finder or even in nature."

But I know from my mom that he was also insecure, worried that he couldn't compete with the marquee names on their turf. That led him to focus on the montages, on "self-portraits" in which his subjects controlled the exposure, on heavily filtered color images, on the "anti-photographic." You'll see examples of that work in these pages—some of which may have been experiments; it's hard to know.

I love all of that work. It gave my dad a very good career. But leaf through this book and I'm sure you'll agree: even in his simplest expression, David Attie had no reason to be insecure.

Our whole family visited during my father's *Sesame Street* shoot. My mother didn't think she had, but there she is, standing on the set in a couple of these photo-graphs, probably wondering how many painting hours she can milk out of this miraculous new children's show.

I was still in diapers at the time. According to family lore, I babbled so loudly and so incessantly, I had to be yanked from the set, like a bad Vaudeville act cut short. Even as a kid, this was a source of shame to me. I couldn't even keep it together for Kermit the Frog? My brother Oliver was older, and sager, and calmer. He not only got to stay on the set, as you can see throughout this book, he made it into the show itself. He was already a viewer and remembers getting to meet Gordon and Susan and Big Bird—and Caroll Spinney, the guy inside Big Bird, as well. He says this wasn't at all disillusioning.

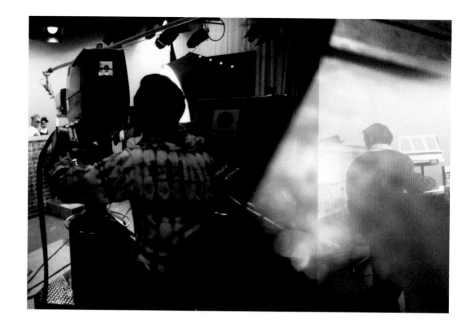

What was disillusioning to him was this: He was filmed sitting inside Hooper's store. He fully expected he'd get to drink some kind of fun soda or malt while he was there. Alas, he says, "it was just an empty glass." He even remem-bers it being a bit dusty. Four years old and already learning hard truths about show business. Still, for years I was jeal-ous of this. An empty glass is better than no glass at all.

What do I see when I look at these photographs now?

I see the raucous fun and the radical invention of *Sesame Street* springing to life before my dad's lens.

I see the work of a man who loved children and con-nected instantly with the comic mayhem that was already the show's trademark.

And as the father of a raucous eighteen-month-old girl myself—David Attie's granddaughter, who will never get to meet him—I see how fast our lives slip by. How rare and precious our childhood memories are. And why they should never gather dust in an overcrowded closet.

These pictures were taken for a magazine called *Amerika*, which was distributed in the Soviet Union by the now-defunct U.S. Information Agency—a form of Cold War cultural exchange. I'd never seen the original

Experimental montage of McGrath and a *Sesame Street* cameraman at Reeves Teletape Studios.

Experimental montage
with Gordon, played by
Matt Robinson; Long;
Pete the Street Sweeper,
played by George Zima;
and some of *Sesame Street*'s
production executives.

spread, and as this book headed to print, I started hunting for it, eager to see which images were used. It was maddeningly hard to find. A former USIA official told me that *Amerika* was scarce in its heyday too; the Soviets claimed no one wanted a glossy magazine about our country, and would return most of the copies as "unsold." Never mind that they fetched huge prices on the black market. When I finally tracked down the *Sesame* issue, at University College London of all places, I was stunned to see that the November 1970 article—"A Stroll Down Sesame Street," by young-adult author Elinor Lander Horwitz—used just two photos from the entire exhaustive shoot. One was heavily tinted, the other taken from a pixelated TV monitor. Leave it to my dad to steer clear of the merely photographic.

David Attie has a healthy Internet presence now. Getty Images started licensing his work, and a gorgeous book of his Capote photographs came out about six years ago (*Brooklyn: A Personal Memoir*, The Little Bookroom, 2015). I had emailed one of his Capote portraits to a publisher,

Angela Hederman, on a whim, asking if she wanted it for her website. She suggested an entire book about five days later. It's still selling.

At some point, I also told Angela that my dad had photographed *Sesame Street*. She mentioned this to a woman who was talking to the wonderful Trevor Crafts about getting involved with his new *Sesame Street* documentary.

That woman never got involved with the documentary, which became the deeply affecting, downright Proustian *Street Gang: How We Got to Sesame Street*. But as you know from the book in your hand, David Attie did. In a pretty big way.

I'm getting used to the fact that fluke accidents and sheer happenstance will always govern his career—just as they did when he was alive.

And eight years into my ham-handed effort to revive his work, maybe it's time for me to just get out of its way. If I'm right about all this—if my dad didn't think these images deserved to be seen—I think he'd also be thrilled to know: The work has proven him wrong.

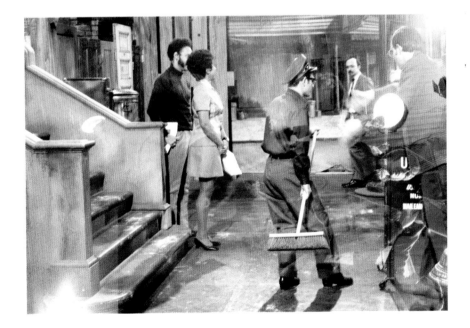

Eli Attie is an Emmy-winning TV writer and producer whose credits include long stints on *The West Wing*, *House*, and, more recently, *Billions*. He previously served as Vice President Al Gore's chief White House and campaign speechwriter through Gore's concession of the 2000 presidential election, which he and Gore wrote together.

David Attie was a highly prolific commercial and fine-art photographer from the late 1950s until his passing in the 1980s. In March 1970, he photographed the very first season of *Sesame Street* for *Amerika*, a Russian-language magazine distributed in the Soviet Union during the Cold War. Attie's work is in the Smithsonian's National Portrait Gallery, and is represented by Getty Images and by Keith De Lellis Gallery in New York City.

22
—
23

Experimental montage of
Oliver Attie, Long, Frank Oz,
Bert, Ernie, and Jim Henson.

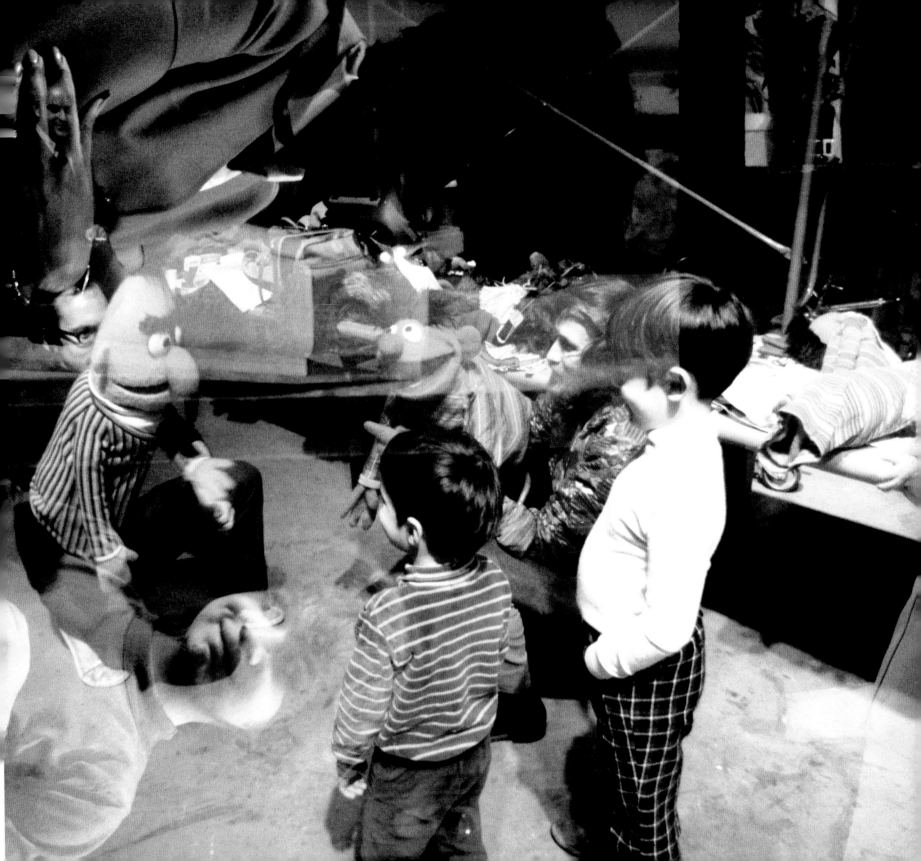



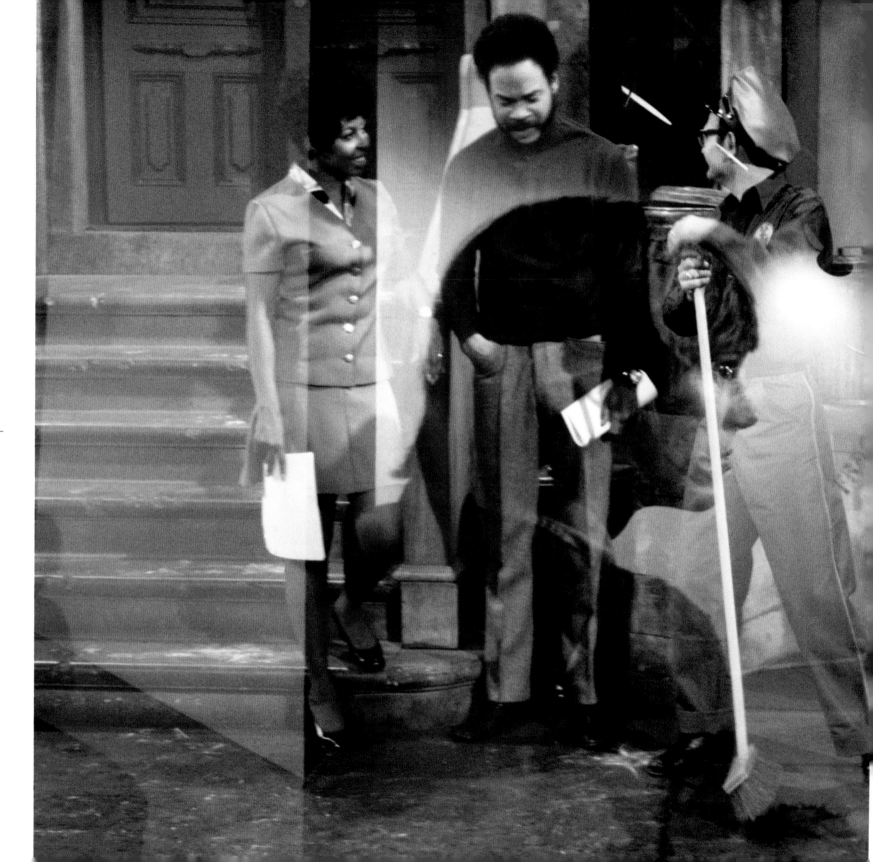



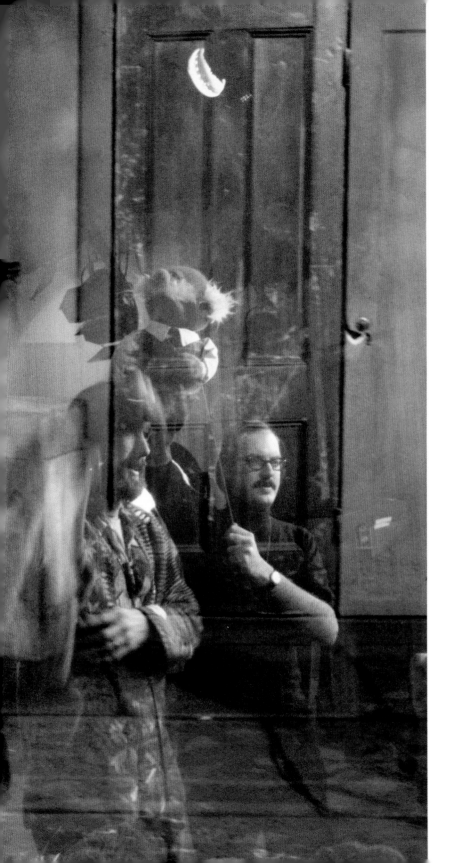

Experimental montage featuring
Long, Robinson, Zima, and
puppeteers Daniel Seagren,
Henson, and Oz working with the
"Fat Blue" Anything Muppet.

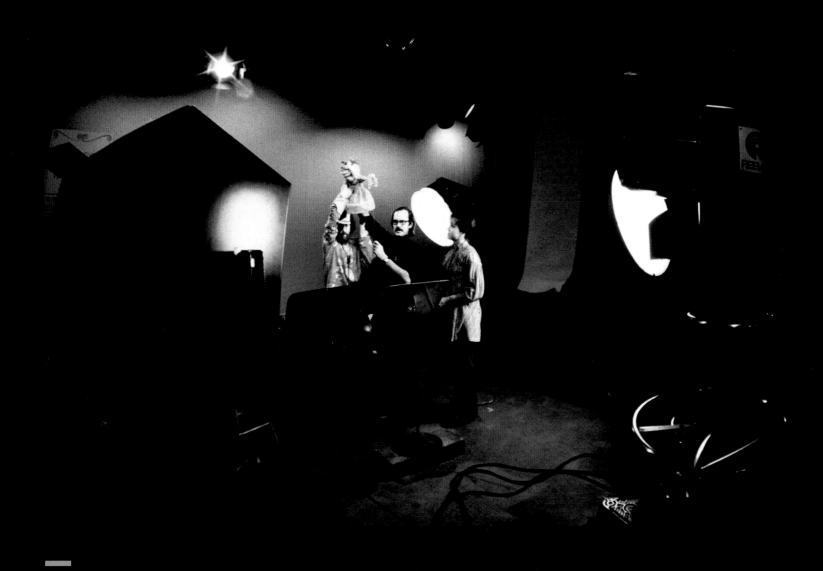

A series of Attie's color-tinted images.

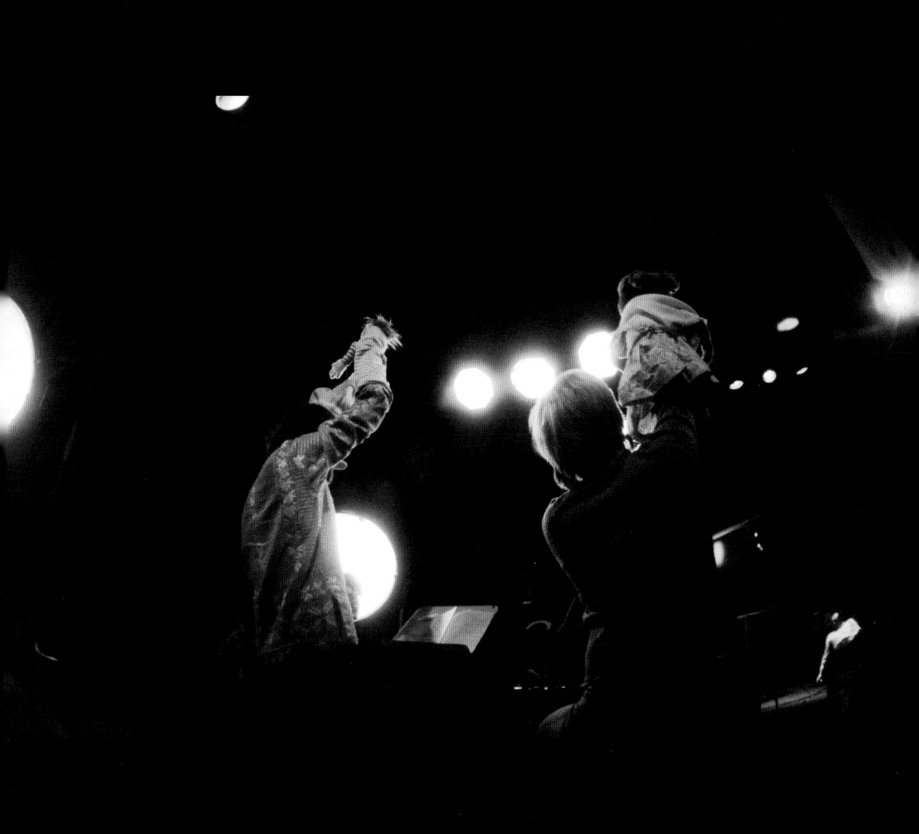

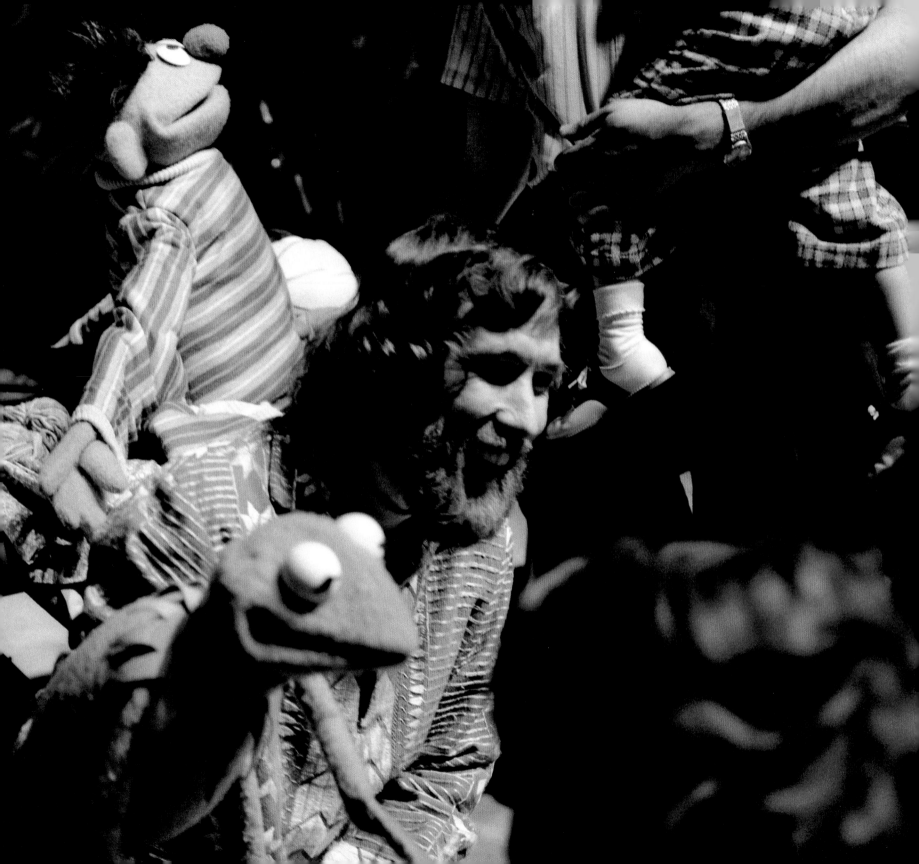

FOREWORD

Michael Davis

———

Picasso once said, "Everything is a miracle. That we don't dissolve in our bath like a lump of sugar is a miracle."

I'm with Pablo.

That *Sesame Street* continues, reliably and effectively, to stimulate the intellect of children—fifty-plus years after its public-television debut—cannot be easily explained. As someone who devoted years of research into the show's origin and formative years, all I can tell you is that the alchemy was conjured by both the mundane and the mystical. David Attie's frozen-in-time images attest to that.

In them we see an American workplace circa 1970, a windowless staging area cut off from the outside world. Scattered about are union carpenters and electricians, stagehands, camera and boom operators, costumers and make-up artists. It's a landscape littered with discarded coffee cups and cluttered with scaffolding, ladders, and cables, coiled and snaked across the floor. The walls and ceilings are painted a grim black.

Most television studios, then as now, are disarmingly unglamorous and unremarkable places. Most aren't what you might expect. The start-and-stop pace of activity is unnatural. Boredom and tedium are as much a part of the workday as in other professions, where groups of people are constructing something layer by layer, piece by piece, moment to moment until someone calls "Lunch!"

If you study the edges of Attie's photos, you'll pick up on the workaday atmosphere where yesteryear episodes of *Sesame Street* were staged and shot. These documentary images call to mind the archival photographs we've seen of weary workers with sledgehammers securing railroad ties or soot-faced laborers in Western Pennsylvania heading

out of the coal mines. Attie's images capture a time and a place, a distinct and honorable photographic purpose. They're a visualized history of art and craft, but also of toil.

Most of the people hired to create *Sesame Street* expected it to last no longer than a season or two. It was television, after all, a capricious medium where ratings and advertising determine a program's fate. And here was a series made for the nascent public airwaves that barely registered a rating point in some markets and had not a dime of advertiser-supported revenue. For the laborers in the studio—and even for the writers, actors and production staff, the high creatives— *Sesame Street* was a paycheck, a gig, a way to pay the bills.

New York–based performers are acutely aware of how tenuous steady work can be. And even though *Sesame Street* quickly became a national sensation, despite the odds, it still took years before the acting company, musicians, and puppeteers felt secure enough about their employment to exhale.

That said, to watch episodes from the early years of *Sesame Street* is to see television bursting with vivid and ambitious ideas, expertly and often cheekily executed. Unseen was the physical, emotional, and psychological toll paid to make it all look wrinkle-free and easy. That's where the mystical enters, stage left.

Something wondrous was at play in the studio, something evident in the images Attie captured as a result of extraordinary access provided by the Children's Television Workshop, now known as Sesame Workshop. You see it in a rarer-than-rare photo of Jim Henson, so overtaken by delight that you can't help smiling back at him—and then feel a pang of loss for an American original who left us all too soon. All these years later I can feel the *whoosh* of air escaping from the void created by Henson's senseless and avoidable death.

Henson wasn't the only creative genius in *Sesame Street* history to die young; *Street Gang*, the book and movie, chronicle the painful narrative of grief that has hung over the series like layers of dark cloud. So many men died

———

Henson and Kermit.

before their time. The most consequential of them all was executive producer Jon Stone, the bewhiskered visionary who gave *Sesame Street* its moral compass and soul.

In the studio, both Henson and Stone trafficked in a kind of managerial wizardry, bringing the best out of their employees during workdays that stretched well into the night. Both were wildly imaginative workaholics. Both could easily access their inner child, and both exhibited an uncanny and natural ability to communicate with kids brought into the studio to complete the illusion that *Sesame Street* was a real urban neighborhood where the races mixed easily. (Important note: Those children you saw interacting with Henson were decidedly not professional actors, nor were they accompanied by whirlybird stage parents.)

Henson and Stone had a level of creative output that now seems damn near impossible, in that they led a production staff to complete 130 hour-long episodes of *Sesame Street* per season in its first years. Nowadays, each new season of *Sesame Street* on HBO includes 35 30-minute programs. That's 17.5 hours of television.

Henson, who wrangled the Muppet performers, and Stone, who wrangled the humans, had to find ways to mitigate against the production misfires, blown lines, technical delays, and fatigue. Adding to that was the staging, lighting, and blocking necessary to make it possible for the actors and Muppets to work seamlessly.

None of it would have worked had Jim Henson not had a flash of insight that popped like a bulb in an old Speed Graphic camera.

As a puppeteer barely out of his teens, Henson and his wife, Jane, produced five-minute bursts of anarchic hilarity for a local station in Washington, D.C., with a show called *Sam and Friends*. Their experimental work led to a realization that the television screen, with its contours and aspect ratio, was its own puppet theater, an electronic realization of the confined, rectangular space once occupied by Judy and Punch. Henson's playful use of the edges and background of the screen provided a prologue for what would later be satiric news flashes featuring Kermit (in a trench coat and fedora) reporting from such exotic locales as Rapunzel's castle ("Get me yowtta here!" she pleads in an ear-splitting, borough-of-Queens dialect) and the accident scene in which horses and king's men attempt to reconstruct Humpty Dumpty. Once put back together again, the excitable (and amphibious) "Sesame Street News" reporter offers the smiling egg a congratulatory slap on the back, sending Dumpty back over the wall. Ambulance sirens wail.

As a duo, Henson and Stone created a culture that honored inspired silliness, a comedic style familiar to anyone who reveres the television work of Ernie Kovacs or Monty Python or Conan O'Brien at his zaniest. Truth be told, the duo introduced several generations of children to comedy in all its forms. What are Bert and Ernie if not a comedy duo in the style Costello and Abbott, Burns and Allen, Carney and Gleason? (I'll leave it to you to decide whether the *Street*'s Two-Headed Monster is a solo act or a pairing. It's an existential question I've long pondered.)

Sesame Street gave us ensemble comedy, pratfalls, stand-up and, of course, those deliciously satiric parodies. One of the hallmarks of the early days was Henson's spoofing of commercial television as Guy Smiley, the over-stimulated game-show host. And who could forget the "Monsterpiece Theater" send-ups with Alistair Cookie in a smoking jacket?

Saturday Night Live owes a debt to *Sesame Street*. A series aimed at preschoolers has yielded generations of comedy-literate adults, giving new meaning to "ready for primetime." Laughter being the universal lubricant, Henson and Stone oiled the works with it generously. The outtakes in the *Street Gang* documentary provide all the evidence one needs to understand the improvisational hilarity abounded in that studio.

That free-spirited ease continued well after Henson and Stone were no longer walking the Earth. It was their legacy actually, a way of doing business that allowed for spontaneity and joy to break up the tedium and stress. Performers and production people carried on in the ways of their teachers, and they carried it forward to the next generation.

That torch passing partially explains why *Sesame Street* remains what it is: the most influential series in the history of television. If you doubt this, simply ask the person in the next room who their favorite character is from the show and why. You'll be reminded that *Sesame Street* resides in both the head and heart. We all carry it with us wherever we go.

In my reporting for the book, I had quite a studio moment with my favorite. While scribbling notes in a pad,

Grover suddenly popped over my shoulder. "What are you doing?" he asked, whereupon I began a conversational exchange with what essentially is nothing more than blue bathmat fabric adorned with unblinking applique eyes and a furry pink nose. And yet, my sense of disbelief dissolved, I realized I was talking to Grover, a character whose neurotic inner life I know better than my own.

During my term of service working for *TV Guide*, I was only star-struck once. A celebrity puppet reduced me to babble. It was an unforgettable encounter.

As they did for photographer David Attie, the gatekeepers who oversee *Sesame Street* allowed me in for a privileged peek at the making of a few episodes. There's no proper way to express my gratitude for that access. Without it, *Street Gang* would have died aborning.

That filmmaker/producer and fantasy world-builder Trevor Crafts has uncovered Attie's trove of previously unseen photographs feels miraculous to me. I find these photos at once astounding, exhilarating, gratifying, and maybe divinely inspired.

And now to my bath, where I hope not to melt.

Journalist, editor, educator, and producer **Michael Davis** was a Nieman Fellow at Harvard University. He covered children's television as a senior editor and Family Page columnist at *TV Guide*. Davis is the author of *Street Gang: The Complete History of Sesame Street* and served as a co-executive producer of the *Street Gang* documentary.

Photos taken of on-air promos of *Sesame Street* during the first season of the show in 1970.

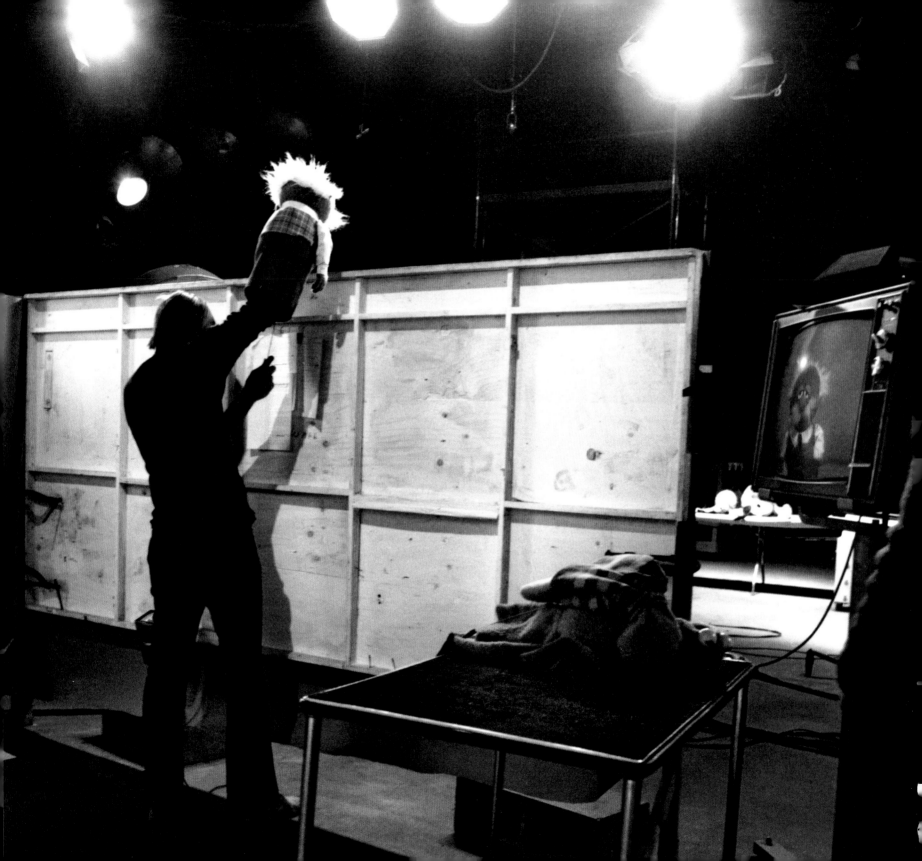

CHAPTER 1

BRING IT TO LIFE

One day in 1966, psychologist Lloyd Morrisett witnessed his three-year old-daughter Sarah stare, mesmerized, at the test pattern of their TV set without turning away. He was inspired to ask: "What if you could create content for television that was both entertaining and instructive? What if it went down more like ice cream than spinach? What if we stopped complaining about the banality we are allowing our children to see and did something about it?"

Lloyd knew he wasn't going to find out the answers on his own. He enlisted the help of an upstart public television producer named Joan Ganz Cooney and with this, one of the most important relationships in television, educational, and popular culture history was born.

As a socially conscious young woman working in the fledgling world of public television, Joan Ganz Cooney was inspired to do something profoundly different: create a children's show that would "master the addictive qualities of television and do something good with them." Joan envisioned TV being used in a new way. It would become a tool to reach and educate all children, especially minority kids from inner cities. To accomplish this goal, Joan gathered a gang of creative geniuses who lent their talents to this revolution. While many talented people came together to answer this call to action, a few in particular were hugely influential in *Sesame Street*'s early decades and became the driving force to bring the show to life and into the homes of children everywhere. They were Jon Stone, the show's original director and writer, who had the idea to put the show on a street, and Jim Henson, the creator of the Muppets.

In fact one of the core elements that makes *Sesame Street* so recognizable is, of course, the Muppets. They are iconic and synonymous with the show itself. But the origination of these characters truly comes from the people who control them. After all Muppets are just bits of fleece and fur stitched together, but a certain amount of creation occurs when a human hand slips into one of these colorful friends.

Maybe it was that working friendship that was at the core of the success of Jim Henson and Frank Oz. They had been working together for years when *Sesame Street* came into being. The two had honed their comedic timing with each other on dozens of commercial spots and TV specials. When the opportunity came along to create Muppet alter egos for the upstart show from the Children's Television Workshop, it was actually Jim who first put on Bert and Frank who was the pilot for Ernie. The experiment didn't work, but when reversed, one of the great comedy teams was cemented in the history books. This collection of images shows the working nature and intense relationship between puppet and puppeteer, of Jim and Frank, and of the Muppet to the lens of the camera.

Brian Henson, chairman of The Jim Henson Company, son of Jim and Jane Henson I was six when *Sesame Street* started, so I was pretty much the age of the audience. It wasn't anything unusual. Like any six-year-old, I thought, honestly, that my neighbors' families were probably all pretty much the same as mine.

My dad was one of those people who believed that if you're pure and honest, everybody will be pure and honest back to you. There was an innocence to him that was just delightful.

He was sort of the reluctant performer. "Let's do something that's never been done before, even though people are saying it's impossible." I very much have that same thing. He instilled that in me. I also love to try something that's impossible, that hasn't been done before. But if you do that—if that's what excites you—you know you're gonna fail. And you're gonna fail often.

Oz behind the wall with the "Fat Blue" Anything Muppet.

That was something that was also really cool about my dad: He honestly appreciated people for their efforts. If the efforts didn't work, that was okay. If it didn't work out, that's okay. That's way better than taking the safe path, and doing something that worked last month, "So let's just do it again this month." He was always into "Let's do something that hasn't been done before."

Karen Falk, head archivist for The Jim Henson Company Jim was a doodler, and he would make sketches in the margins of notes when he was in meetings. In the early years, he carried sketchbooks around with him, but Jim sketched on any available surface, and that included placemats. There is a placemat from a restaurant that was on 3rd Avenue called Oscar's Salt of the Sea. Jim and Jon Stone would go to lunch at Oscar's, and I guess the owner was sort of grouchy and didn't really treat his customers very well. But they went back there over and over again. So that's the source of Oscar the Grouch's name.

He was originally designed in magenta. Of course, now he's green, as we know him, but in the first season, he was actually orange.

Fran Brill, actress and puppeteer (*Sesame Street* puppeteer, 1970–2014); first female puppeteer, after Jane Henson, hired by Jim Henson I knew about Jim Henson. I mean, I knew who he was. I think I had seen the puppets on one of the shows he had done. He wasn't huge—he wasn't like "Jim Henson" to me. I think he became Jim Henson because of *Sesame Street*.

I was sitting in an agent's office one day, and there was an ad in *Backstage* saying that Jim Henson was looking to train puppeteers for an upcoming *Ed Sullivan* Christmas special. I thought, *Wow, that can't be too hard. I mean, I'd never played with a puppet in my life, but I knew I could do voices.* I thought, *Oh, they'll just use me to do character voices or maybe I'll do some of the animation.* About two weeks later, I had a meeting with Jim Henson and Frank Oz in a room over at the office, and there was a big black box of puppets and a floor-to-ceiling mirror. Jim said, "Well, you know, all our puppeteers, they do the voices. They do the

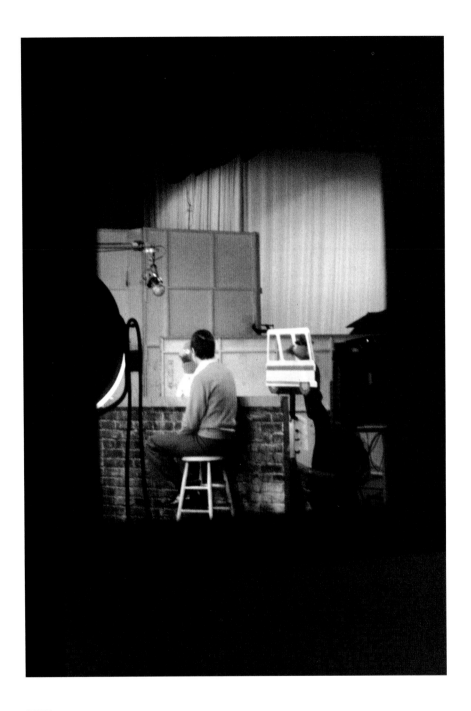

McGrath performing "People in your Neighborhood" with an Orange Anything Muppet.

manipulation and the voices." And I said, "Oh, I didn't know that. I'm not a puppeteer." And he said, "Well, let's just do some stuff." I mean, it was just so unbelievable. It would never, ever happen again. But I stuck my hand into this box and I pulled out a puppet. And there were some scripts, and Jim would say, "Oh, try doing this kind of voice, or try doing that." I have flexible vocal cords, so that was easy for me. But the manipulation is something I had to learn. I did this two-week workshop, and there was good chemistry among Frank Oz and Jim and me. I think Jim liked the idea that I had been an actress because he thought I could bring some acting chops to these characters.

Brian Frank Oz in particular was very advanced in his area of puppetry. His characters would do things that even he didn't expect, and it was really wonderful and delightful, and really genuine. And Frank, back then, was probably the shyest, quietest person I knew.

Later in life, he became the friendliest person. But in those early days, he would only talk to my dad. My father was also a pretty quiet, shy person. But then they put puppets on, and they'd get the cameras up, and they would deliberately try to make sure the crew couldn't work. They would try to get them laughing so hard that the cameramen couldn't be quiet, that they couldn't point the cameras—and they would slay the audience.

Even if it was just a video shoot, it was amazing to see, because it was these two introverted, quiet, shy, unusual men off camera, and then they would do this whole other thing when they had puppets on. Now, I can't say that's true with all puppeteers, but it is true with a lot. There are some puppeteers who are actors, and they're quite extroverted; they put puppets on, and their puppets are similar. But a lot of puppeteers, this thing happens where once they put a puppet on, it allows them to tap some-thing that they can't tap themselves. Something that's very genuine, that's inside of them, and has an energy that can't come out through them because of their shyness, or their introverted sensibility.

That's pretty special. It's really extraordinary to watch puppeteers who can do that. My father certainly

had a wide range of characters coming out of him; some were expected, and some unexpected. Kermit was very similar to my dad . . . but Guy Smiley? The quick, fast-talking game-show host kinda character? Way opposite of my father.

The range of characters that came out of Frank Oz was wild. He could do Cookie Monster and Bert in the same show, and then pull out Grover as well.

Norman Stiles, television writer (*Sesame Street* writer, 1971–1995) Frank had a knack. You have to remember these are just cloth—these *things*—with eyes stuck on, and to be able to get a character to express an emotion with just a slight little twist of the fabric is extraordinary, and Frank was just the best at it. It was wonderful, and you combine that with his ability to be funny with his voice and performance . . . such a phenomenal puppeteer.

Fran The whole idea is to make this piece of felt and fuzz react and move and look like a person, like a real thing. It's so, so hard to do. Just learning how to do eye focus is extremely difficult. In fact, when I did the training with Jim and all these other wannabe puppeteers, we had little eyeballs that were stuck on our fingers. Because that was so important to learn: "How do I do this while looking in a monitor that's on the floor?" Because that's how you see what you're doing. You're not watching the camera; you're looking down here or out there, wherever you can find a monitor.

It was at that same workshop I met Richard Hunt, who was hired at the same time I was. After that Jim asked, "Do you want to do this Christmas special? We're shooting it in Toronto." And I said, "Sure, why not?" When the shoot was over, Jim said, "I'd like you to do *Sesame Street*." I went, "Oh gosh, Jim. I don't know. This has been fun, but I'm an actress. You know? I want my face to be seen." He was so sweet. He understood where I was coming from. He said, "Well, just try it for a year. Tell us when you're available. We'll write stuff for you." So, sort of begrudgingly, I agreed to do it. There I was, not long after I graduated college, on the set of *Sesame Street* next to Will

Lee playing Mr. Hooper. Will Lee was my acting teacher at Boston University during my final year! He looks at me, and I look at him. And he says, "What are you doing here?" It was lovely. But it was also so bizarre!

You learn what life is like in a studio. I learned that I had to really watch what Jim or Frank were doing. And in those days when we did big musical numbers to our pre-records, we were wearing cables for the microphones. So not only did I have to wear high shoes because I was five-four and Jim and Frank are like six-one, six-two, but I also had to run around on the studio floor being attached to these guys with my right hand while *their* right hand is in the head of the puppet and their left hand is in the sleeve . . . and I'm in the other sleeve. So I'm just, you know, trying to follow this choreography without tripping and killing myself on the studio floor. They were wild times!

It was hard, but they started me slowly. They gave me anything Muppets. I was a girl, a frog, a pig, whatever. I very clearly remember the day that Jim Henson said to me, "We'd like you to try this little girl puppet." And this little puppet did exist already. I think her name was Little Pink or something. She became Prairie Dawn.

So he gave me this pink puppet, and he said, "You know, what we really want is a very sweet, I would say 'quintessential' little girl." In fact, she had a smocked dress and she even carried a hankie at that time. In the very beginning she had this blonde pageboy haircut and she was small, so it was easy for me to manipulate her. It wasn't a big, hulking thing like Bert, which is very difficult. I started thinking, *Okay, how do I make this girl really sweet?* So I sort of went into Marilyn Monroe-ish very breathy voice. That seemed to work okay, because they started putting her in shows.

Women's liberation started in the sixties, right before *Sesame Street*. But it forced *Sesame Street* to reevaluate what they were doing in their early seasons, especially with regard to how they were viewing little girls, how to write

for female characters, and what they were projecting as role models.

Prairie Dawn, who was the first principal female who was on *Sesame Street* and who wasn't a monster, but a little humanoid, was very sure of herself. She got to be more and more sure of herself. Because I was playing her, for one thing, and I liked juxtaposition of a small, tiny character with all of these boys—and yet she was smarter than any of them. She knew she was smarter than any of them, because she would write these pageants for the boys and play the piano. And I loved her because she was docile, but she also would tell the boys what to do.

Sonia Manzano, actress, writer, speaker, musician (*Sesame Street* cast member, 1971–2015) It was very difficult, in the beginning, to work with Muppets, especially when Caroll Spinney [puppeteer, writer, and artist; *Sesame Street* puppeteer, 1969–2018] would whisper under his costume, "Don't be nervous. There's only gonna be millions of people watching this."

My first bit was with Frank Oz as Grover, and we had to sing a song. And I kept looking down at him because the puppeteer is at your feet and the puppet's head is above you, and Frank said, as Grover, "Quit looking at that man down there, okay?!" It is disconcerting because the puppets are simple. They're just a sock with ping pong balls on them, but they're brilliant in that they come to life. They're very simple creatures, especially the hand ones like Grover. They don't have a lot of mechanics. And the actor is so strong that you feel a real personality coming through. I think the Muppets are appealing because there is something reckless about them.

And I remember when I first became a writer, and I was very nervous about my first bit that I wrote that they were going to perform. Somehow, in the back of my mind, I thought that every bit that they did was just improvised. "Look how reckless and crazy they are." And they're *so* crazy. I think that's why they're so appealing.

The iconic duo, Ernie and Bert, with puppeteers Seagren, Henson, and Oz.

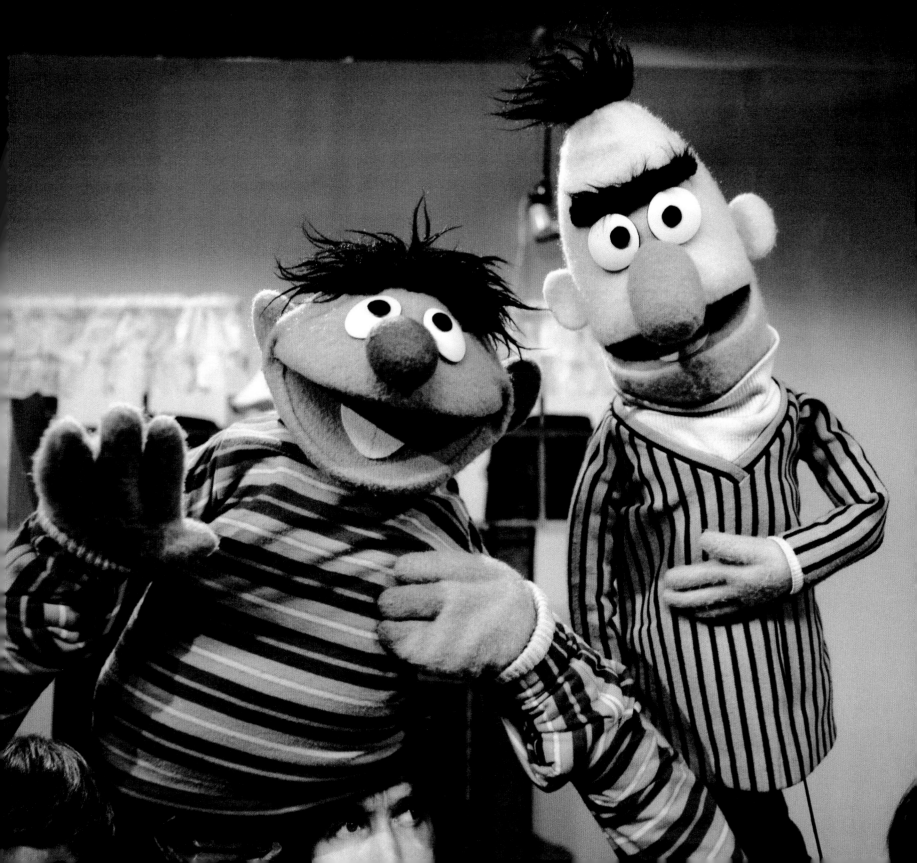

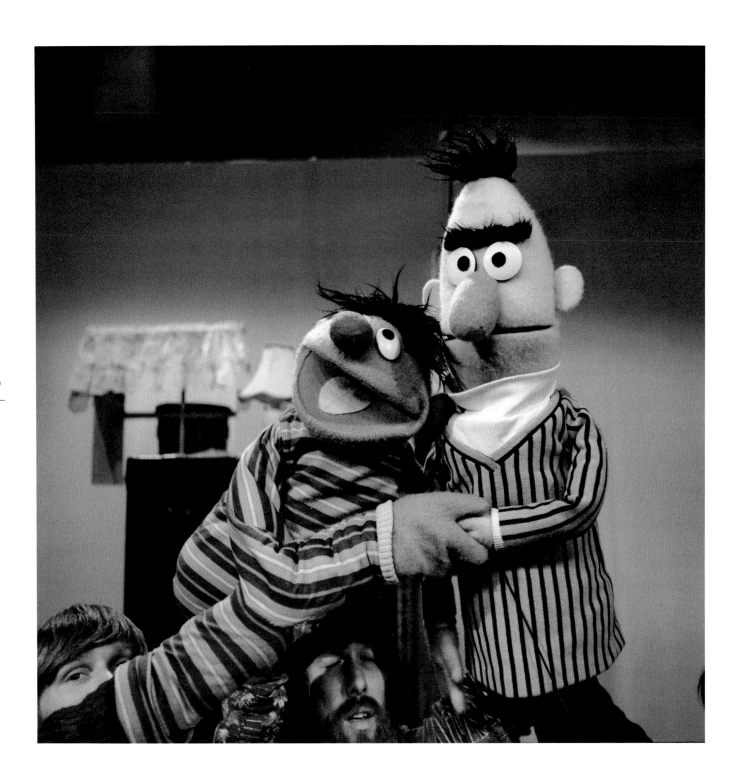

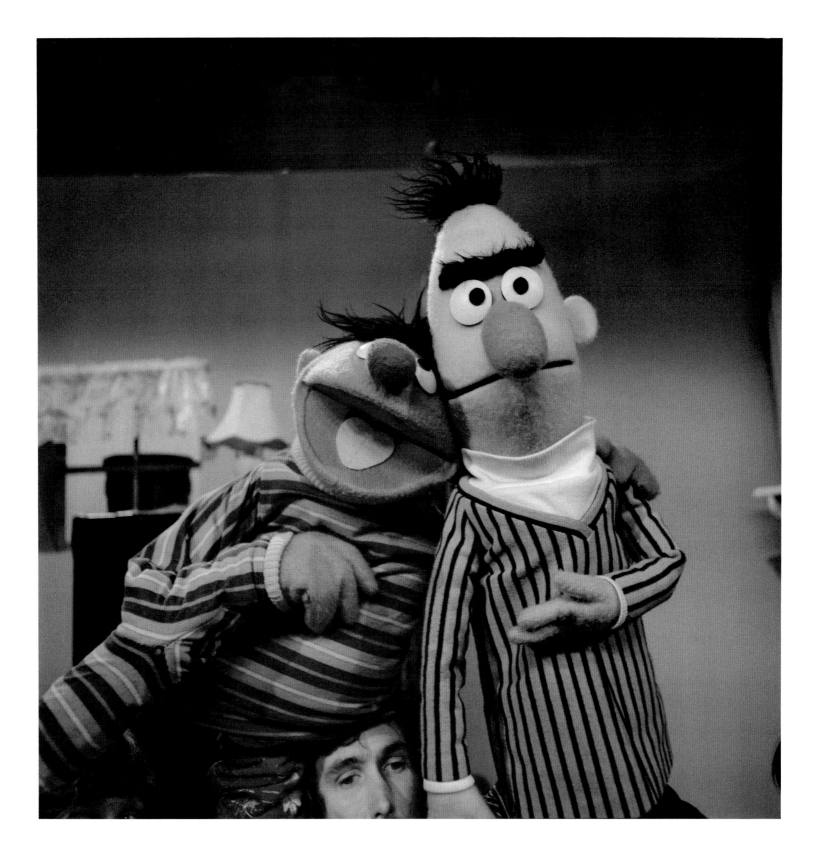

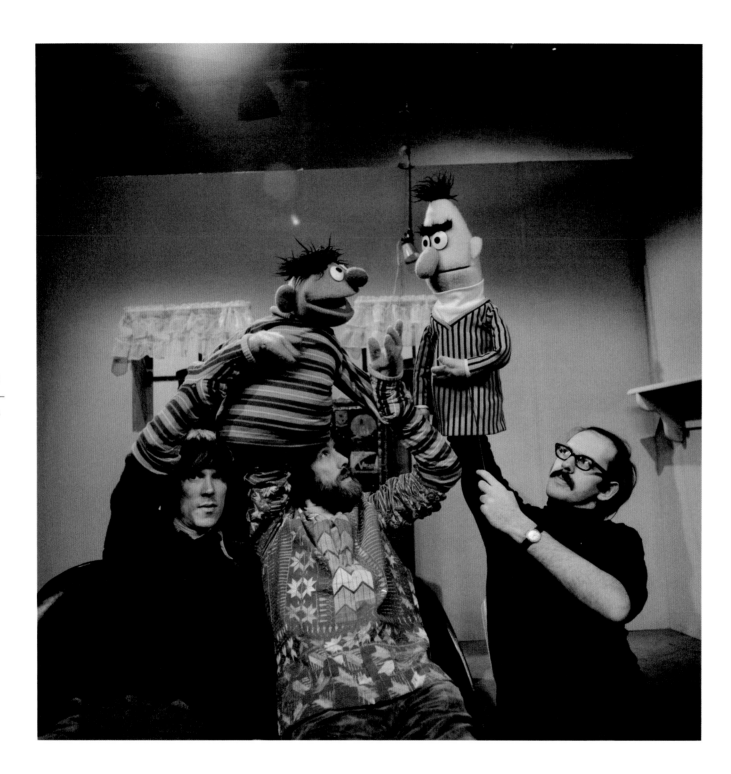

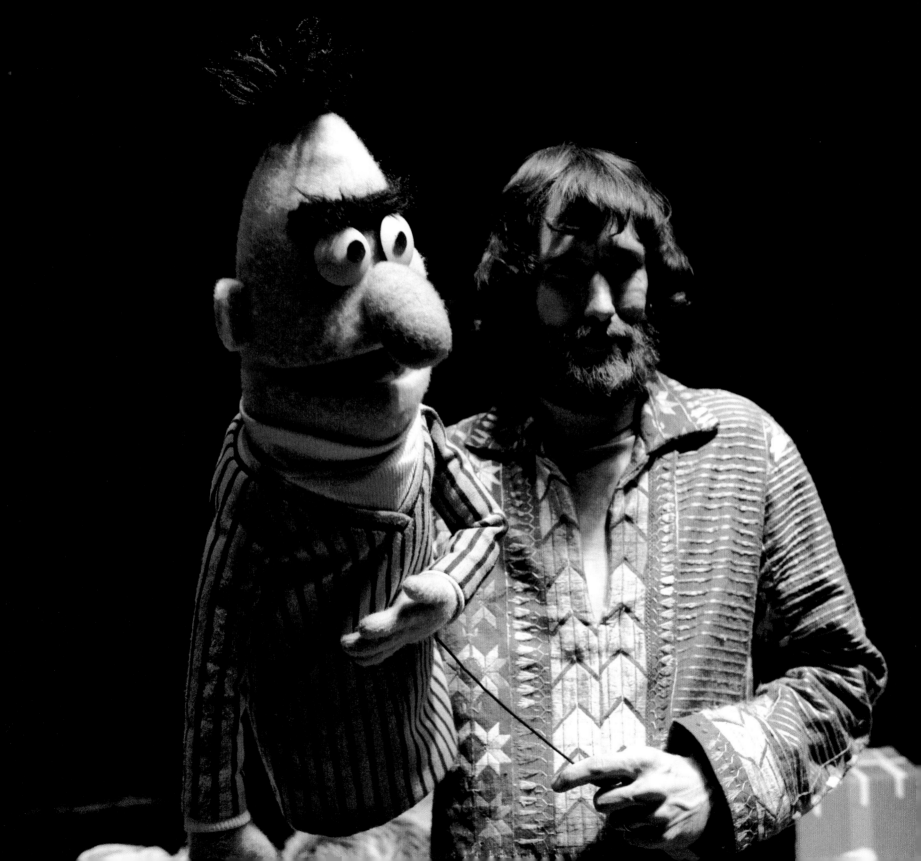

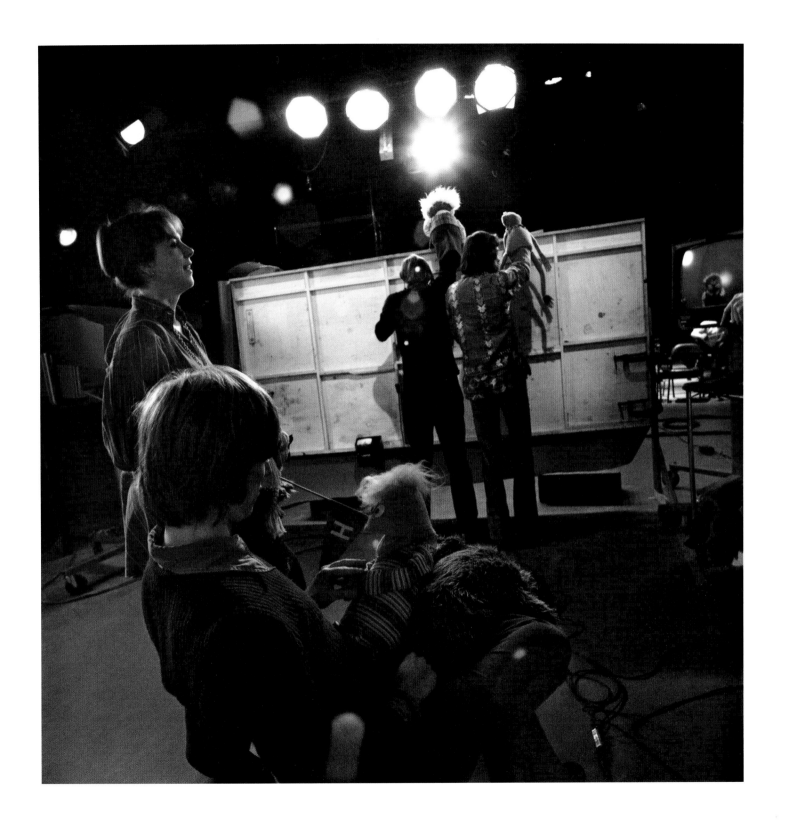

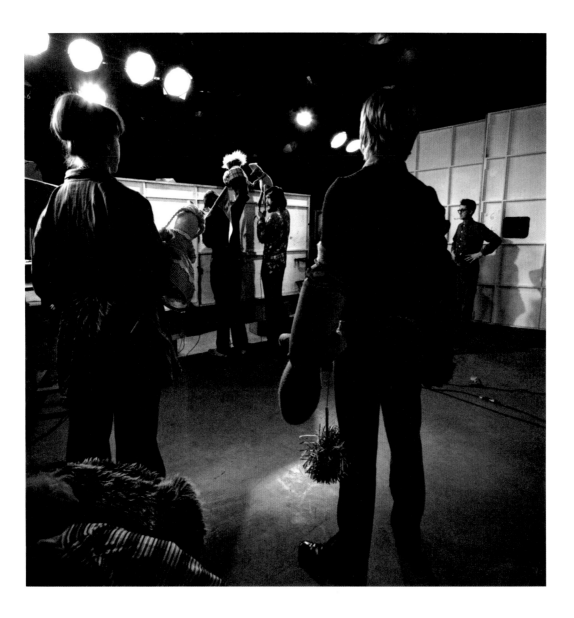

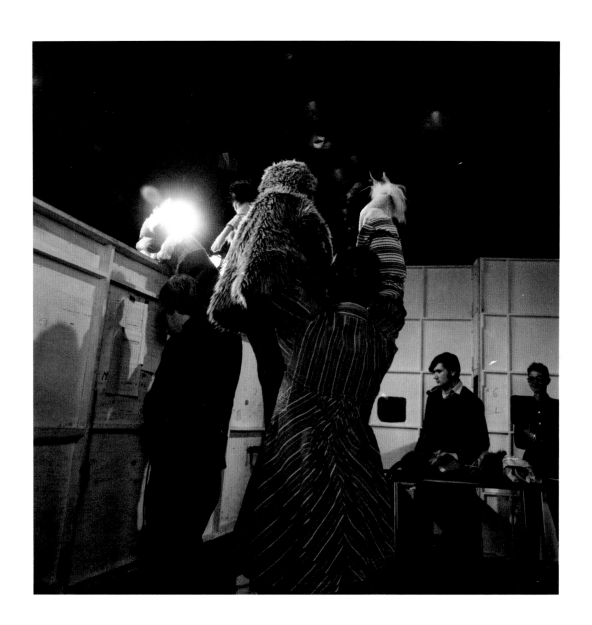

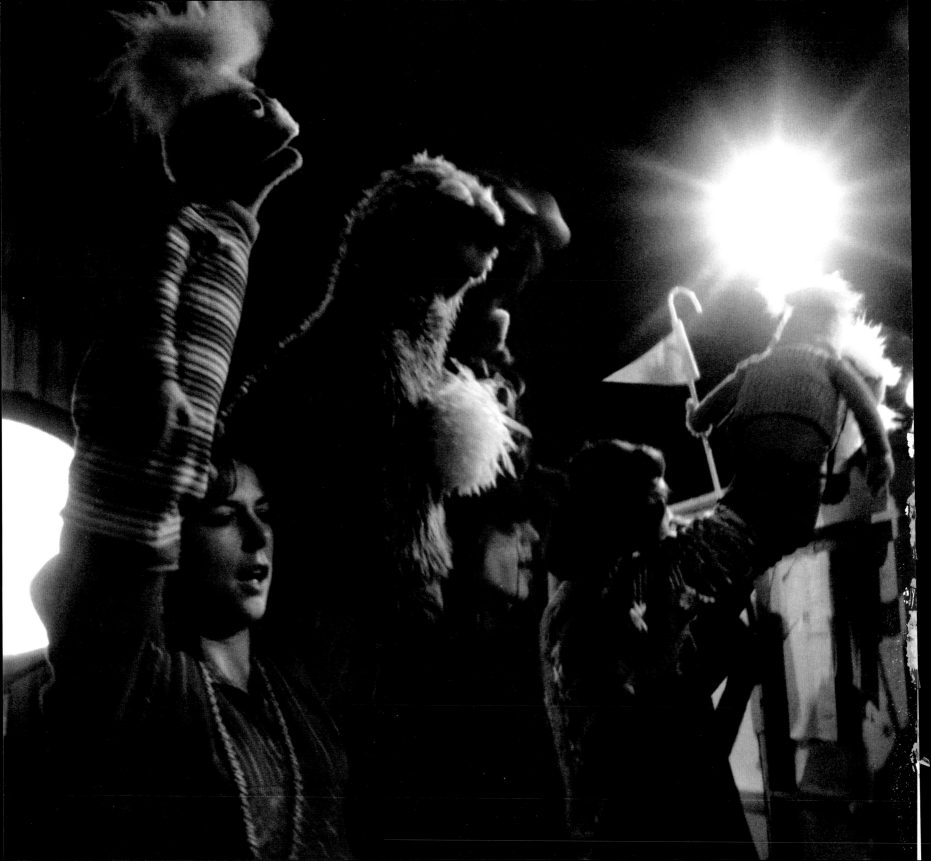

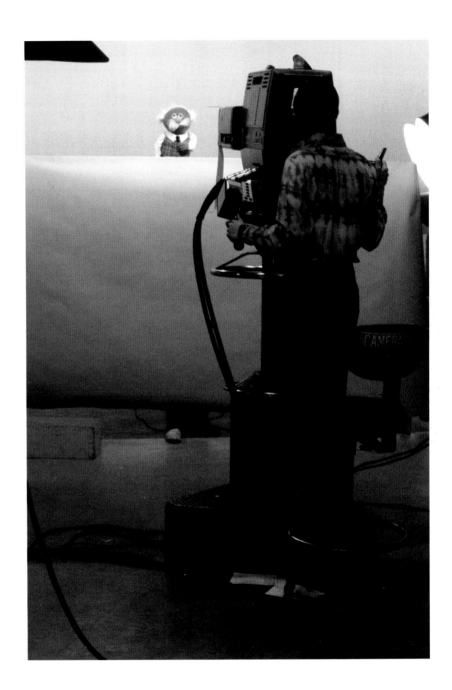

Left Muppet designer and performer Caroly Wilcox
lends a hand to Henson, Oz, and Seagren.

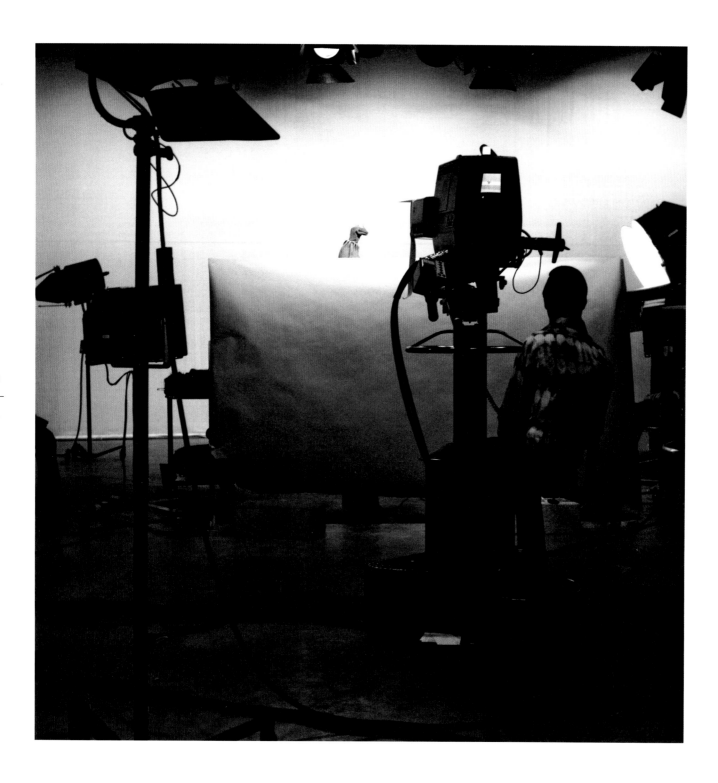

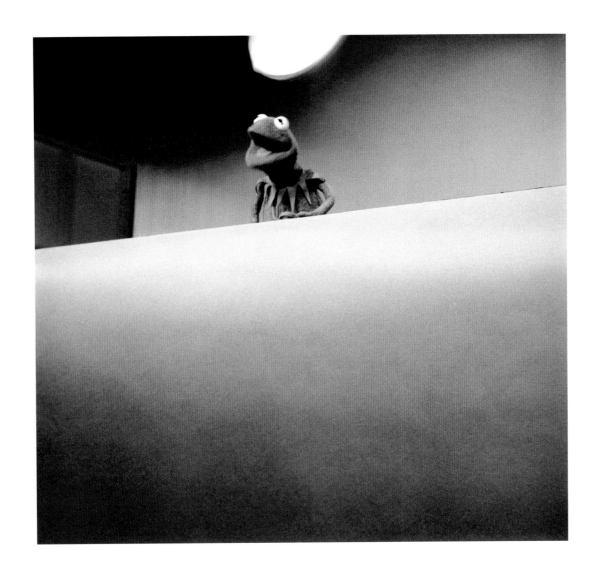

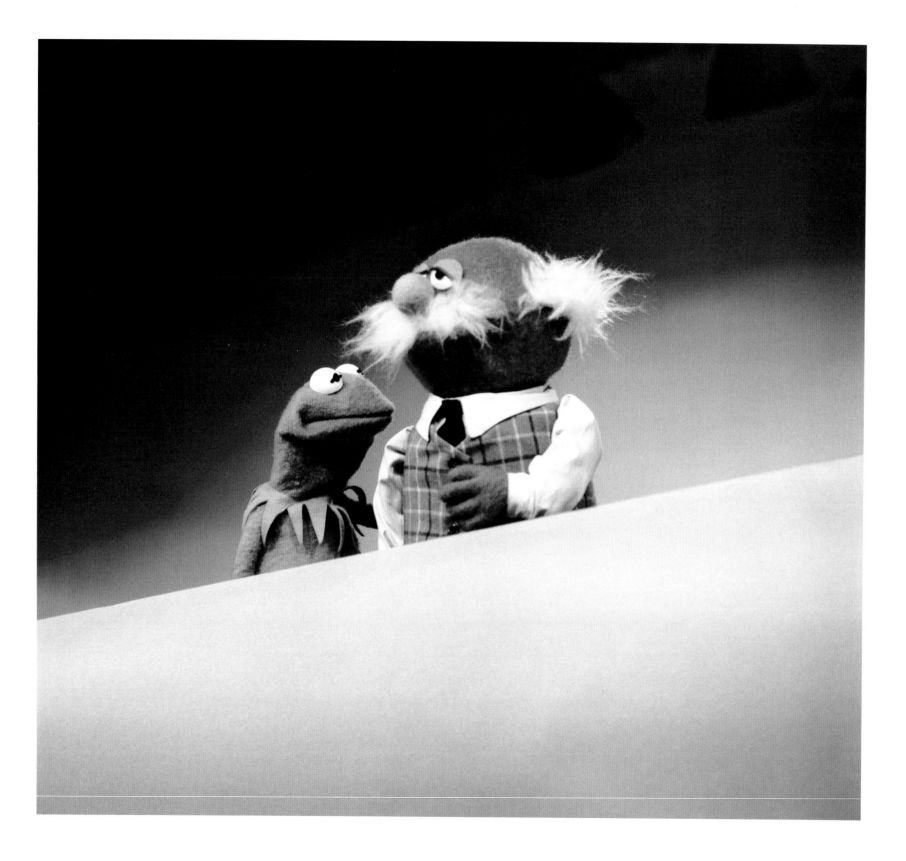

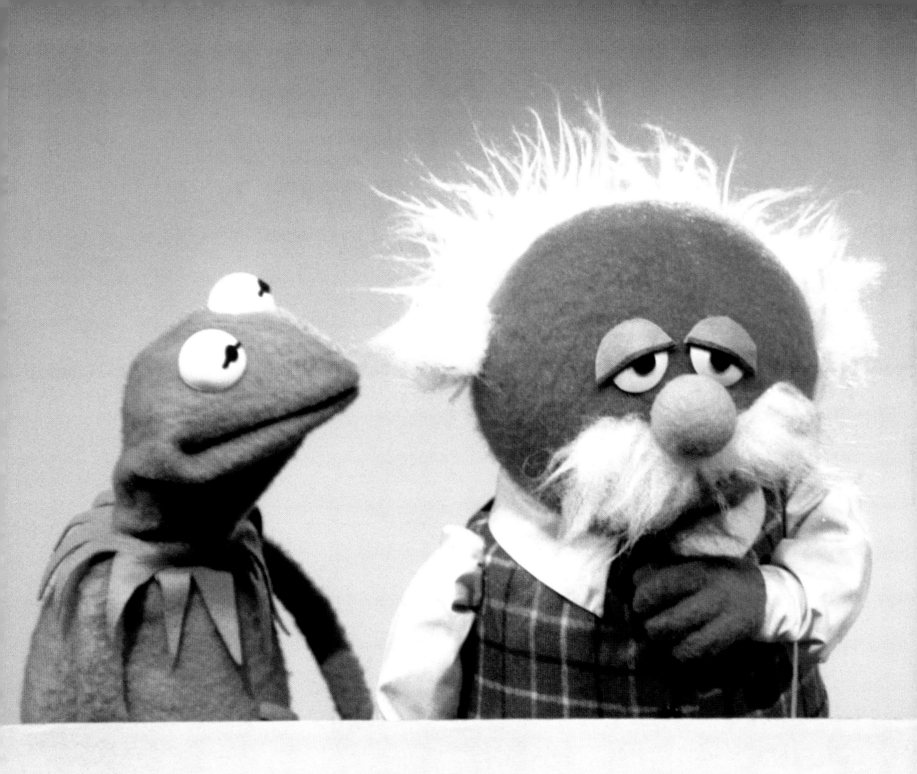

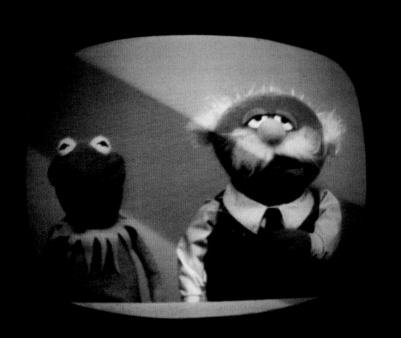

Seagren performs with the "Fat Blue" Anything Muppet
as Grandmother Happy for Episode 112.

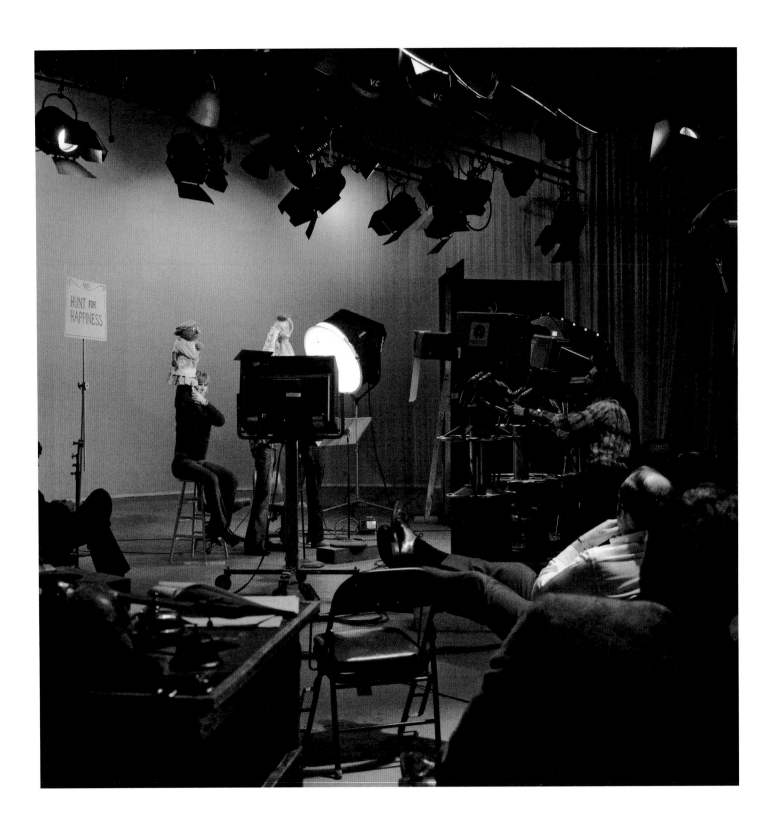

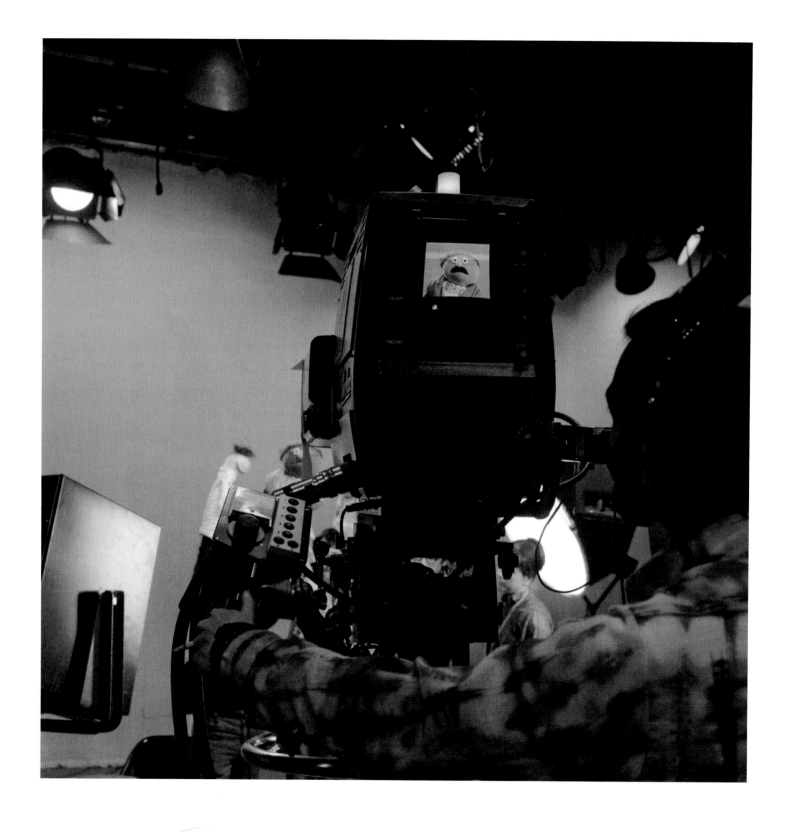

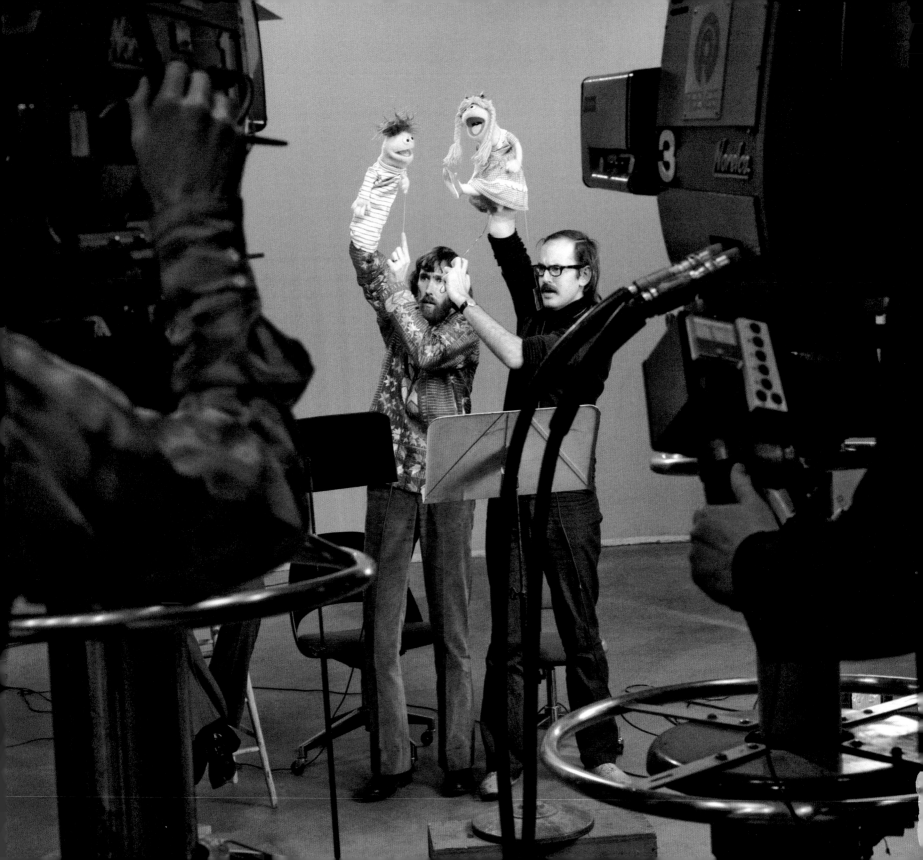

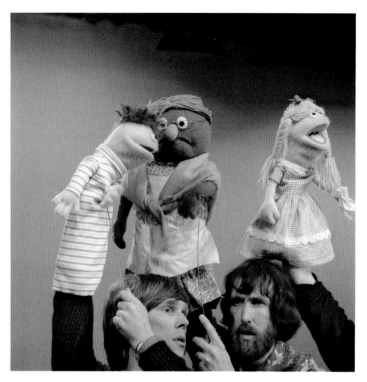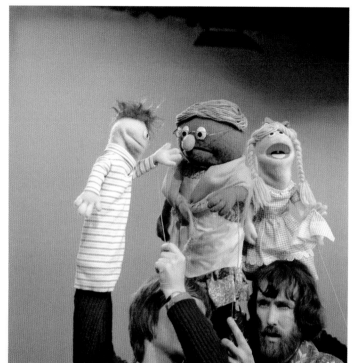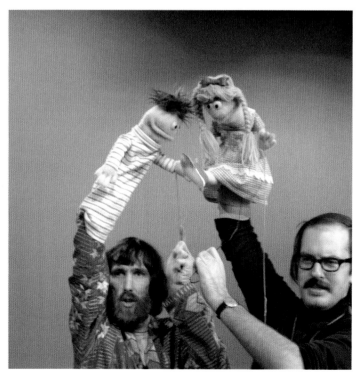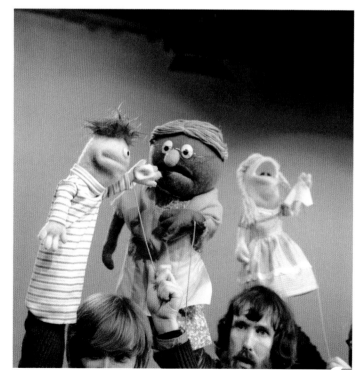

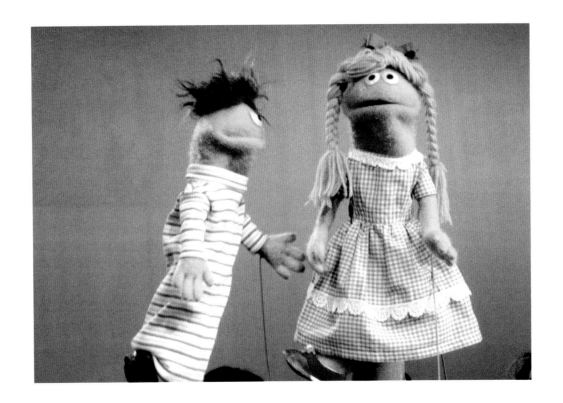

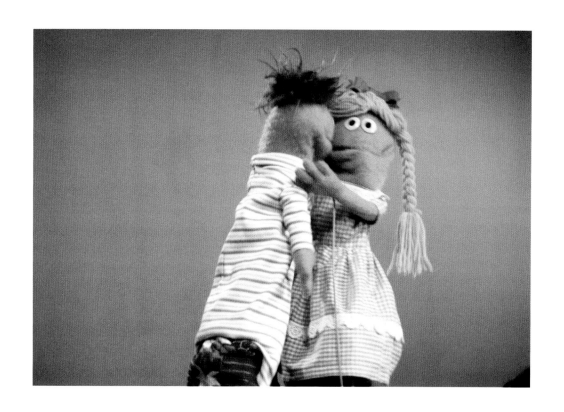

Director Jon Stone goes over notes with Oz during an
Anything Muppet scene about the "Hunt for Happiness."

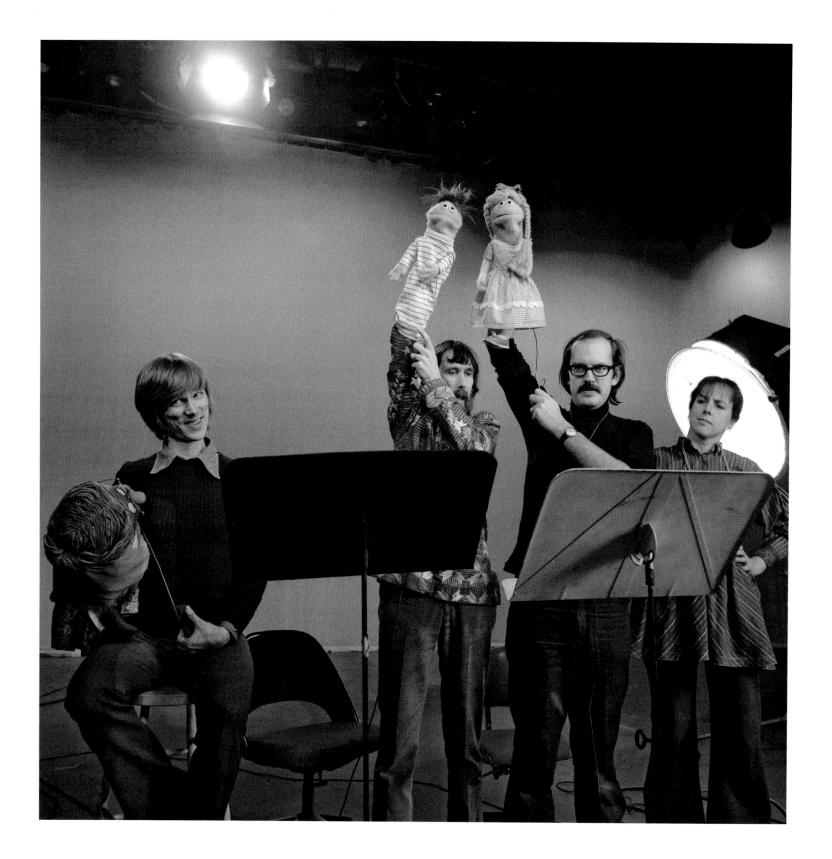

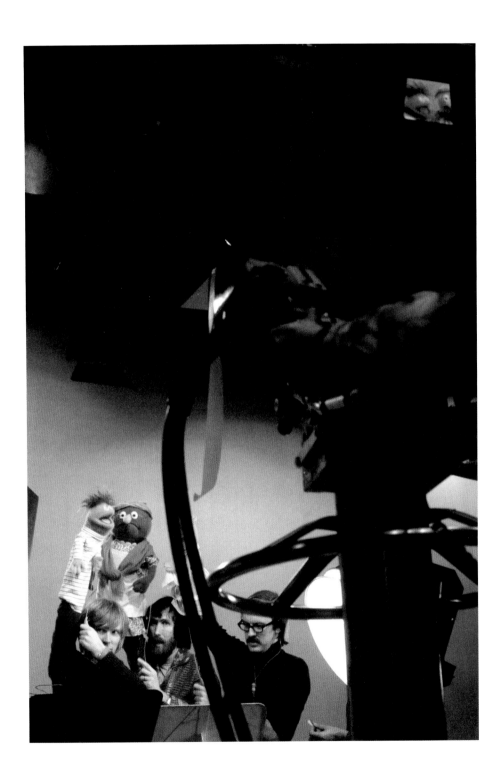

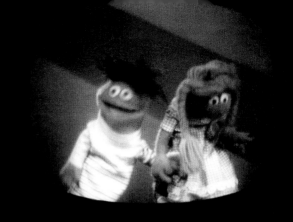

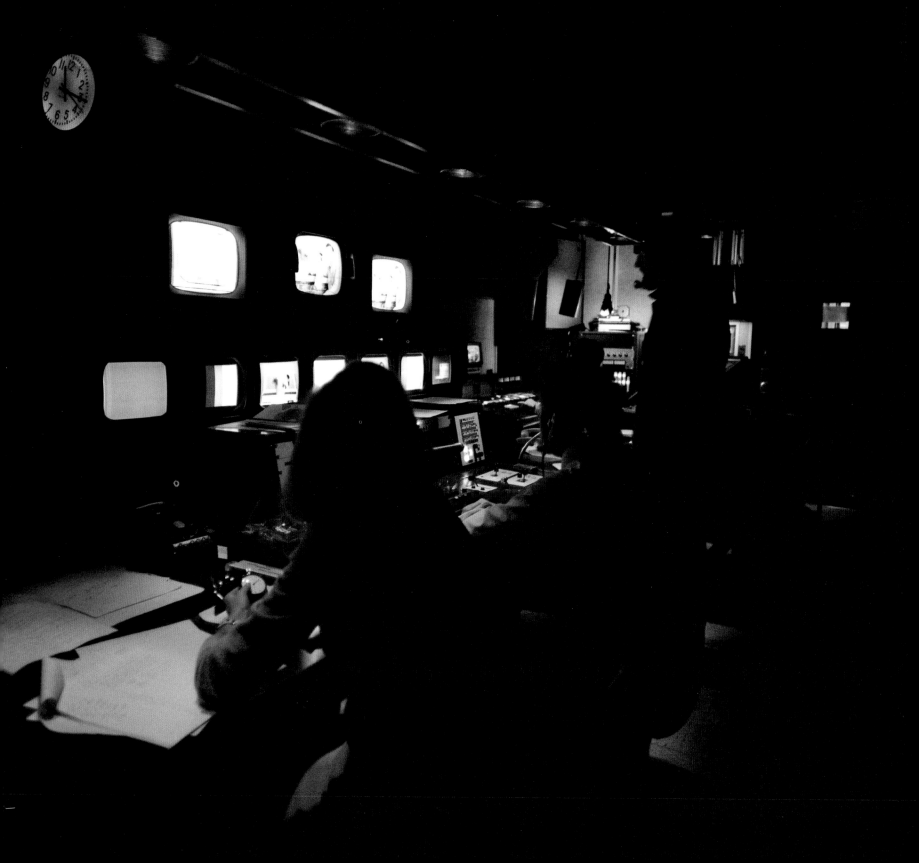

130 EPISODES A SEASON

When *Sesame Street* began production, the Children's Television Workshop had secured funding from both the U.S. government and private sources, a budget of $8 million, or about what a single season of *Game of Thrones* would cost in today's dollars. With that money, the creators of the show researched, wrote, filmed, animated, puppeteered, scored, and finished 130 one-hour-long episodes. That is a staggering amount of production. There isn't a network in the world today that would be able to create that much content for the same budget. For comparison, those 130 episodes would cost about $750 million per season today.

In 1969, one person was at the top of the production pyramid for the workshop, and that was Jon Stone. He had quit working on the *Captain Kangaroo* show a few years earlier, and as he puts it, "had done everything I had wanted to do in TV." Jon was semi-retired and living in Vermont when he got a call from Joan Ganz Cooney. She wanted to know if he would be willing work with her at her new company, the Children's Television Workshop. Jon's quick reaction was to say, "No, thank you." But Joan persisted and when they finally met, Jon saw the spirit behind what she was doing. It was her vision of social change that inspired him to lead both the writers room and the production floor. He knew all of the aspects of production as well as we can recite our ABCs. Jon's daughters were interviewed for the first time for our documentary. We gained unique insight from them into the inner workings of a creative genius, one of the forgotten heroes of the creation

of *Sesame Street*. The images in this collection show the world that Jon presided over, the chaotic wire runs and mic booms of the set and crew that made the Street come alive.

Brian Henson Jon Stone [writer, director, and producer; *Sesame Street* writer, director, and executive producer, 1969–1994] was bigger than life. He had all the extrovert energy that my dad Jim wished he himself had had. Jon was the guy who would walk into the room and be loud and funny, and everyone loved him. There was something so attractive about that to my dad, and he just loved working with Jon. He loved that big, bold, positive energy.

Polly Stone, voice actress; daughter of Jon Stone and actress Beverley Owen My dad would talk about the fact that he could watch television and tell you whether or not it was a happy studio making whatever show it was. He'd know nothing about the studio, but he could watch the show for half an hour and say, "They're miserable," or "They love being there."

Kate Stone, daughter of Jon Stone and Beverley Owen Dad was an amateur photographer. He loved to take pictures, and when he would suffer from writer's block—tortured and nothing, nothing, head on desk, exhausted—suddenly an idea would appear for him, and it was exactly like framing a photograph. He would hear the click, and everything would come together. For him, that was the creative process of total darkness and nothing else, and then suddenly *click*, and that's how things came for him.

Polly I spoke to my father fairly late in his life about the fact that he wrote, he directed, he produced. He wore all the hats, and he was exhausted at the end of it. I said, "You can choose at this stage in life. Do you want to do this?" And he said, "Well, I write the script, and then if I have the vision in my head of how it should look, the only way I can make sure that it is created the way I want it to be is to also direct it. So, I have to write because I know

The control room at Reeves Teletape Studios in New York City during a taping of "People in Your Neighborhood" for Episode 106.

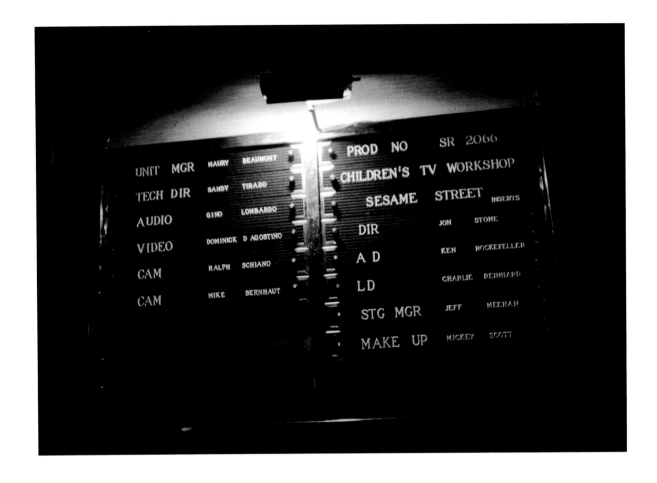

The letter board where Stone would famously prank his coworkers. By simply swapping the "p" and the "w" on the board, he could make the sign read "Children's TV Porkshow."

what I want to get on the screen, and then I have to direct it to make sure it's done well, and I have to produce it to make sure that I am the director and I am the writer who gets hired to do it. So I really have to do all three."

Dad did not suffer fools easily, and if he made up his mind about somebody, it was hard to change his opinion. On the other hand, he had such respect for so many of the people, and he would go to bat for people, and he would celebrate and really make a point of recognizing accomplishment and talent, and the work that was happening on the set. I think in part because he had come up through the CBS training program and knew what it was like to be a sound man on the boom and knew what was involved in making sure the cables didn't get braided on the cameras

and that the props were all there, he made a point of being very upfront and appreciated the work that people did at all levels of the show. For all of his career, if he was going out with friends after a day of shooting, it was as likely to be the electricians and the cameramen as it was to be the performers or the stars that were on the set. If he valued your work, it didn't matter at what level you were working.

Frankie Biondo, *Sesame Street* camera 1 operator (1969–present) Jon Stone and I had a falling out in the beginning. I shot the first year, then the second year he wanted his own cameraman. Every director is like that—they want their own guys. So they put me on boom. I happen to like the boom mic. I became excellent on boom. I'm

not blowing smoke or anything. I liked it. Then his guy quit. So they tried out different camera guys. Eventually they said, "Frankie, you're on camera." I said, "No, I ain't doing it. He didn't want me in the beginning, I ain't going to do it now. If somebody is sick, call on another camera-man. I ain't doing it."

They scheduled me on camera for a week, and if you're scheduled, you've got to do it. So I did it, and after the week Jon Stone came up to me and said, "Frankie, I'd really like you to be permanent on camera one."

I said, "Let's get something straight. You don't like me. I don't like you, but I'm a professional. I'm going to do the best possible job I can do."

He said, "That's it. You got it." We shook hands and then we used to bullshit, you know, and talk, and we became good friends. He's a great guy. He really was.

Polly My father had an understanding of children that is rare in any human being, and certainly rare in a man of his upbringing and the era. He had a gift with children and understood them in a way that absolutely informed every minute of *Sesame Street*, because he knew how to reach them.

He really thought of himself not just as a television director, writer, producer, but also as an educator for all those kids who had grown up on *Sesame Street*.

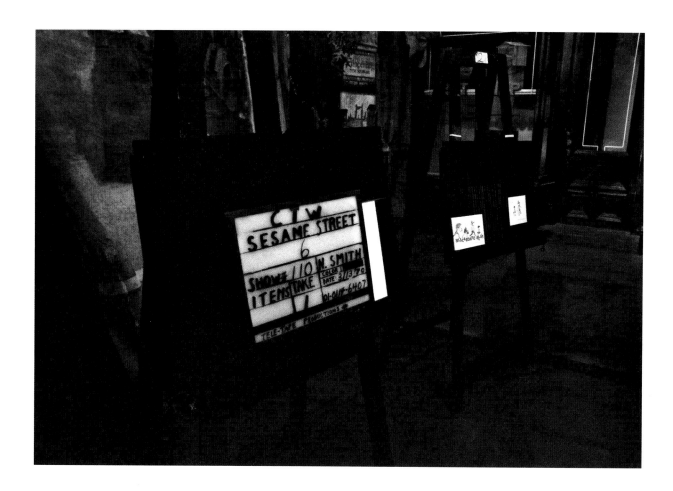

Clapper boards used during the taping of Episode 110.

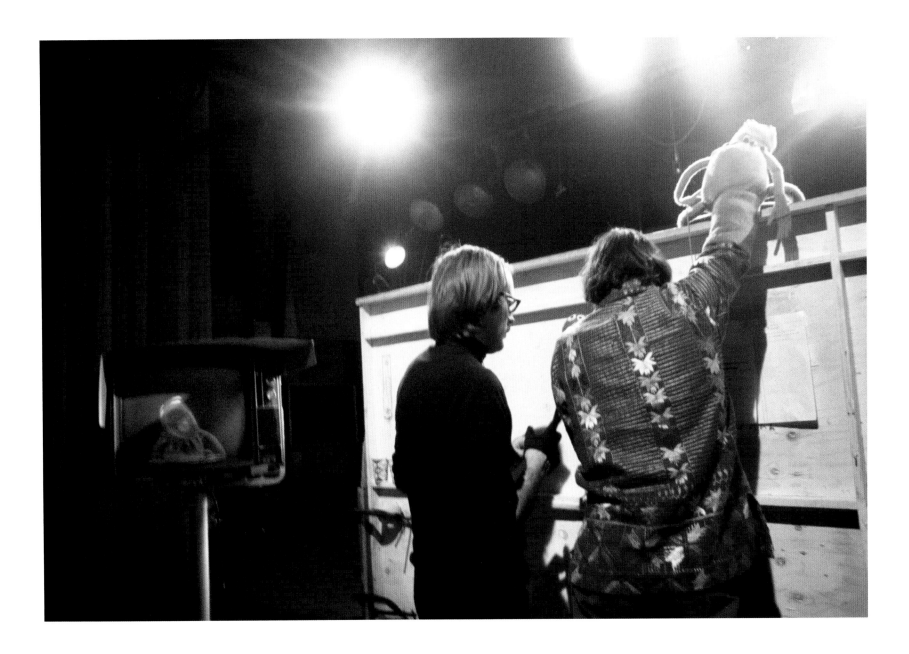

Oz and Henson
performing as Kermit,
working on lines behind
the puppet wall.

Sharon Lerner, writer and producer (former Children's Television Workshop vice president and creative director, 1968–1986) The original studio was at 81st and Broadway, and the show was produced there, but my office was on 63rd and Broadway. I had a monitor on my desk so that I could watch everything that was being done in the studio remotely. It was great, great fun because I got to see Frank Oz and Jim Henson work at the Muppet wall [the set piece that hides the puppeteer from view] with their bare hands and hear all of the banter that went on with the puppeteers, who were all hilariously funny and wonderful. It was magical.

But more importantly, I also saw what was going on in the show. When somebody would do something that was educationally not up to par, I could pick up the phone and say, "Hold on, that's not right." I could call them instantly because I was watching in real time what was going on in the studio.

There were two parts to each show: the street segments and the inserts. The street segments were the live actors and the Muppets that were on the street: Big Bird, Oscar, sometimes Ernie and Bert when the live-action cast were in their apartment. And then the inserts were all of the live-action film, the animation, and the Muppet segments that were done primarily at the Muppet wall. All of those old, classic Muppet pieces were done at that brick wall.

The inserts were pieces that were repeated from show to show, and the number of times each segment was repeated depended on what goal it taught and how important we thought that goal was—say teaching letter recognition gets 20 percent, something else gets 5 percent. When a writer was given an assignment to write a show, they were given a list of goals that had to be dealt with in that show and listed insert segments that they were allowed to use in the show. The writer then had to create the live action that would tie it all together.

Frankie Danny DeVito and Rhea Perlman did the show one time. When they finished, we all applauded, and he said, "Stop. Stop. Don't applaud us. We've got to applaud you." He said, "We have a kid, and we sit down and watch these shows. It's something that we do with our kid, and it's enjoyable." Personally, I think there were way more parents watching it.

Kate Dad's favorite guest in all the years of *Sesame Street* was Danny DeVito. He really felt like he had met his kindred spirit. It was like Oscar the Grouch in person, and that was my dad, too. They had so much fun together that they rebooked him and rebooked him. It was a meeting of the minds.

Dad also took great pleasure in taking these huge stars and putting them in absurd situations. "Will he actually do this? Will he actually get into a chicken suit and go to an audition to be a chicken, even though he's not a chicken, and compete with a Muppet?"

Polly My father was incredibly proud of what he had done, and what he had been a part of creating. He would say, "Creating the show is 10 percent knowing how to direct the shots and block it, and 90 percent cheerleading and creating the atmosphere that creates the wonderful show."

Kate My dad had choices. He could've gone to California, he could've branched out with the Muppets, he could've directed in his own right outside of the Muppets, but he wasn't going to leave *Sesame Street*, the love of his life. It was the love of a lifetime.

74

75

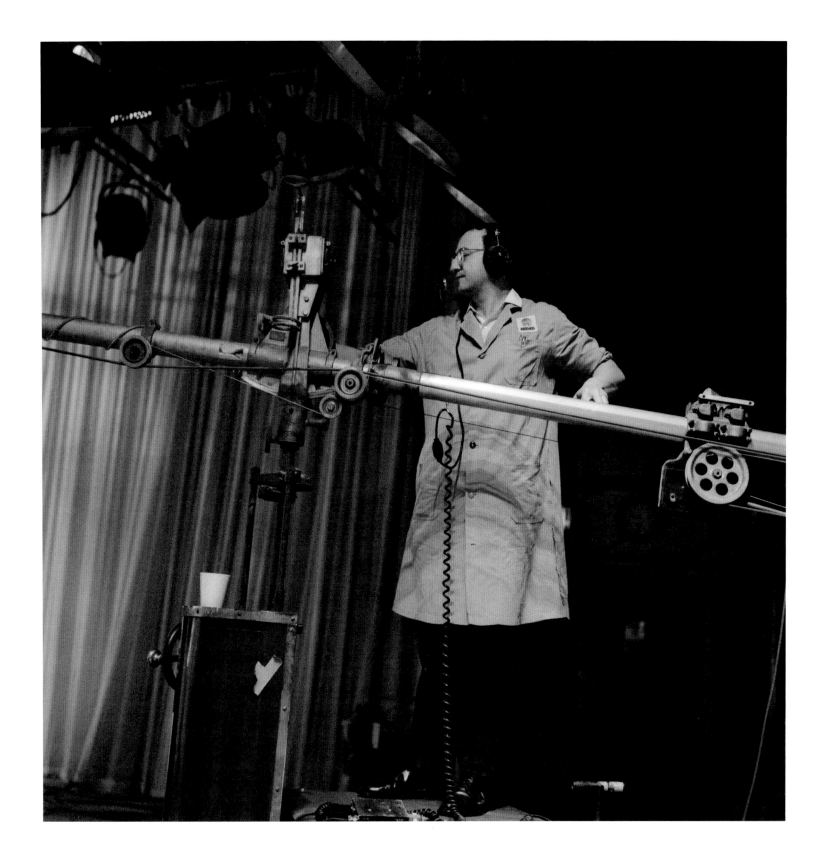

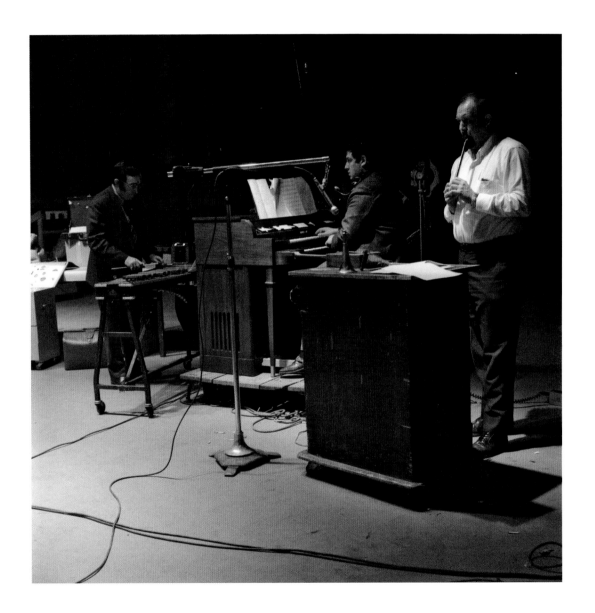

Musical director Joe Raposo performing live in
studio with members of the *Sesame Street* band.

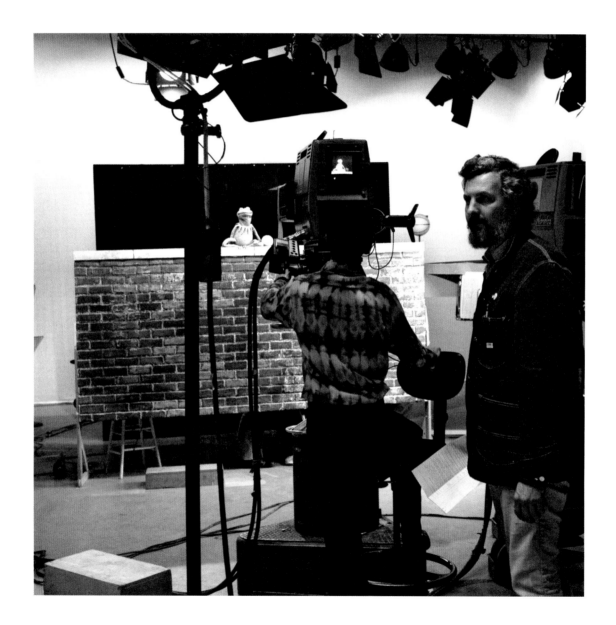

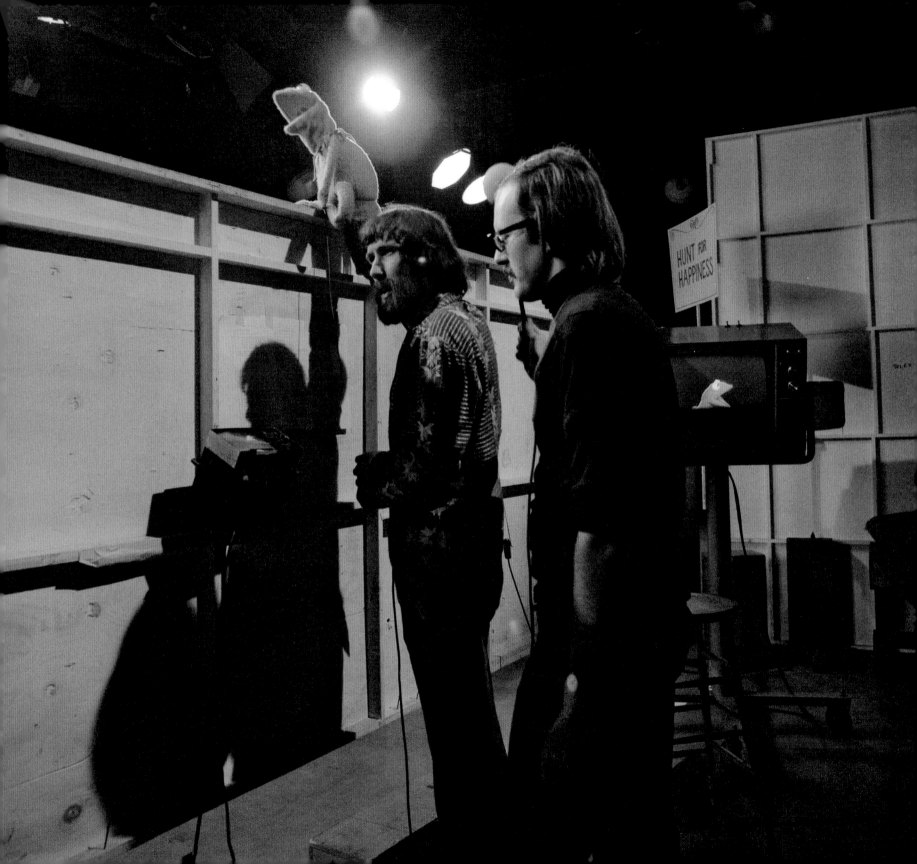

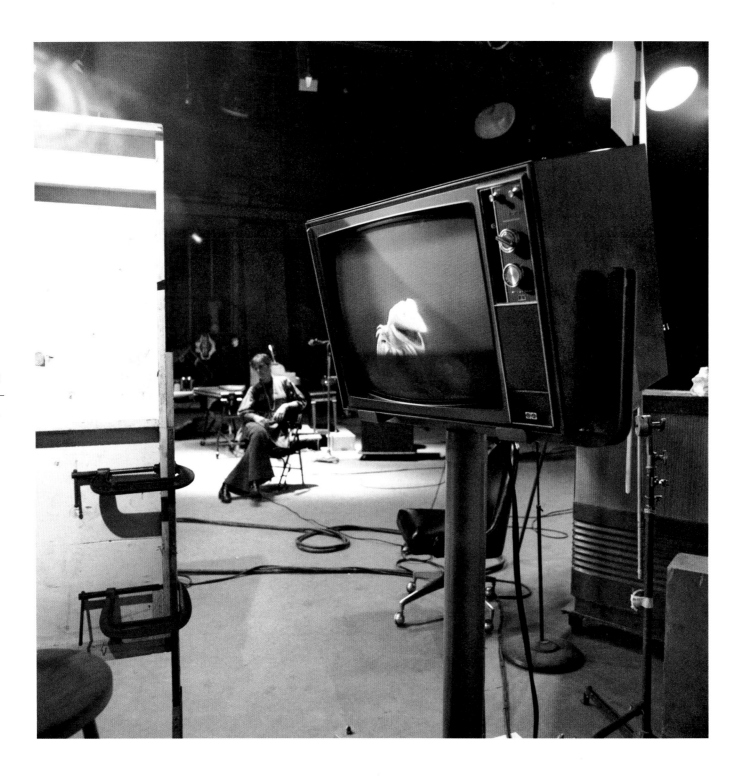

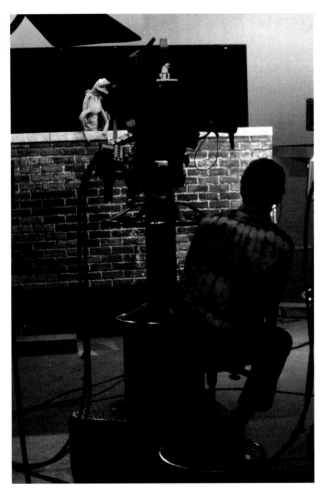

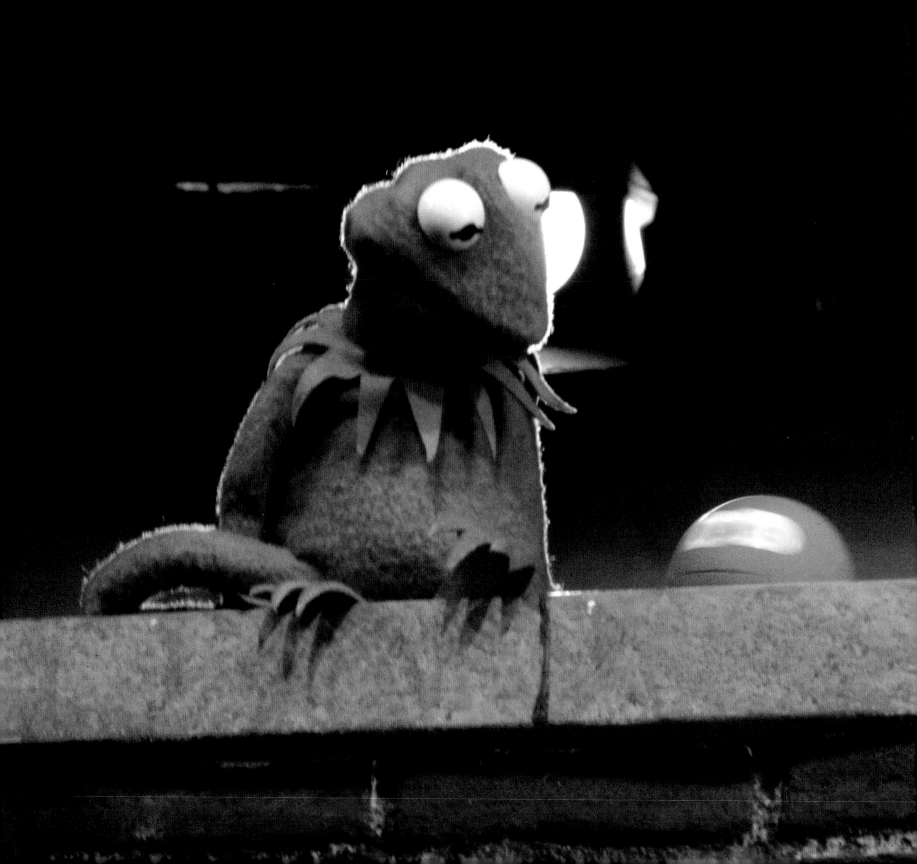

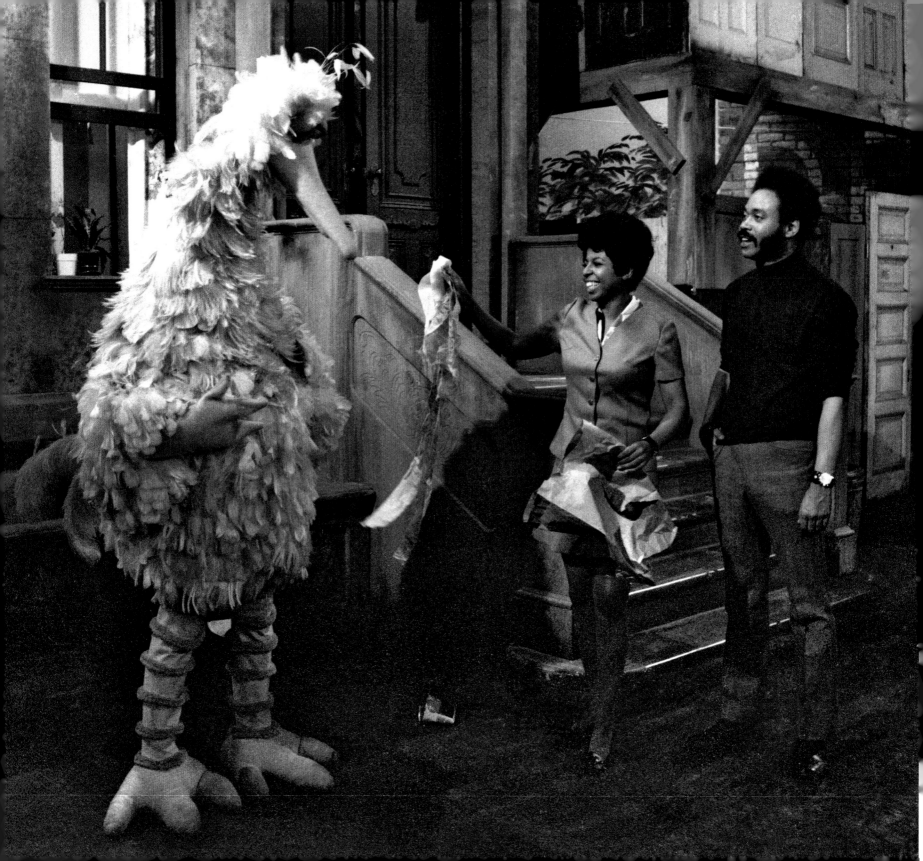

AN EIGHT-FOOT-TALL YELLOW BIRD

Jon Stone said of Caroll Spinney, "Caroll *is* Big Bird. No one else could play him like Caroll," and for almost fifty years, that was true. As one of the original cast members, Caroll created a character that spoke to children in a way they hadn't seen on TV before. Big Bird was their peer, a relatable friend who was dealing with the struggles of childhood as they were, albeit in a more magical way.

"Magic" is a good word to describe Caroll Spinney, the man who originated the role of one of the most iconic characters in children's entertainment. We can all picture the yellow suit, but the soul of Big Bird truly lies within Caroll.

We conducted our interview with Caroll for the documentary at his home, a Swiss-style chalet nestled in the woods of Connecticut. Every inch of the property is unique and special, including the ruins of a small stone cabin in the backyard. The place is a springboard for imagination. You see, the house is an extension of the Spinneys. In every nook and cranny, the spirit of creativity and imagination is present: at the bottom of the stairs, a green square throw rug with Big Bird's head on it; in the art studio, a desk set with a pen made from a familiar yellow feather; on the piano, a small toy Big Bird holding a banjo.

When you're there, you can't help but notice all the photos covering their walls—Caroll with Jerry Seinfeld,

Martin Short, Christopher Lloyd . . . the celebrity photo list goes on and on. You also see photos of him with Jim Henson, Kermit Love (puppet maker, designer, and builder for the Muppets and *Sesame Street*), and the rest of the gang from *Sesame Street*. And while those photos are representative of an amazing life lived on a very large scale, most important are the photos of Caroll and his wife Debra. The love, partnership, and affection of Caroll and Deb was an honor for us to witness.

The house is indelibly stamped and imprinted with the unique spirit of the Spinneys. Anyone else in there seems a bit out of place, with the exception of a really big bird.

We lost Caroll Spinney in 2019. It was *Sesame Street*'s fiftieth anniversary. The entire team felt a profound sense of loss when we heard the news. Even those who weren't there at the shoot felt as if they knew him. When you pore over hours and hours of interview footage, listening intently to subtleties in inflection or finding a specific phrase that connects two thoughts, it's a very intimate experience and you can't help but feel connected to that person.

Caroll Spinney, puppeteer and performer, Big Bird and Oscar (1969–2018) I was on *Sesame Street* from the very first episode. Big Bird had about one or two minutes because the writers had never seen him, and he'd never been completely put together until that time. He looked awful. I wore shoes inside these funny bird feet and there were wader pants for the legs. Then the puppet would be lowered down over me, and I'd go in through the bottom and put my hand up in the head to operate it. It was very elaborate. I controlled the eyes and the beak, all of that with my hand above my head, which is why he's so tall. Big Bird is the biggest character ever on television, but I started out as the smallest kid in school.

I was five when I saw my first puppet show in kindergarten. It was the three little kittens who lost their mittens, and they were just little hand puppets done by high school students, but I thought it was really clever. They came out and bowed with their puppets still on their hands.

Carol Spinney performing as Big Bird with Long and Robinson for a scene in Episode 110.

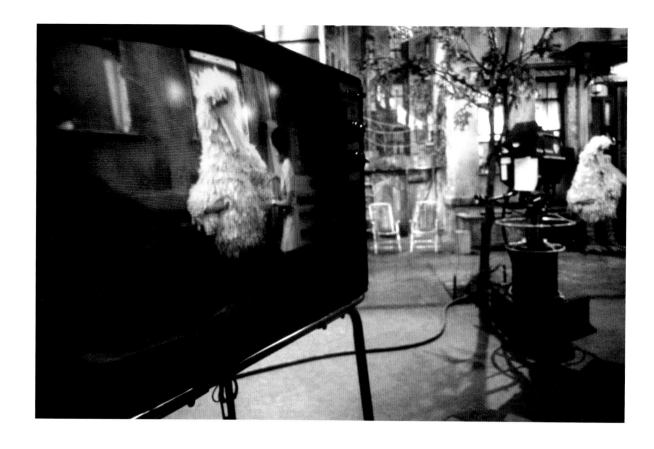

Spinney rehearses a scene as Big Bird with Long.

I thought, *What a great thing!* They could tell a story with animated toys. A few years later, I saw a puppet at a yard sale at the church for a nickel. I already had a stuffed green flannel snake my mother had made—she would make toys for us—and I decided, I'm gonna do a puppet show! I made a little poster: "Spinney's Puppet Show, 2 cents, Saturday at 2:00, Spinney's Barn." I did the show, and everybody I knew actually came. I made 32 cents. I was nine years old.

Years later, I was working in Boston on a TV show for kids, *Bozo the Clown*. I played many characters on that show and it was so much fun. Paid pretty good, too. About that time, I saw this wonderful commercial on television. There was one heavier-set puppet and one little guy, who looked something like Kermit and had a little toy cannon. The little one says, "Do you drink Wilkins Coffee?" Then the bigger one says "No." *Bam*, the little guy fires the cannon, and he blows him right out of the frame. Then he suddenly swings the cannon over and aims it at us, the audience, and says, "How 'bout you? Do you drink Wilkins Coffee?" It was only eight seconds, and it was one of the best commercials on television. I said, "Now *that's* puppetry." That's when I learned about Jim Henson.

But I wanted to do more than the *Bozo the Clown* stuff. So I built this very elaborate theater, which took me a year to build, in order to perform a new show at a puppeteering festival. I saw Jim Henson was sitting there in the audience. I said, "Oh my God, Jim's gonna see me do the show." I was supposed to have my puppets dancing on a screen, and I became an animator, and as I animated them on film, they came alive, but because of the spotlight that was aimed on me onstage, I couldn't see anything at all.

I suppose I was desperate for it to work because I knew Jim Henson was in the audience.

I said, "Turn off the light!" Everything was out of sync because I couldn't see. After the disaster was all over, I'm packing my stuff up, putting the puppets away, and a voice behind me says, "I liked what you were trying to do. You were funny, very funny in your desperation." It was Jim Henson.

He recounted how he'd had some awful mistakes in his history. "Would you like to work for the Muppets? I definitely want you—I'm gonna do this show called *Sesame Street*." Before I got to New York, I said, "What'll I get paid?" Jim answered, "We have a tradition." "Oh, I love tradition," I said. "Well, you won't like this one because you won't get paid much."

Jim Henson designed Big Bird and then Kermit Love built the body.

Frankie Biondo If you touched Big Bird, Kermit Love would kill you. Big Bird was like gold. If a feather hit the ground, that feather was no good. He used to take care of Big Bird like his own kid.

Caroll In the second season, Bob Myhrum came in as a new director. He'd never done anything with puppets before, so it took him a while to get used to it. He would expect impossible things from us, things I said couldn't be done. He'd say, "Well, how come you can't see?" I said, "Well, there's just no way to make an opening without you seeing where I'm looking out. Bob's response was "Well, why don't you buy one of those tiny battery-powered television sets?" So, I got this little image, which was very close to my eyes, and I couldn't focus that close. I found some little glasses in a drugstore for ten dollars that helped me understand what I was seeing. And that actually worked out well. My confidence improved by about 90 percent because I could study Big Bird. I found out that I would often move in the wrong direction from where the director wanted me to go. And what I didn't realize was that you have to go left if you want to go right in the picture because the picture is from the camera's

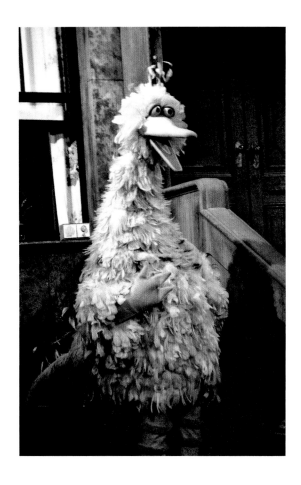

point of view, which is reversed. Now I could actually see the item I was going to have to pick up, and I would always practice before we filmed the scene so I would stand and be able to reach out and grab the prop.

One of the things that made Big Bird unique is that the Muppets can be singular—they like cookies or they like to count things. Big Bird didn't *do* anything. And he—I—would take a script, and I would see the sad thing that was written into it and emphasize that part because Big Bird would sometimes be sad. I think he's useful to the show because he gave it much more depth; he *has* much more depth. He's a very complex character. He had struggles, hopes, and goals, yet he's just a child who happens to be a bird.

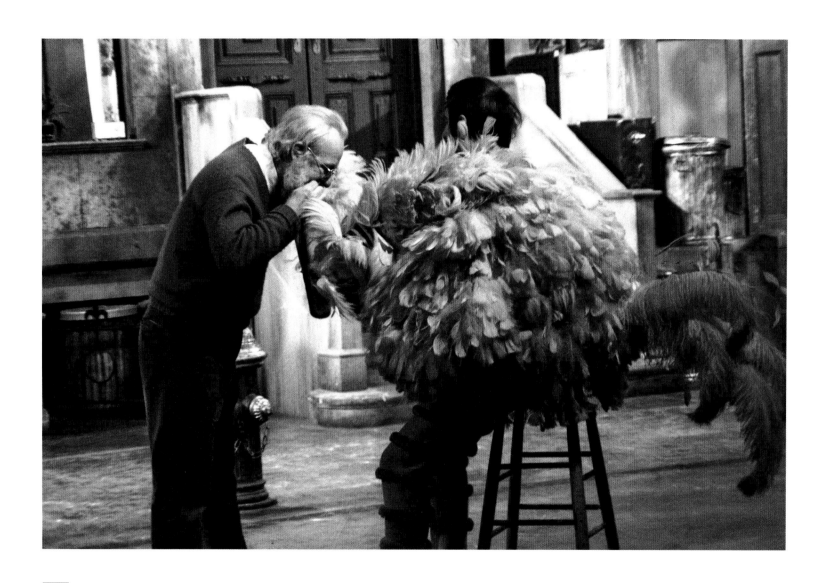

Kermit Love, master Muppet builder,
ensures Big Bird looks perfect on set.

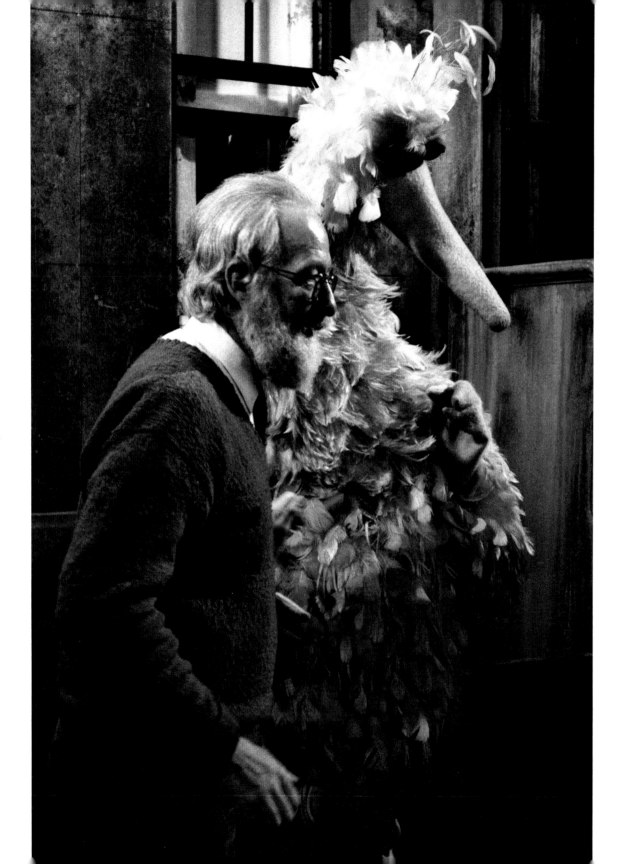

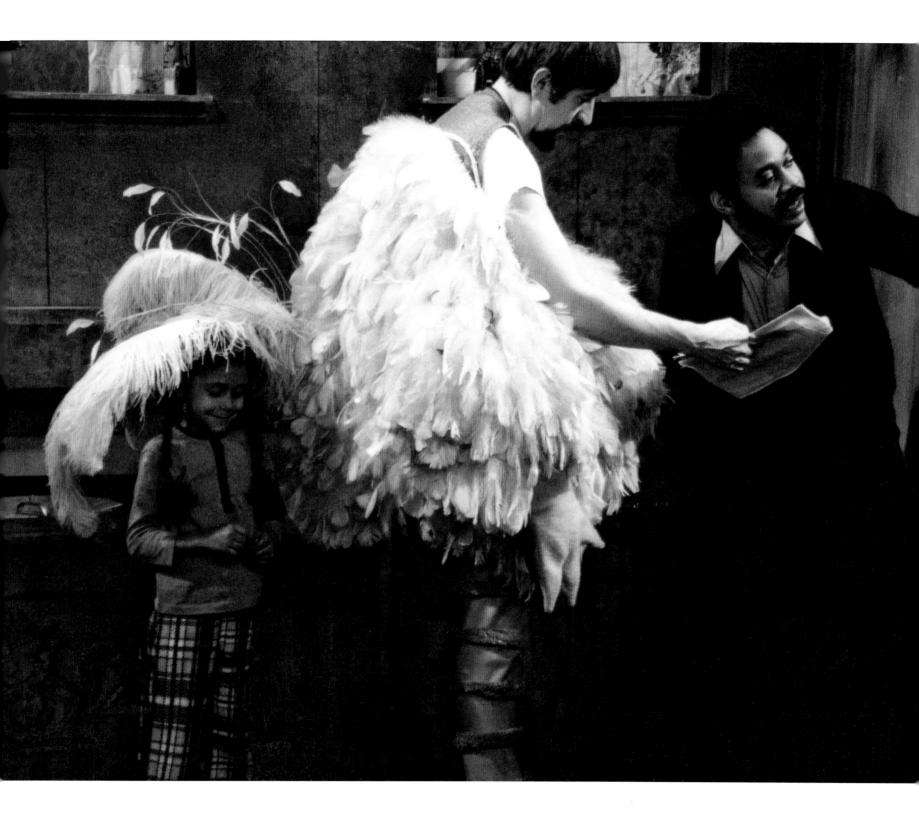

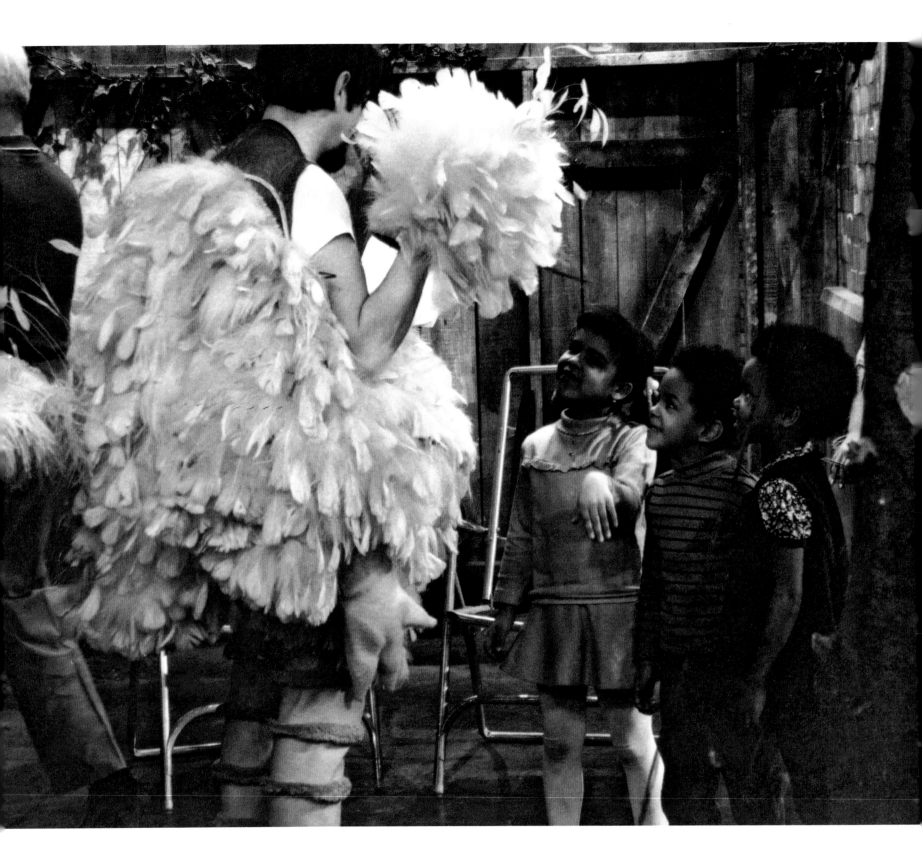

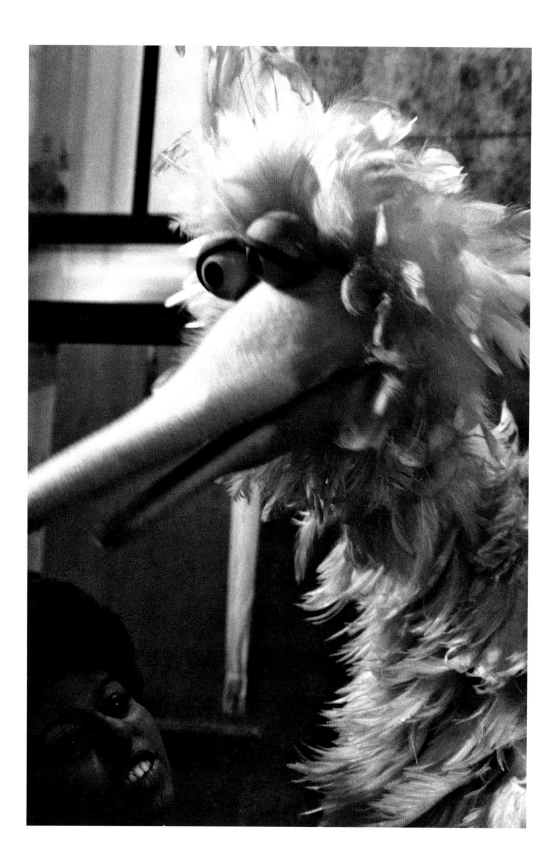

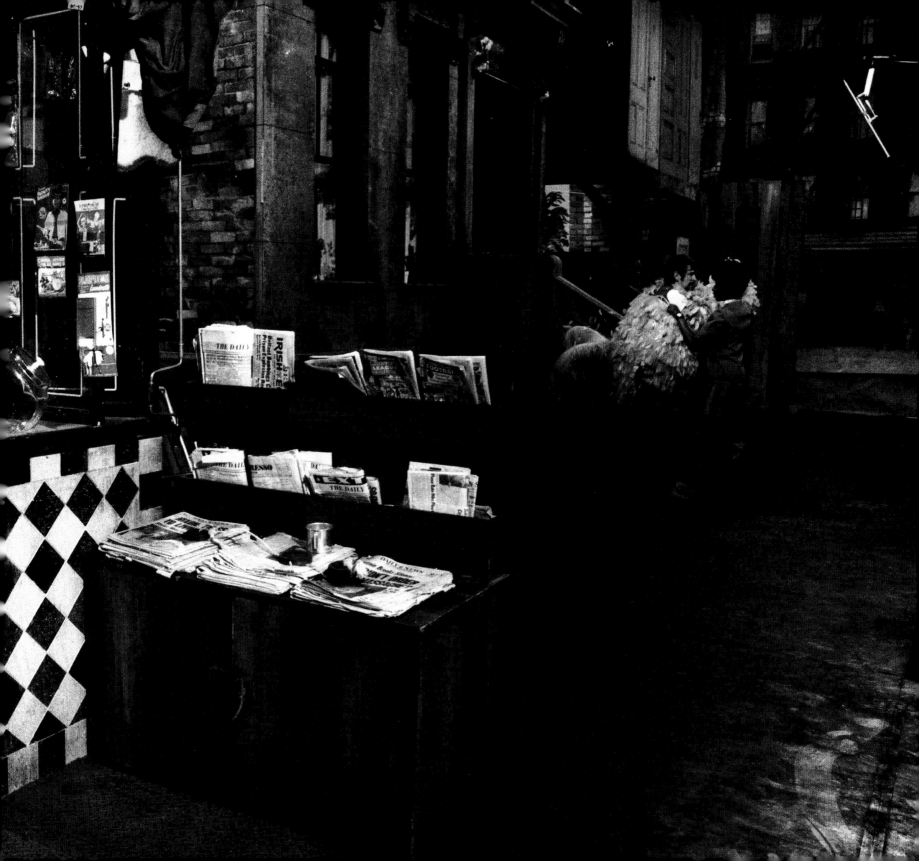

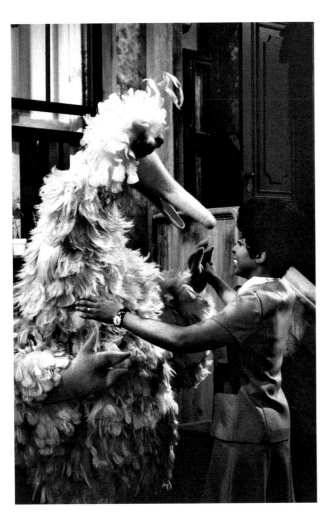

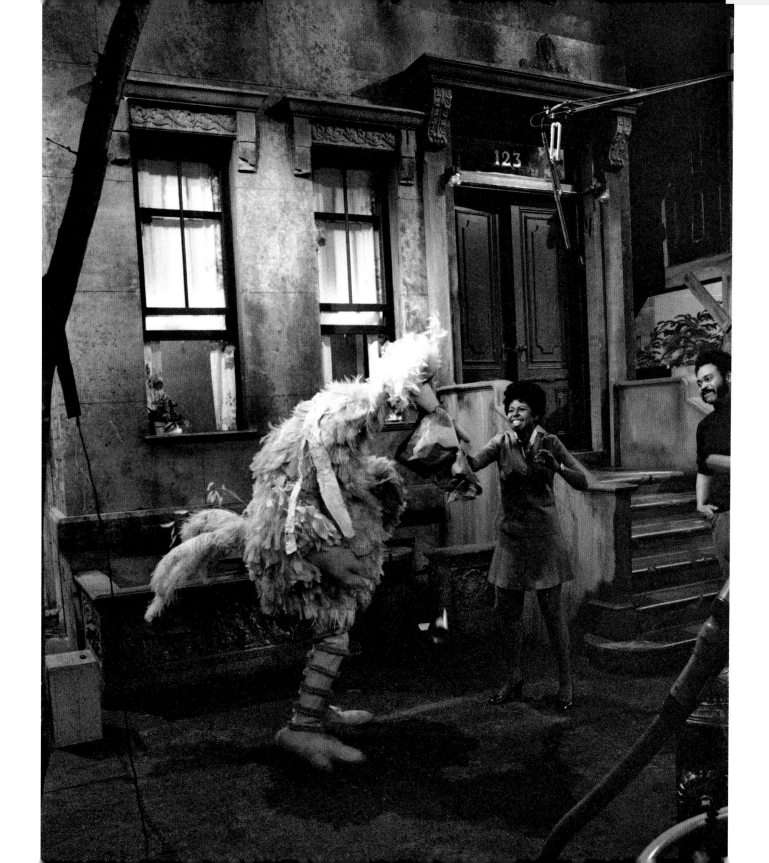

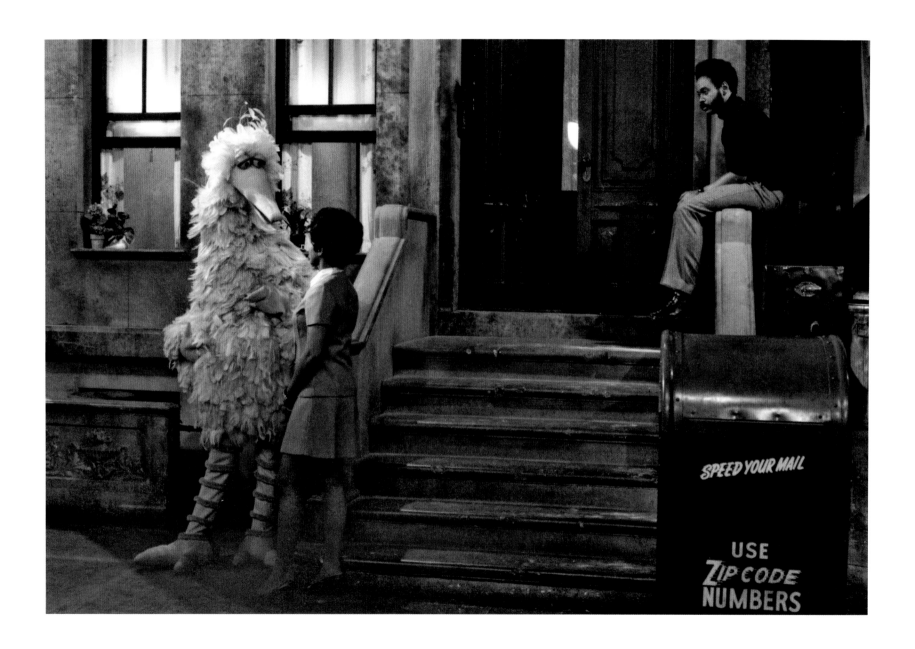

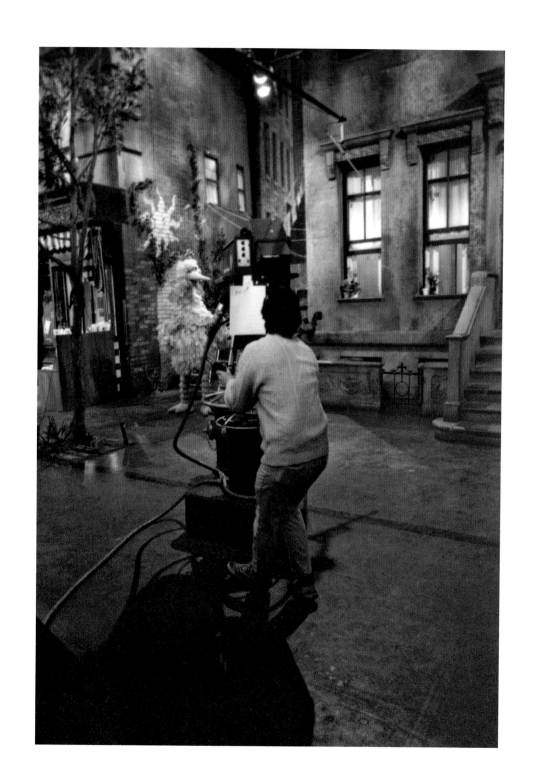

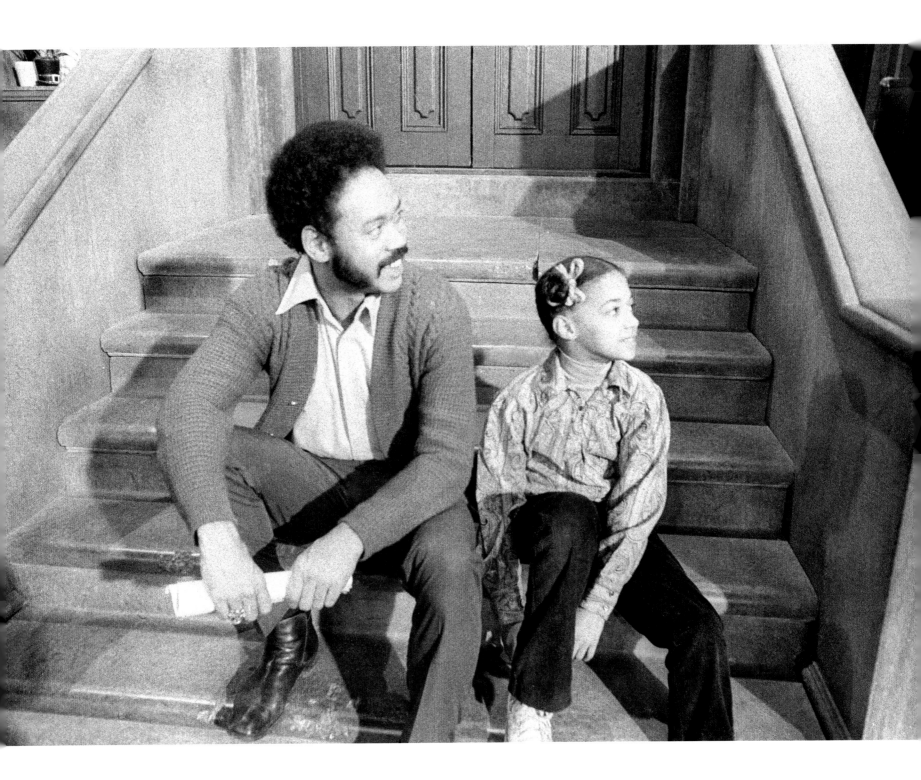

PEOPLE IN YOUR NEIGHBORHOOD

Bob McGrath was one of a handful of people cast to make up the human residents of *Sesame Street*. As a trained singer and performer, he was a perfect and natural addition to a series that was in essence a musical variety show. What was unique about his casting in 1968 was that he was not the lead in the show. A Black actor, Matt Robinson, led the ensemble cast by playing a teacher named Gordon. With the inclusion of his on-screen wife Susan, played by Black actress Loretta Long, Mr. Hooper, played by Will Lee, and of course Bob, the cast broke the mold for television and created the first interracial cast that all lived on the same street.

Bob was only the second interview that we filmed. A strange feeling often comes over you when working on a subject like *Sesame Street*. Your adult, professional self says, "This is just another two-camera interview, nothing to see here . . . move along." But then the kid who still lives inside of you, deep under the disappointments and struggles of life, comes popping out for a visit, and you are transported to another place and time when everything was possible. Out there somewhere, there was a place that was perfect. You wanted to live there. After all, it's *Sesame Street*.

When I saw the text announcing that Bob McGrath had arrived for his interview, I was barraged with images and songs: "People in Your Neighborhood," "Gimmie 5," Bob and Mr. Hooper in front of the store . . . then a new image filtered in. I remembered that I had met Bob once before.

Robinson rehearses a scene.

My father was an opera singer for his entire career and one of the few people I have ever met in my life who really only had one job. He did what he wanted to do from the time he was sixteen years old. One year he was performing the character of Brigella in Wagner's *Das Liebesverbot* at the Waterloo Village Festival in Stanhope, New Jersey. My mom brought me to visit and see him sing, and I remember thinking it was the longest car ride I had ever been on. Long Island to New Jersey, an endless voyage. For a five-year-old, Wagner opera doesn't hold a lot of raw excitement, but as it happened Bob McGrath was also at the same festival. I think my parents wanted me to be surprised because what was going to be a dull evening, erupted into a volcano of happiness as my father carried me backstage to meet him. I remember his smile and how giddy I was that I was actually seeing someone from the TV in real life. He asked me if I watched *Sesame Street*, which I did, and we sang an impromptu version of "Sunny Days" together. I can still remember the market lights that illuminated the tents of the festival and cast a warm glow over everything.

Bob McGrath, actor, musician, writer (*Sesame Street* cast member, 1969–2016) I was standing in front of Carnegie Hall in 1968, and Dave Connell, who was a fraternity brother at Phi Gam at Michigan where we washed dishes together, came across the street. I found out he had just left the *Captain Kangaroo* show. He was getting involved in a new children's show and he said, "Do you think you would be interested in hearing about it?" I was thinking *Ding Dong School* and things that I didn't think were that interesting and said, "Not in the least." He said, "Okay," and that was the end.

I was an Illinois country farm boy Irish tenor singing with Mitch Miller for a few years on his NBC show. After Mitch I had nine concert tours, over three years, singing for five thousand screaming teenagers in Japan. I thought, *Maybe I can become another Andy Williams or Perry Como*. But when I came back to the U.S.,

The Beatles had invaded, and that was the end of that old music era forever. I wasn't quite sure what I was going to do.

A couple months later, somebody called, and my wife picked up and said, "Dave would like to have you come in. They have a guy by the name of Jim Henson." I said, "Who is that?" and she added, "Something about Muppets?" "What are they?"

Eventually I said, "Okay, sure, I'll take a look." They had everything set up for about eight minutes of animation, film, Muppets. . . . Once I saw what they had, it took me a minute and a half to say, "Never mind with everything I had planned; this is what I want to do. I have never seen anything like this." It was obvious this was going to be an incredible show.

They had four characters lined up. They knew there was going to be a shopkeeper, who turned out to be Mr. Hooper, played by Will Lee. I was fortunate enough to share a very small dressing room with him. He was a fantastic actor and coach; he taught James Earl Jones, for instance. Since I had very little formal acting experience, whenever I came in and had a question about a scene I would say, "Will, I just don't know where this is going," and in no time at all he would be able to fix it up.

They wanted someone with experience performing and singing to be the music teacher on the show, and the fact that I taught school for two years didn't hurt because I would be working with children, so it all kind of meshed together. They had about six names lined up for my character, and one of them was Bobby. I haven't been called that since I was five. "Let's drop the 'b-y' and can I be Bob?" And to my surprise they said sure.

They knew they wanted an African American couple, who turned out to be Loretta Long, who played Susan, and Matt Robinson, who was Gordon.

Dolores Robinson, actress; wife of actor Matt Robinson (*Sesame Street* cast member and producer, 1969–1972)
When Matt first started with *Sesame Street*, he was a producer of live-action film. It's quite accidental that he became Gordon. Matt was auditioning other actors

to find who Gordon was. The producers had their idea; they had their picture of who Gordon was. Guys would come in, and they auditioned them, and it wouldn't be quite right. "He needs to go up. He needs to come down." And Matt is there telling them what to do. Then, all of a sudden, the people in the booth said, "Well, if he's telling them what to do, why aren't we looking at him for Gordon?"

Matt knew how to be loose. How to relate to the other characters. How to relate to Big Bird. How to talk to Oscar. And it was so unusual, because he was so not that guy. He was shy. He never wanted to be on camera. After he became Gordon and people would see him in public, he would run from people. He always wanted to be behind the scenes. He wanted to be the writer, the producer; he had this whole other image of himself.

I think playing Gordon to him meant that he could be influential in some way in educating young people. He was an educated Black man, which one did not see on television very often. If Black people wanted to see successful Black people on television, there was only Gordon on Sesame Street.

Sonia Manzano Matt Robinson was a great influence on me. He scared the heck out of me. He stopped me once, and I had just gotten there on the show, and he said, "You know, you're not here just to be the cute Latina. You have to make sure the Latino input is correct." And I thought,

What? When did I become a spokesperson for Puerto Ricans? I mean, I didn't sign up for that. I'm just trying to memorize my lines. I'm a nervous wreck.

But what he said stayed with me, and I began to watch, to look at all the scripts, to see if they had any kind of references to Latinos. And then I made my first political act. There was a fruit cart on the show, and it had apples, bananas, stuff like that. And I went to the producers and I said, "You know, if this was a real diverse neighborhood, you'd have coconuts and plantains on this fruit cart, too." They said, "Good idea!" The next day, Mr. Macintosh's fruit cart had Latino kind of stuff you'd find in a Spanish neighborhood.

Bob There was a lot of great and wonderful research going into the shaping of the show for two years before it aired, going back to when they had kids watch all the pieces and did little tests on them to see what they liked.

I learned very quickly that I needed to be on top of my game. Every time I did a piece with the Muppets, and especially doing "People in Your Neighborhood," where we covered almost every occupation in the universe, I knew that if I didn't have my mind tuned up that day, I would look like a dummy, because Jim and Frank are very sharp and they made you stay that way, even if you did two or three takes on something that was a prerecorded track and they ad-libbed their little dialogue about who they were.

"You the plumber?"

"No, I'm not the plumber."

"Santa Claus?"

And it goes on and on and on. Jim could talk in eighteen voices and then, moments before I had to start singing, "because the plumber is the person in your neighborhood," they would drop in a little line that I had never heard before that you wanted to just fall down on the floor and laugh at. But you couldn't. You had to stop and be where you were. So, it was challenging in a most miraculously wonderful sort of way. I wish that could go on for my entire life.

The first year after the show, we toured some of the major cities that had inner cities. Our first concert was out in Los Angeles. We had about two or three thousand kids out on a big lawn in the park somewhere. And Matt Robinson, who was very bright, went out to sort of warm the audience up. And he came back, and he says, "Jesus, this is like Woodstock." We made a very determined effort across those first three seasons to reach inner-city, African American, and Latino communities, in particular, to help level the playing field.

Sonia It was such an idealistic place. I mean, the fact that Bob would live in the same neighborhood as Mr. Hooper, who would live in the same neighborhood as David and Maria and Susan and Gordon . . . we were all so different. Bob from Indiana and Mr. Hooper the old Jewish storeowner. That's the iconography of the old neighborhoods; you see characters like that in the movies of the '30s and in my neighborhood in the Bronx. They were all very, very sincere and they were very real, and I think that people like that.

Bob I remember this one guy; he must have been six-foot-one or two, helping me with my bag at the airport. He was huge, in good shape. And he took one look at me, and tears came to his face. Out of the blue, he gave me a hug and he said, "Man, you were my father growing up." You give as hard a hug as you can back.

Another time I was rushing to catch a plane, I heard this voice say, "Yo, Bob." So I looked over and there was a lady behind the American Airlines counter at Newark Airport. I took the time and went over, and she told me she had grown up in the worst possible neighborhood in Newark during all the troubles there, and she said, "No one in my family had ever gotten out of high school." She said, "I watched the show. And I said to myself, at that point, I'm going to do whatever it takes to get to live in a place like Sesame Street." Then she said, "I went to college, got a degree." She's now at a top job at American Airlines. You hope that for everyone like that, there's a couple more out there that have had that same experience and it's changed their lives. There's no question that *Sesame Street* has changed people's lives all over the world.

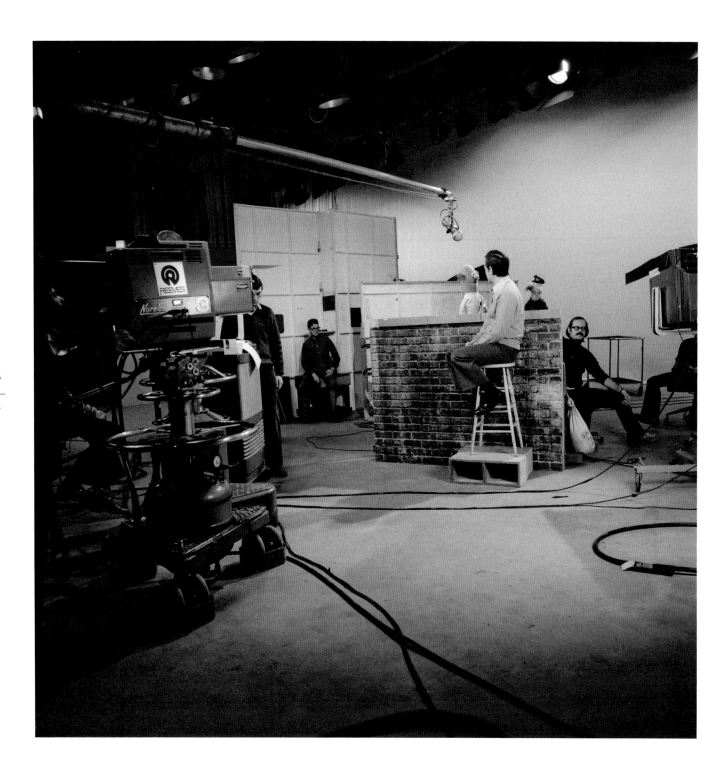

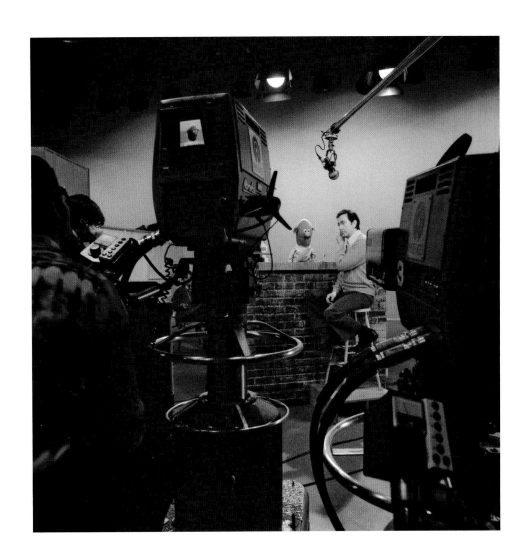

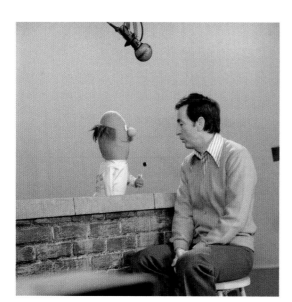
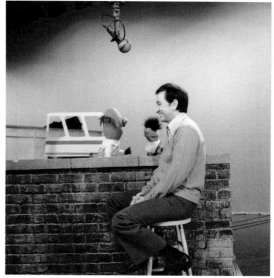
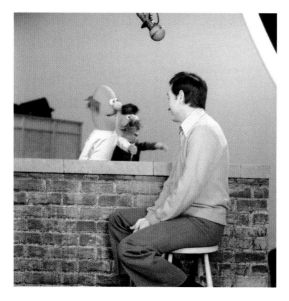
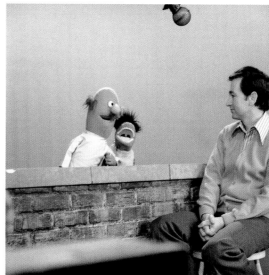

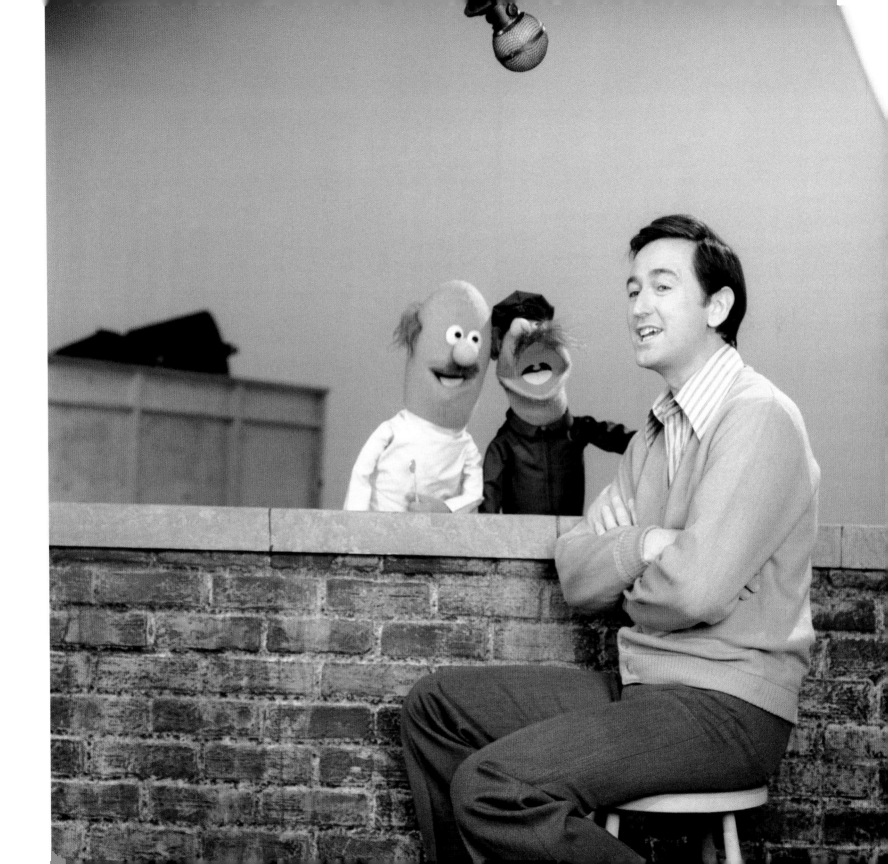

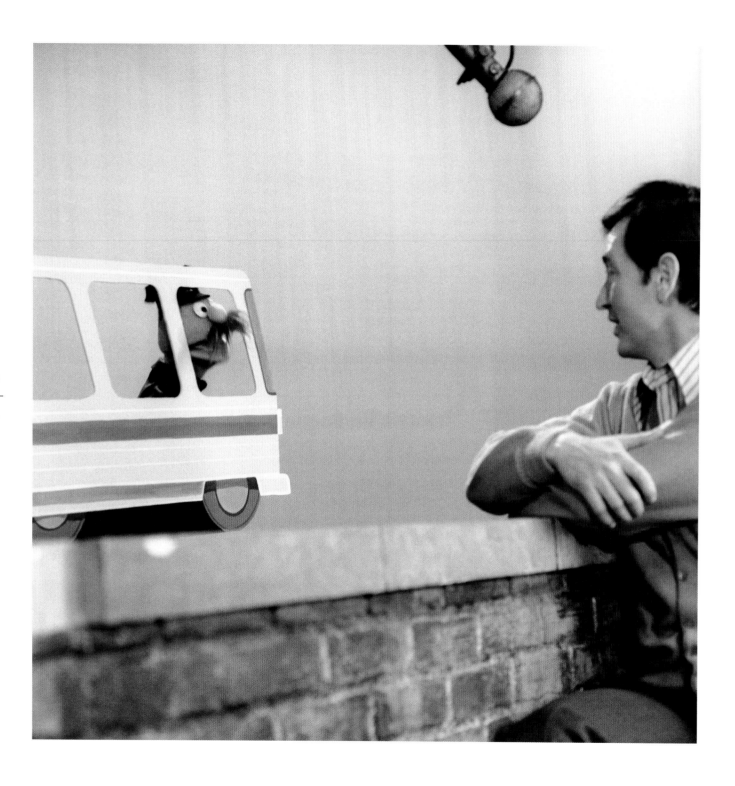

110
—
111

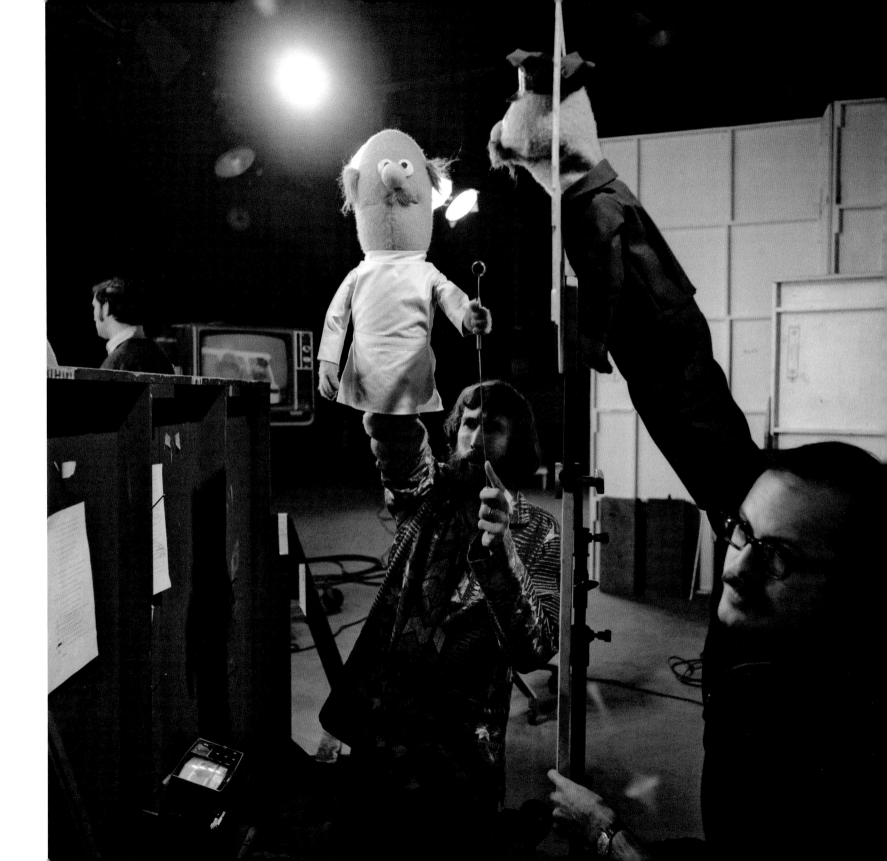

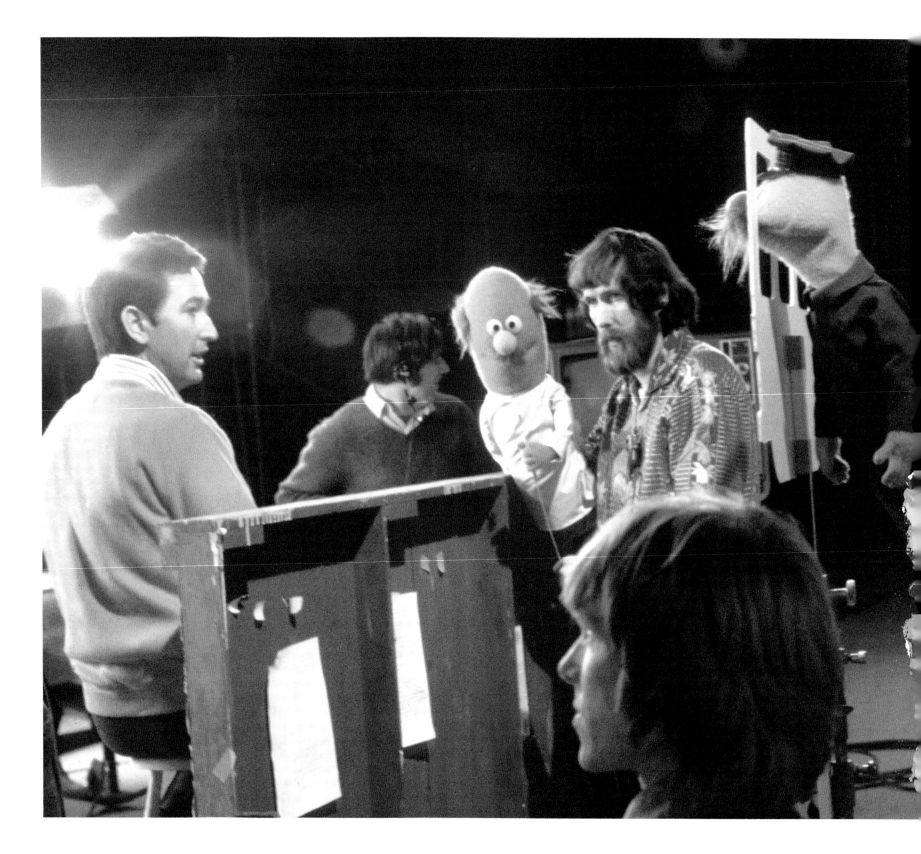

"The People in your Neighborhood,"
with McGrath and the Dentist,
played by Henson; his patient,
played by Seagren; and the Bus
Driver, played by Oz.

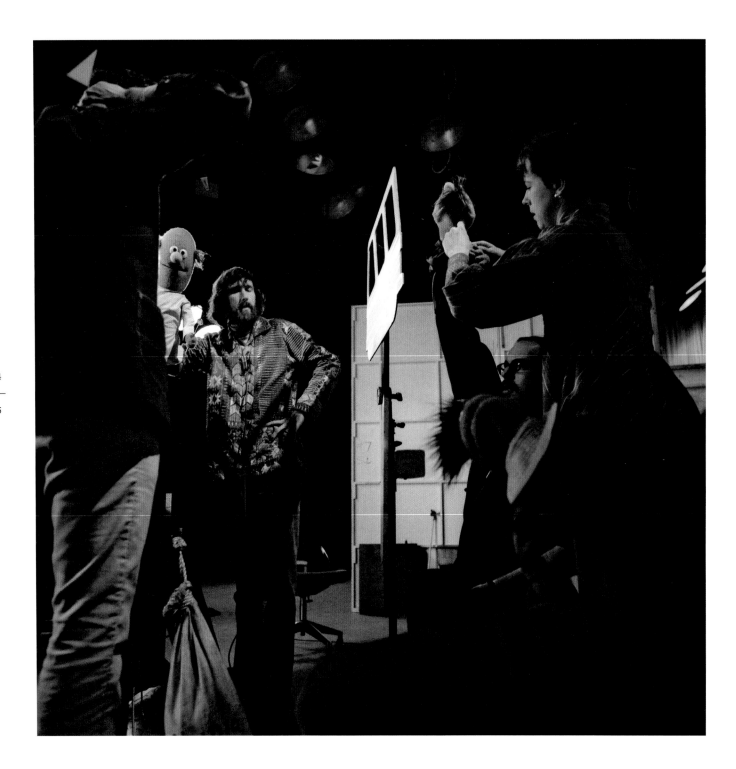

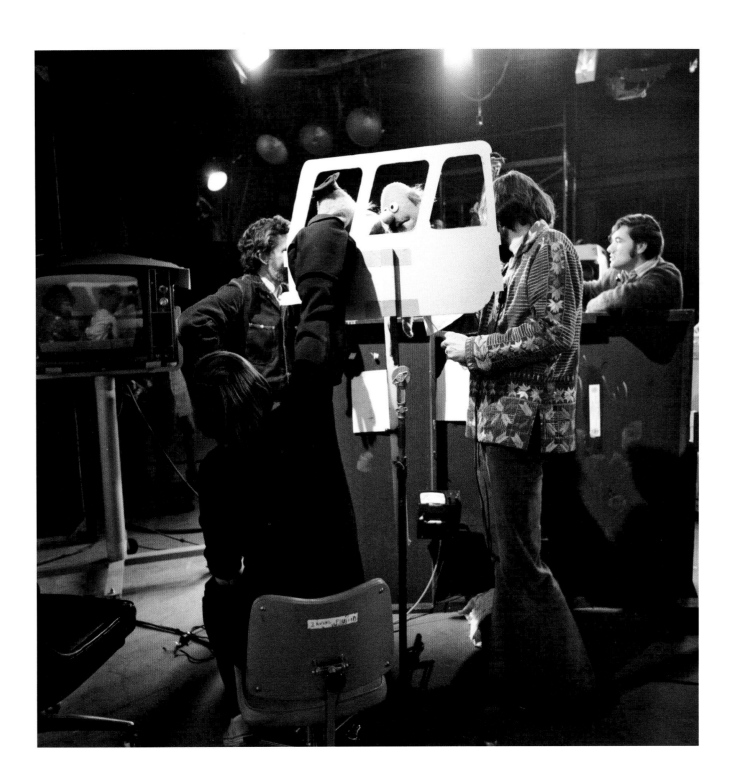

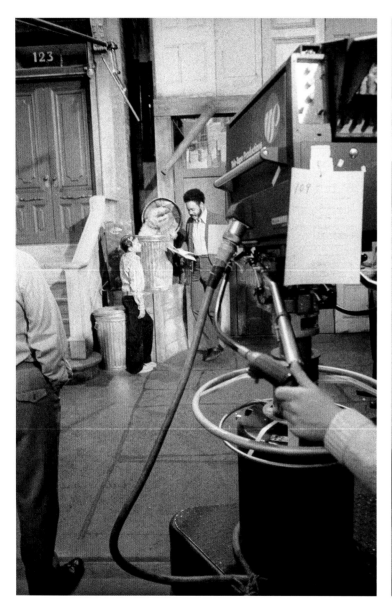
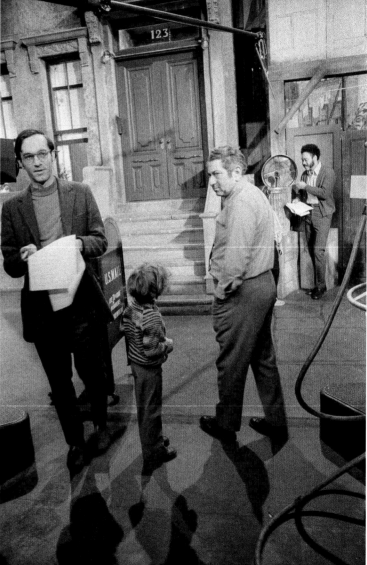

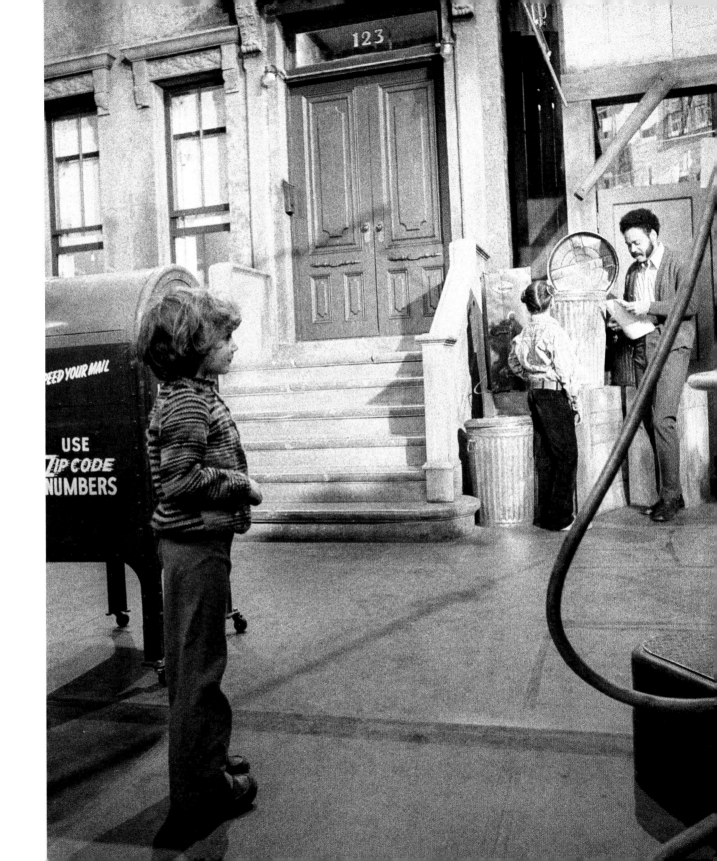

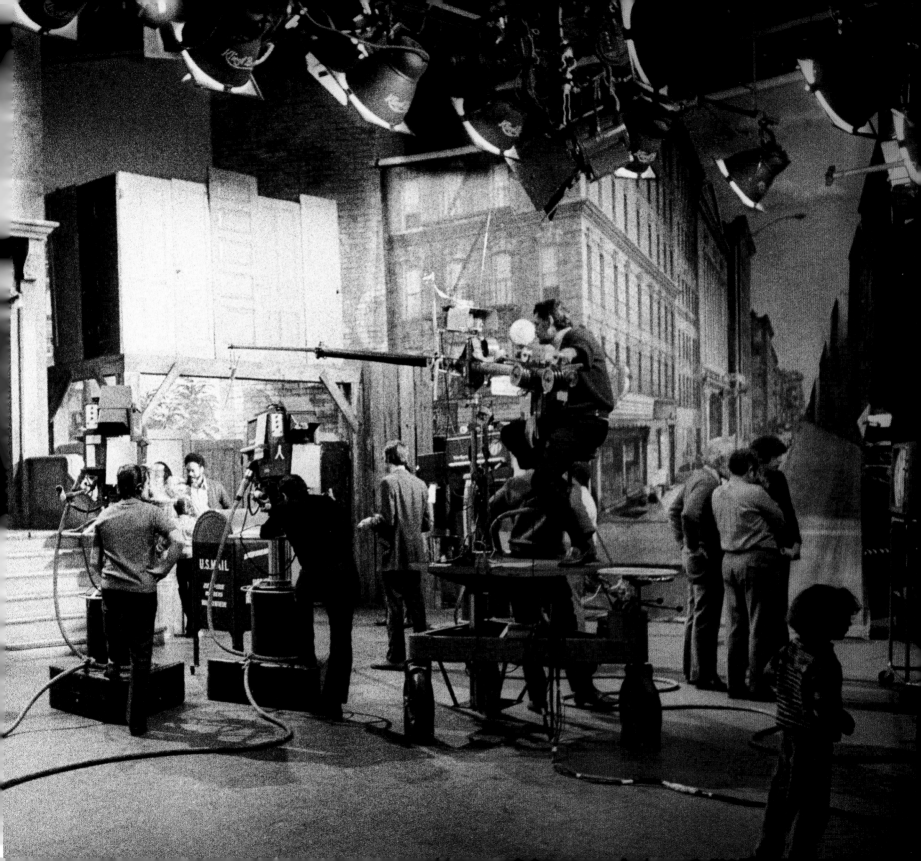

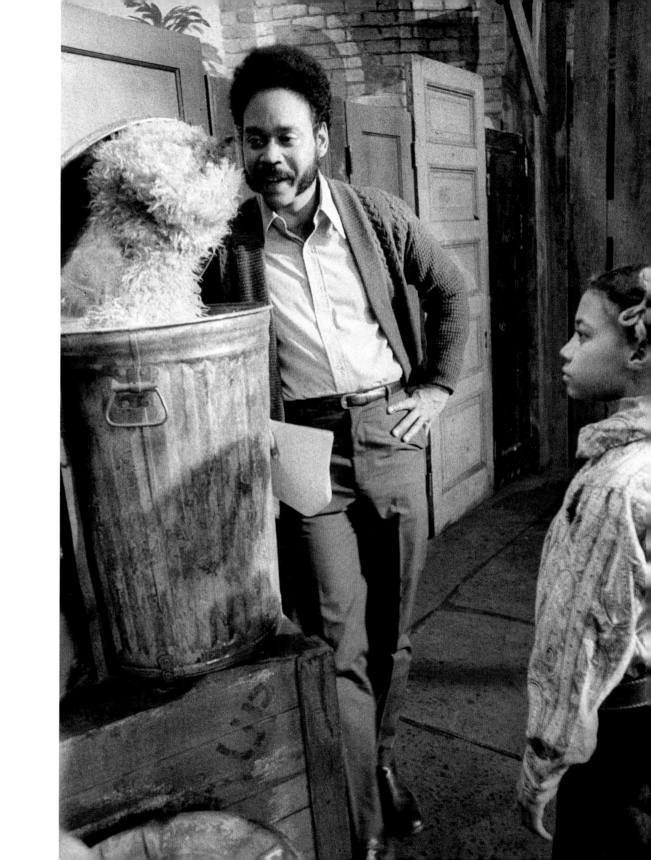

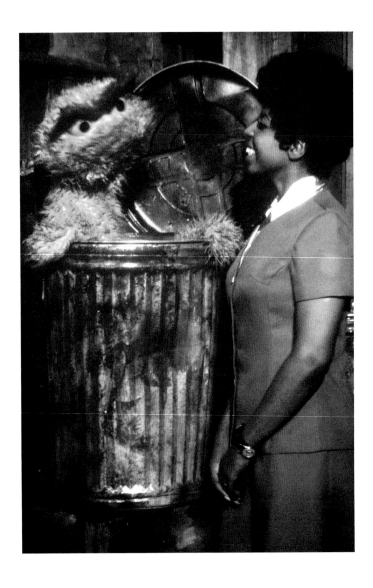

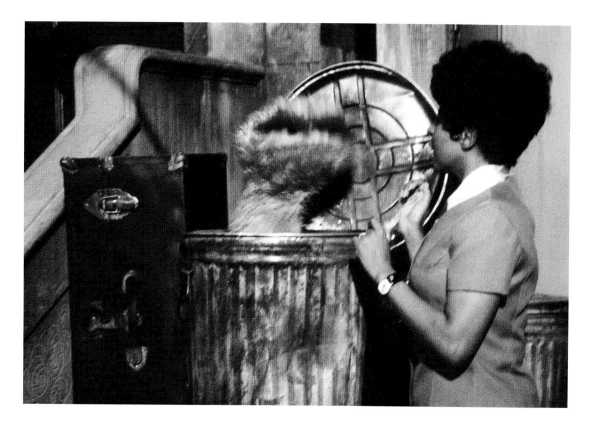

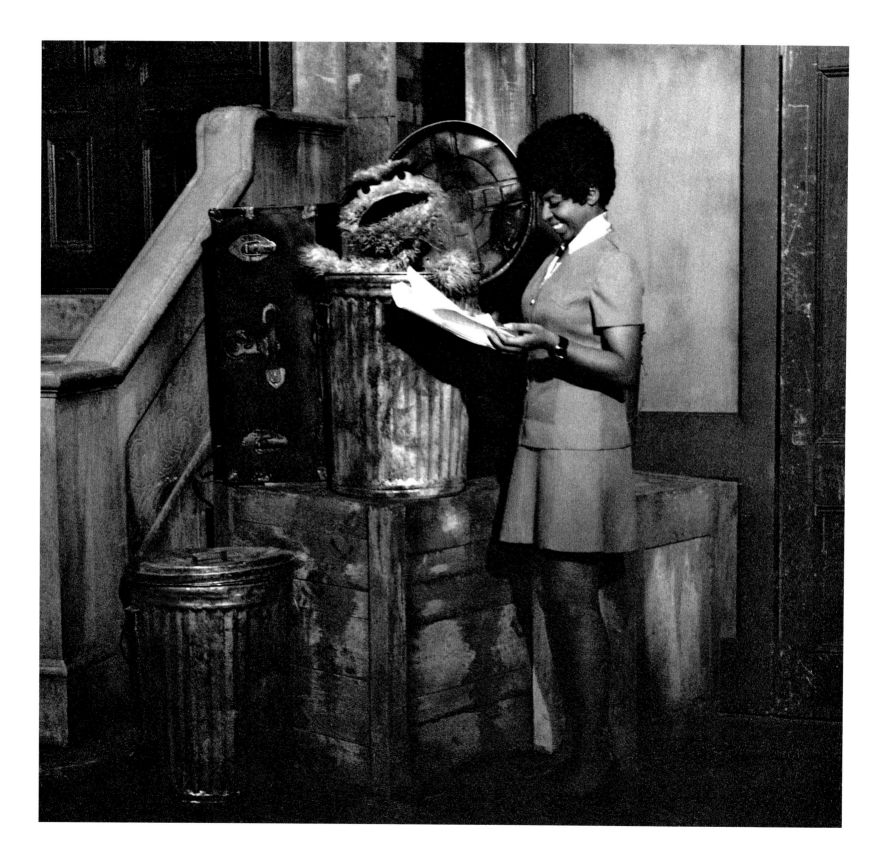

Spinney with the original
Oscar the Grouch, who
in the first season was
orange. Henson initially
intended Oscar to be
magenta, but at the
time, television cameras
couldn't process magenta
shades well. It wasn't until
season two that Oscar
became the green shade
we know so well.

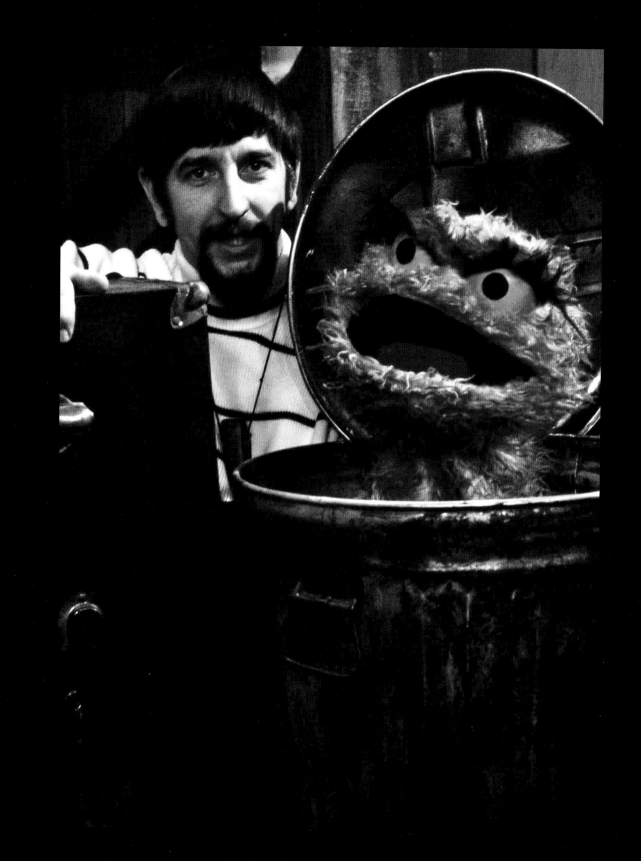

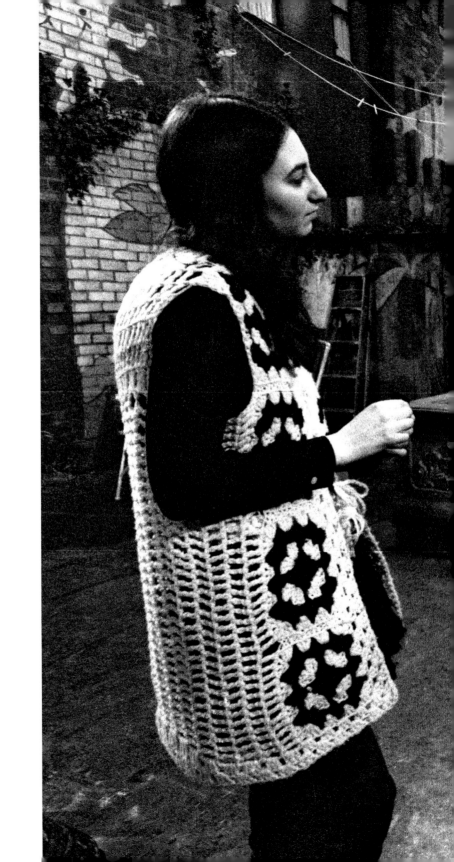

Dotty Attie watches as Oliver Attie pays
a visit to Long in between takes.

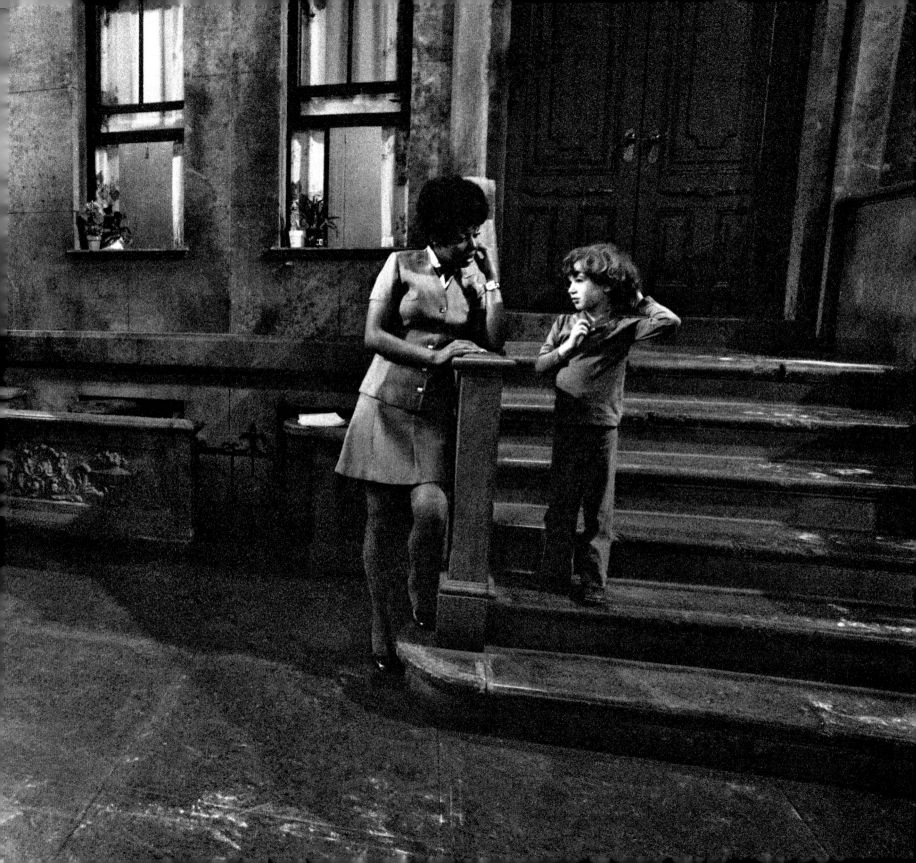

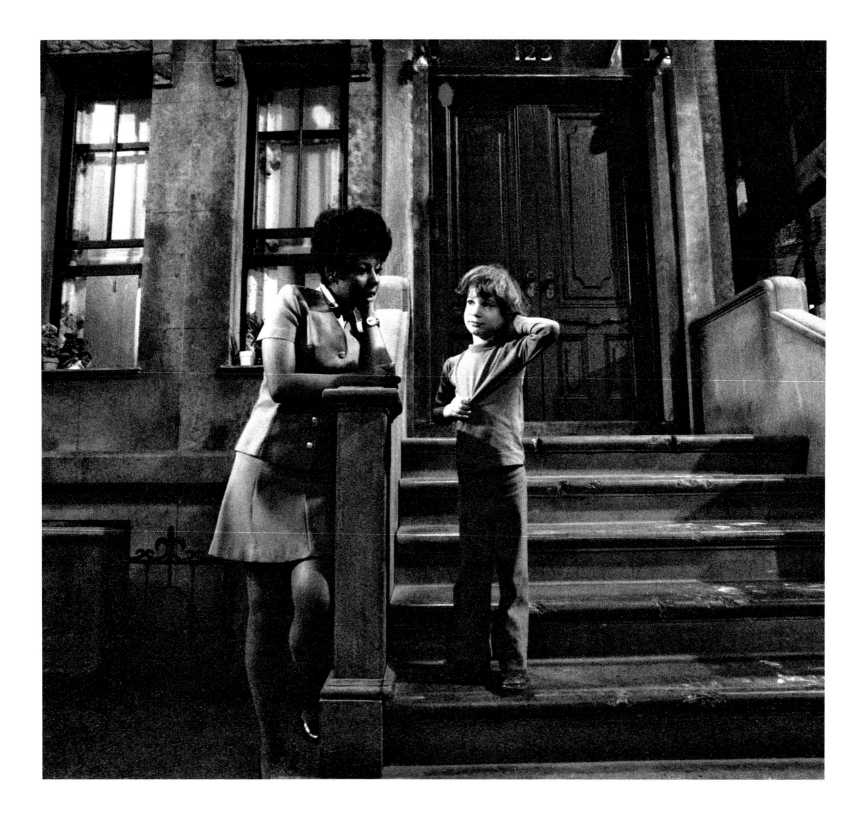

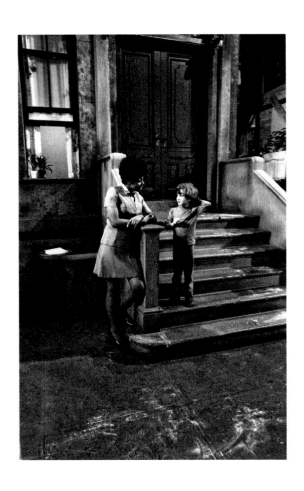

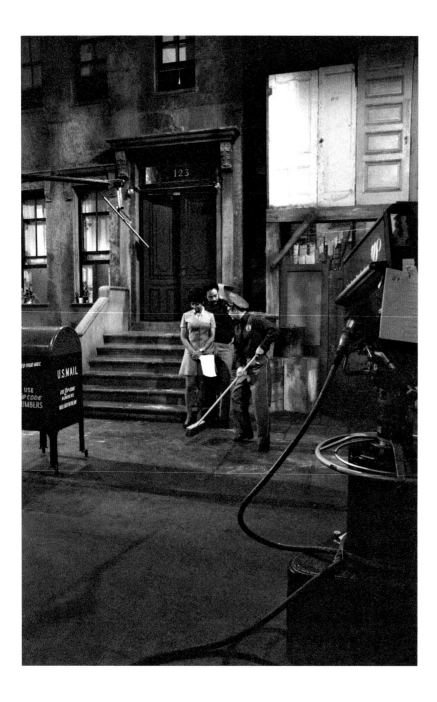

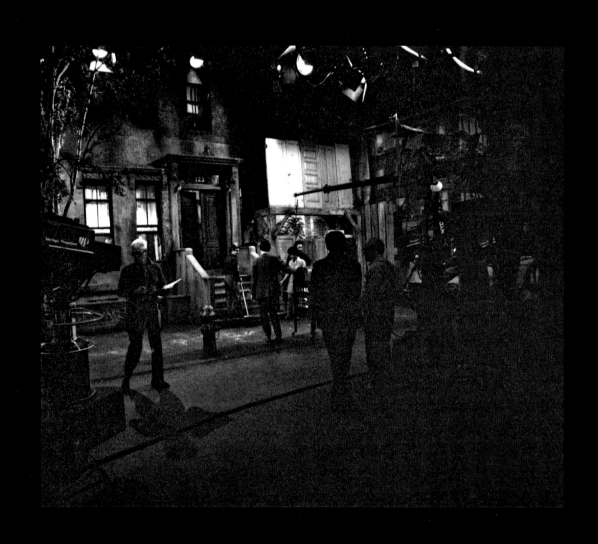

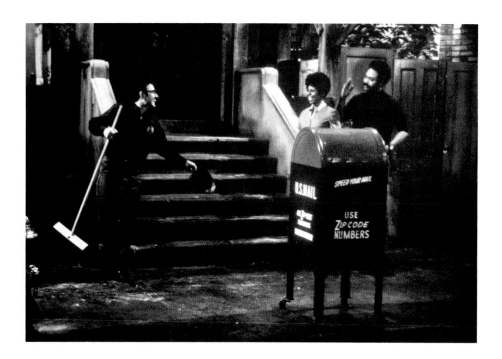

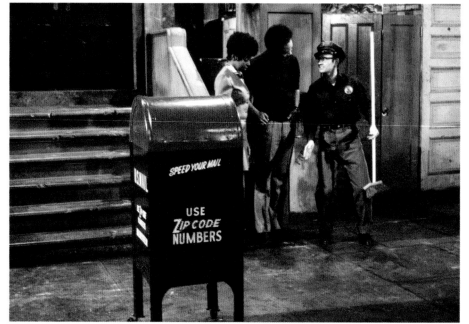

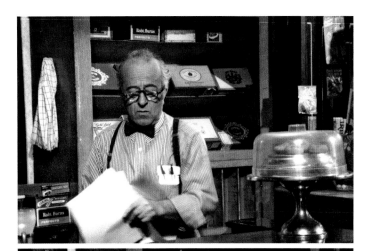

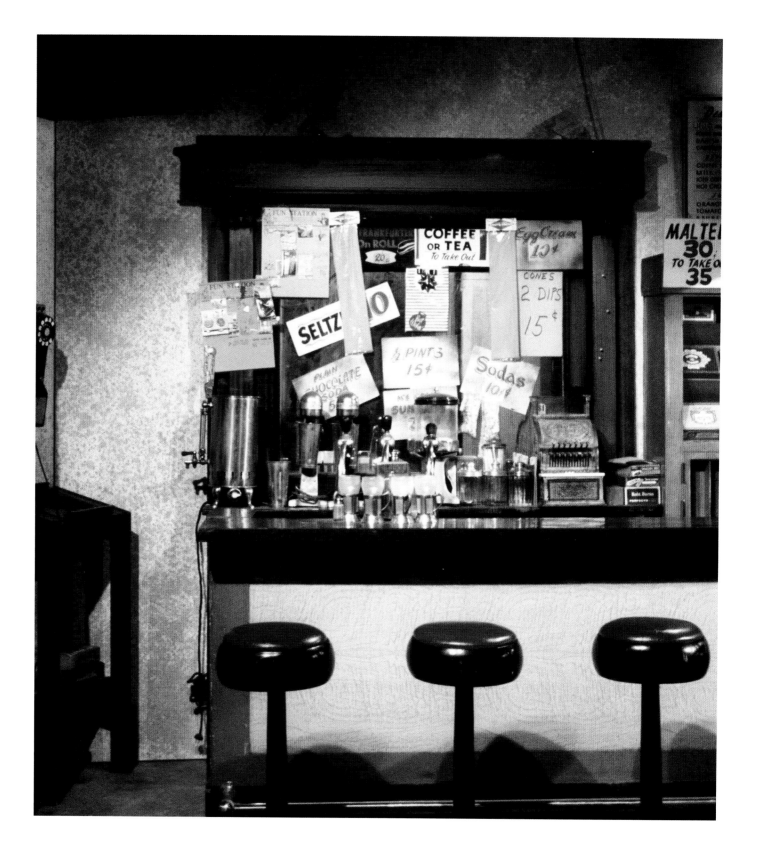

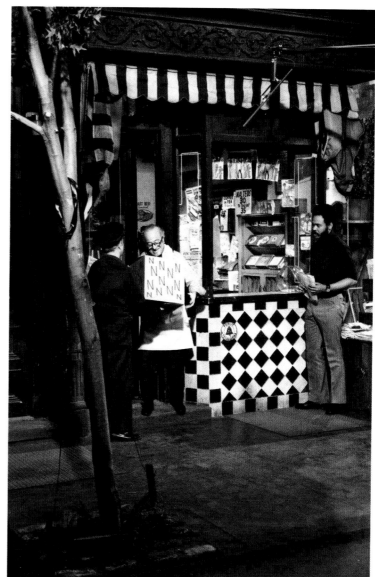

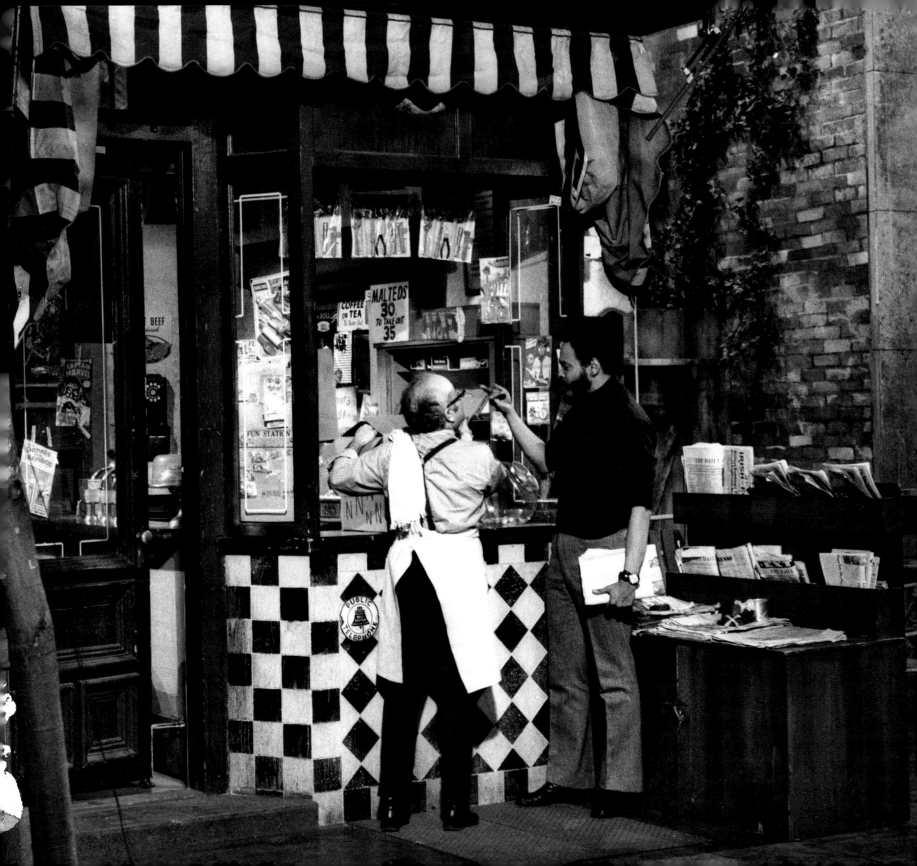

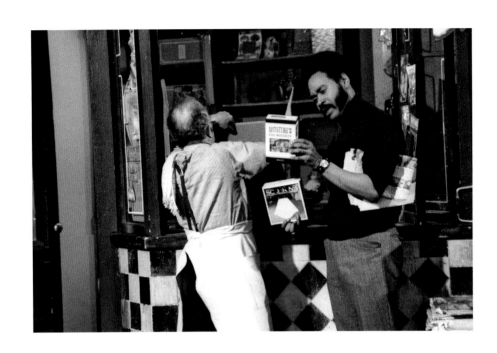

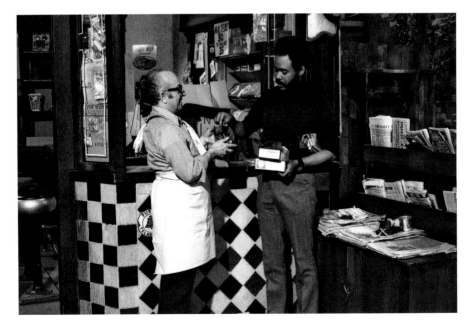

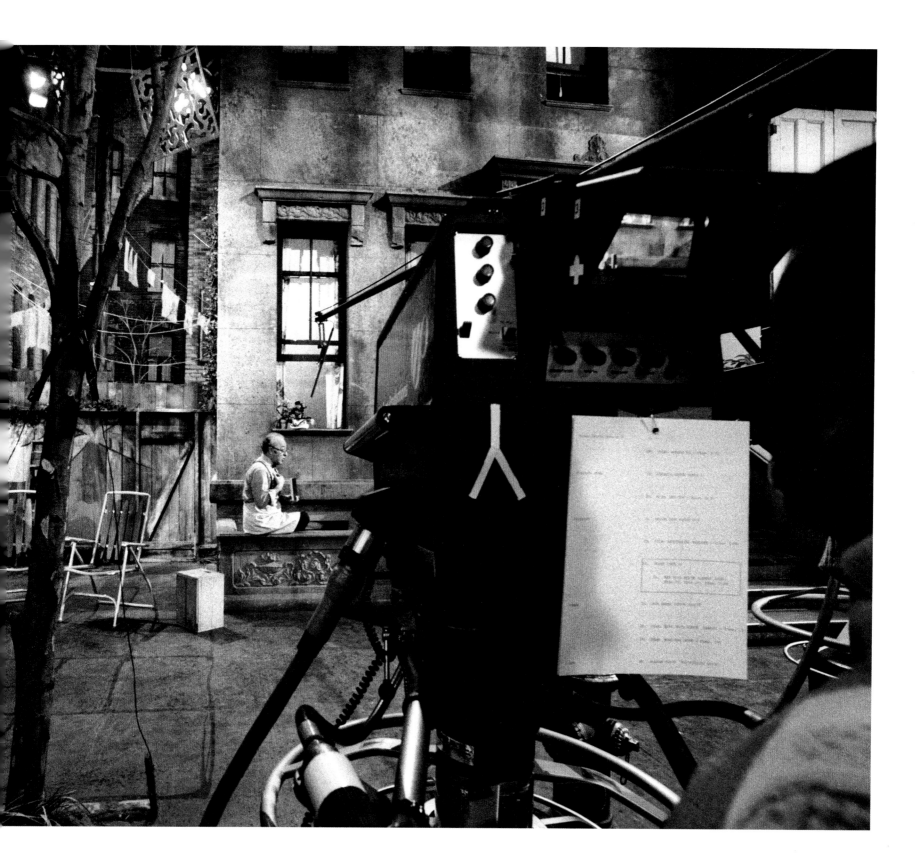

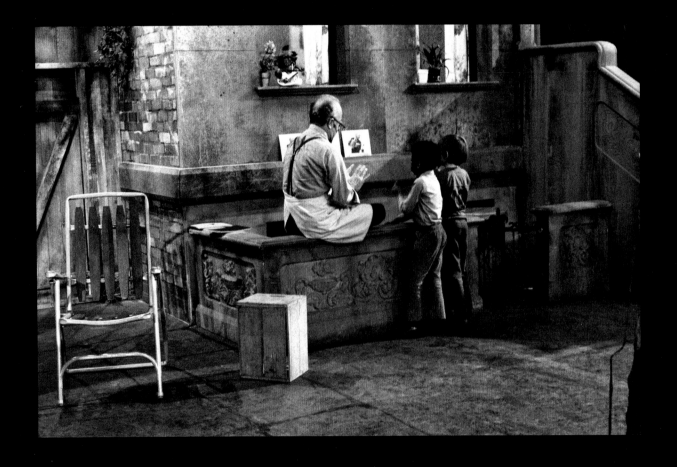

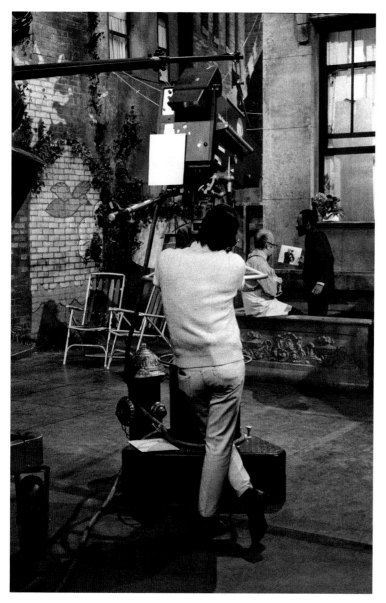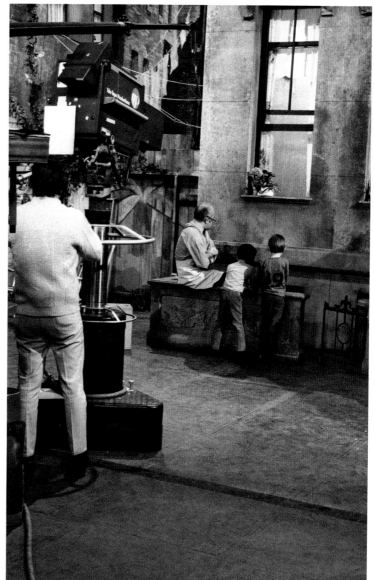

McGrath and the *Sesame Street* crew set up a scene for Episode 110 where he and his "Finger Faces" count to nine.

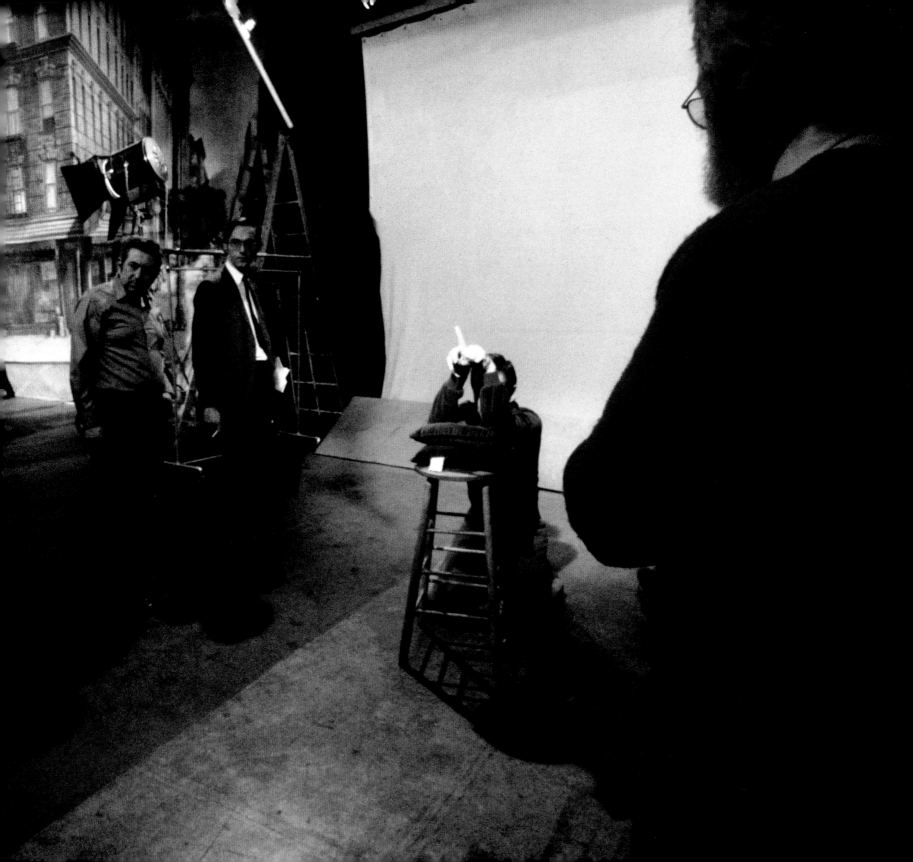

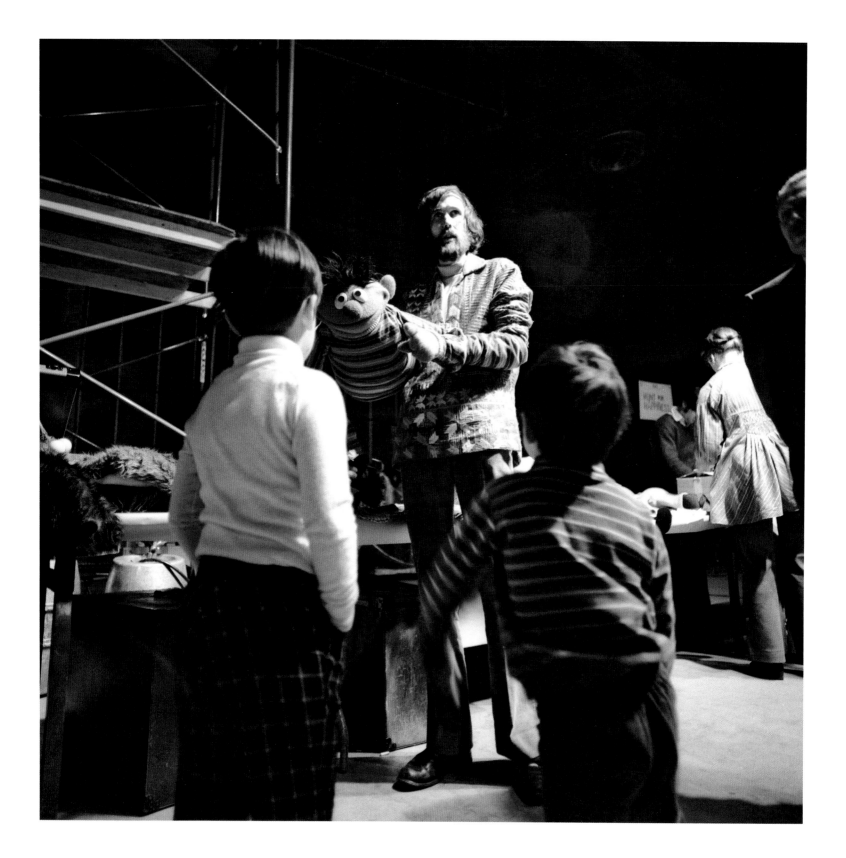

CHAPTER 5

HOW TO GET TO SESAME STREET

Early in the development of the show, the "street scenes" and the Muppet skits were separated. Muppets and humans didn't interact. When kids actually viewed the completed pilot episodes, they we bored by the street and delighted by the Muppets. Some big changes needed to be implemented. It was Jon Stone who put the two together, and the power of the two worlds interacting is what gave *Sesame Street* its unique charm. Big Bird and Oscar were the first to walk on the street, and it changed everything for not only the kids on set, but also the millions of kids in the audience.

If you know *Sesame Street*, then you have seen these little scenes throughout the seasons when a child and one of the Muppets interact together. They are unscripted and always charming. One of the best examples is one of the kids, Joey Calvan, saying the alphabet with Kermit, but continuing to insert Cookie Monster in the song. I realized that these scenes boil down everything that makes up *Sesame Street*: The magic of imagination paired with the zaniness of improv comedy linked to the power of education. For these kids there was no puppeteer—it was only Grover or Kermit or Cookie Monster.

In telling the story of the original gang and the success of the Street, and its origin, you need the Muppets and the kids who were there.

This final section is full of images of impromptu performances with multiple Muppets, the visible enjoyment of the people that made them, and the palpable joy from the children and parents who witnessed the magic firsthand.

Henson behind the scenes with Ernie and the kids who got to visit the set of *Sesame Street*.

Nick Raposo, son of composer Joe Raposo (*Sesame Street* musical director, 1969–1974; writer of the "Sesame Street Theme") I literally grew up on Sesame Street. It was an insane, incredible gift to have, being able to see and participate in *Sesame Street* when I was six, seven, eight years old on the sound stage. Being treated nicely by Kermit Love, being over at the puppet table, I had an amazing time. Kermit Love was a very compelling character for me as a child because he looked exactly like Santa Claus and he oversaw the puppet table. He was the guy who would make the Anything Muppets [puppets that had a basic shape, but different eyes and noses could be applied to change their appearance] be whatever we wanted them to be. Kermit Love would ask me, "Do you want this nose? Should we put these eyes on? Do you want a unibrow? What do you want?" He was the nicest, sweetest guy in the world. I mention him because as a child the puppets were objects of such obsession and fetishization that when the man who is in charge of the puppets lets you touch them, it was a great experience.

Being in the same room with Kermit the Frog is pretty thrilling, too. Being able to hold Kermit the Frog, even for a minute, or Grover—wow! I loved Grover. I actually had a crush on Grover. I wanted to marry Grover and live with Grover for the rest of my life. And Frank would be Grover and let me hug him—and it's his hand, and it's a man who's sitting right there, but I was entranced by it. Just absolutely enchanted. And so was everybody else in America. What's gentler and more beautiful than Grover?

Entering the world of *Sesame Street* as a viewer was very different than watching it being made. For my brother and me, watching it as children we were one step removed because we could say, "Oh, that's Frank doing that character." Or "That's Jim doing that." Or "That's our father singing that song." We were conscious that it was a production of people we actually knew. But at the same time, it was inescapably attractive and funny and sweet and touched us. Whether we saw it primarily as something other than our lives, I don't know. It was part

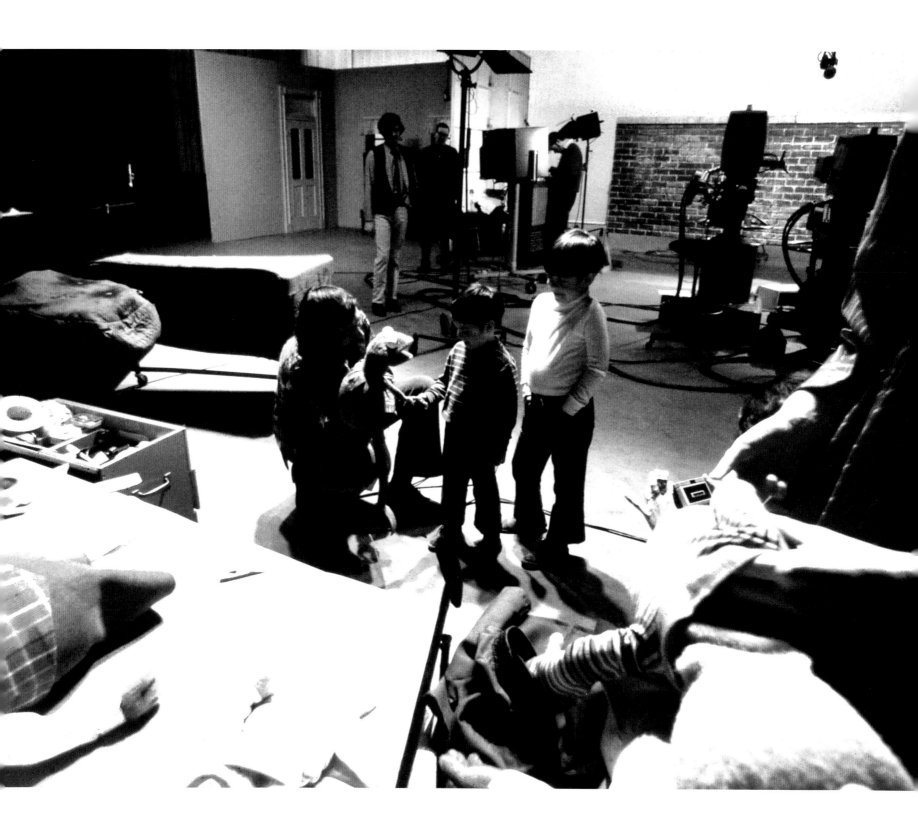

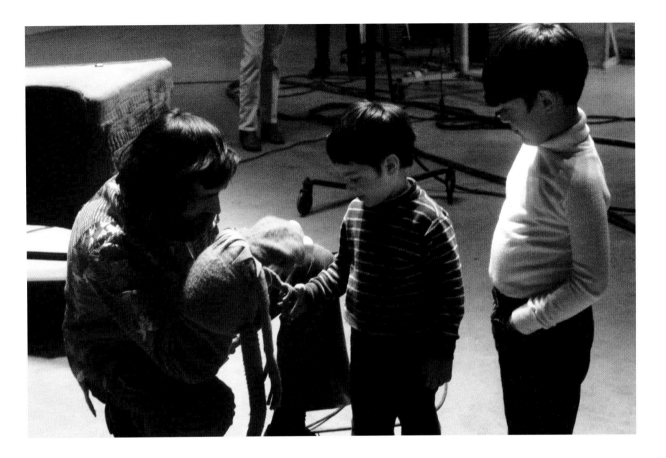

of us. Even though we didn't make it. But it was being so connected to it, it was like watching your family movies.

You can't be jaded about *Sesame Street*. It is the opposite of jaded. I often say my father's work was an irony-free zone. And so was Jim's. They were very funny and naughty and wicked in their humor, but they were genuine and believed in what they were doing. They knew that the culture had changed. They knew what they were trying to achieve educationally and socially, and that comes through in every frame.

Polly Stone At various times when dad was directing, producing this show, people had questions about a script. They wanted to know what time they were due. The phone would ring and dad would talk to somebody from the set. One day, I picked up the phone, and we were very

carefully instructed on how, if you're going to answer the phone, you answer the phone properly. So, I picked up the phone and I said, "Hello, Polly Stone speaking, who is this please?" It was Grover! And he was calling to talk to me. He asked me about what my day at school was like and he asked me what I was doing, and I will never forget it.

Grover, this superstar on television that all of my friends knew, called me to ask what I wanted to talk about, and hung out on the phone with me. And then we got off the phone, and a few minutes later the phone rang, and Frank Oz was calling to ask dad what time he was due at the studio. Just what a wonderful way to grow up where I had all these friends that were blue and fuzzy, and they were as much a part of our lives and our friendship circle as the people behind them are.

Kate Stone I remember as a kid being at that studio at 81st Street, it was a day care basically. The kids on the show weren't professional actors, they were just kids, and there would be kids in the back room and then a voice would come in and it would say, "We need four kids to come down for 'One of These Things Is Not Like the Other.'" And they would point at a few of us, and you would go down. Then, there were other bits that were one-on-one with the Muppets, but it wasn't rehearsed and it wasn't professional children with professional smiles. It was pretty low key, fly-by-the-seat-of-your-pants. I mean, that was part of the charm of it—everybody was real.

Polly One of my fondest memories of being in the studio was that Will Lee, who played Mr. Hooper (or "Mr. Looper," as Big Bird used to call him), never ever broke character if there were kids on set. They would finish taping and you could go into Mr. Hooper's store and he would welcome you to his store. He had cookies back behind the counter. You could order something, and he would say, "Oh, well, I don't have that, but here, I've got a cookie." He *was* Mr. Hooper, and just would never change who he was in front of children.

The strongest memory that I have about the day that I was on with Grover and with Prairie Dawn happened many years later. I had a friend who was working as an interior designer in an architecture firm, and her son was in a half day of school, so he would come to the office in the afternoon, and he rapidly figured out that I had more toys at my desk than his mother did, so he would come and hang out with me. So I got to be good friends with this little boy, and one morning, the phone rang and it was his babysitter. Was very apologetic, but said, "I'm really sorry, but he is so insistent, and I've got to get him off to school. Would you just talk to him?" I was like "Um, yeah. Okay."

And this little boy got on the phone and he said, "I saw you on Sesame Street this morning." And I said, "Um, I looked really different. I know you know I was involved in Sesame Street, but I was a little kid. I was your age when I was on the show," and he said, "I know!" I said, "Okay,

so what did you see?" He said, "Well, you were wearing a stripey dress and you said the alphabet with Grover. You left out M and you stopped at V. You weren't very good at it." And I said, "You're absolutely right. You saw me on Sesame Street this morning."

And I realized that clip ran for decades and was still reaching little kids all those years later. And the idea that I had been recognized on the show by this little boy was breathtaking.

I think my dad was so often larger than life. There were quiet times, but he was an immense presence even when it was a quiet time. I think I didn't really recognize how unusual that is because it was just dad. And also, he had all these other larger-than-life people around him. So if you grow up with this is your dad, and his best friends are Jim Henson, and Frank Oz, and Jerry Nelson, and Joe Raposo, to a certain extent there's an expectation or an understanding that that's just how people are. And it wasn't until later in life when I started going home with friends and having dinner at their house, and thought, *This is different.* I really did grow up in a world where you longed to be the kid who was sitting at the table with the grownups. Because those were the grownups, it was extraordinary.

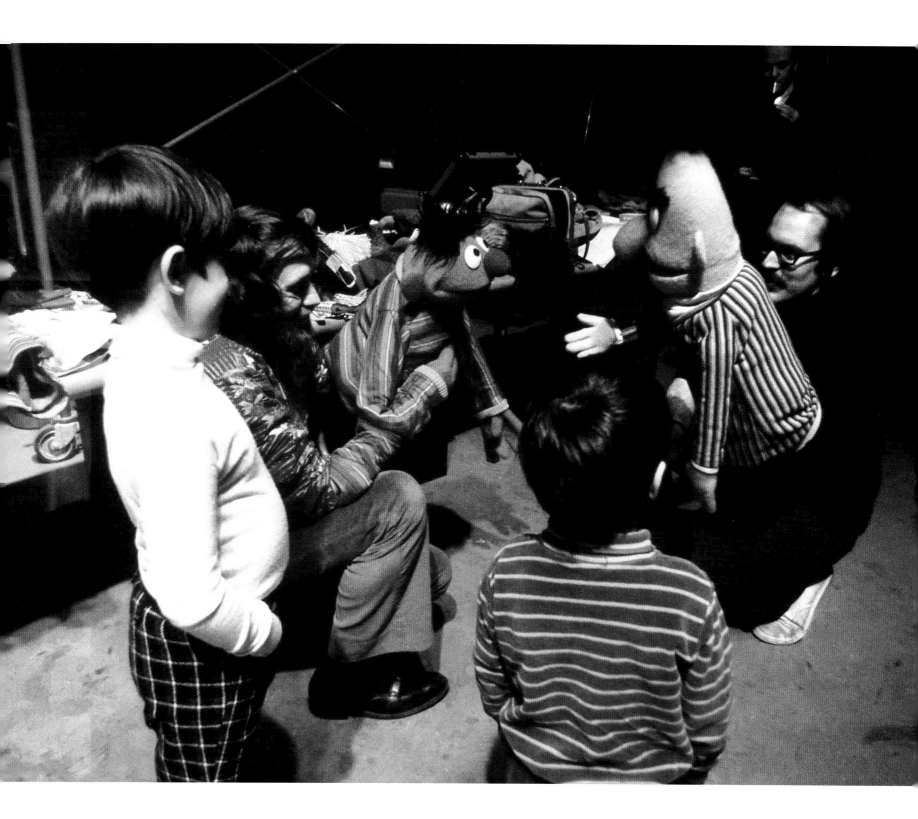

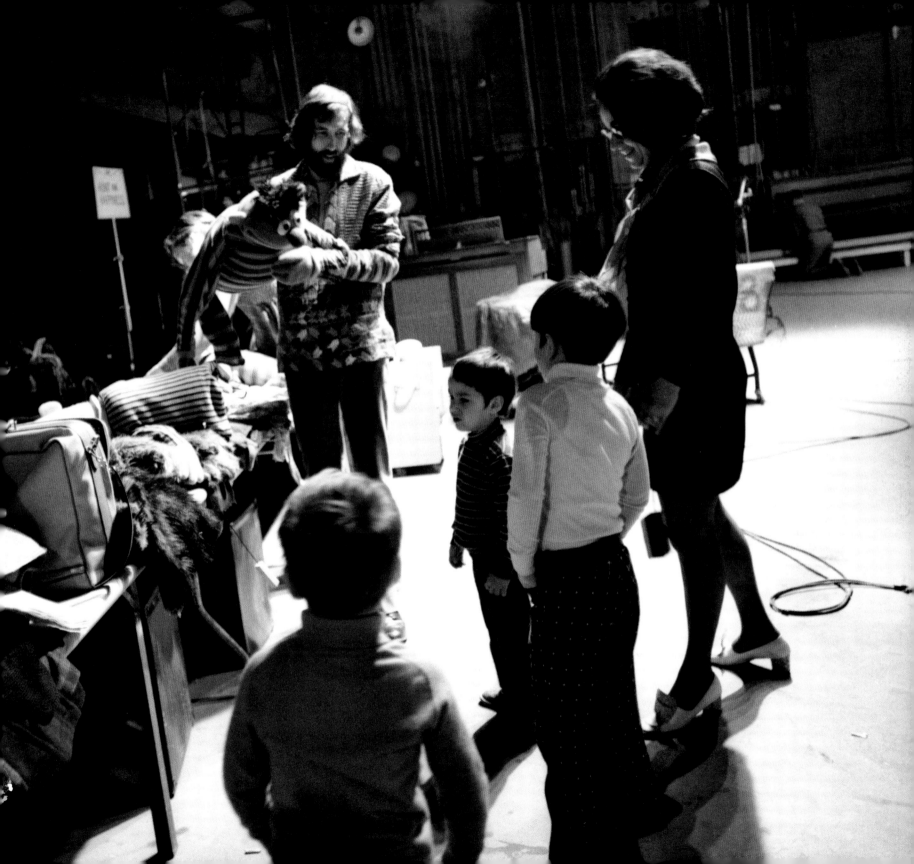

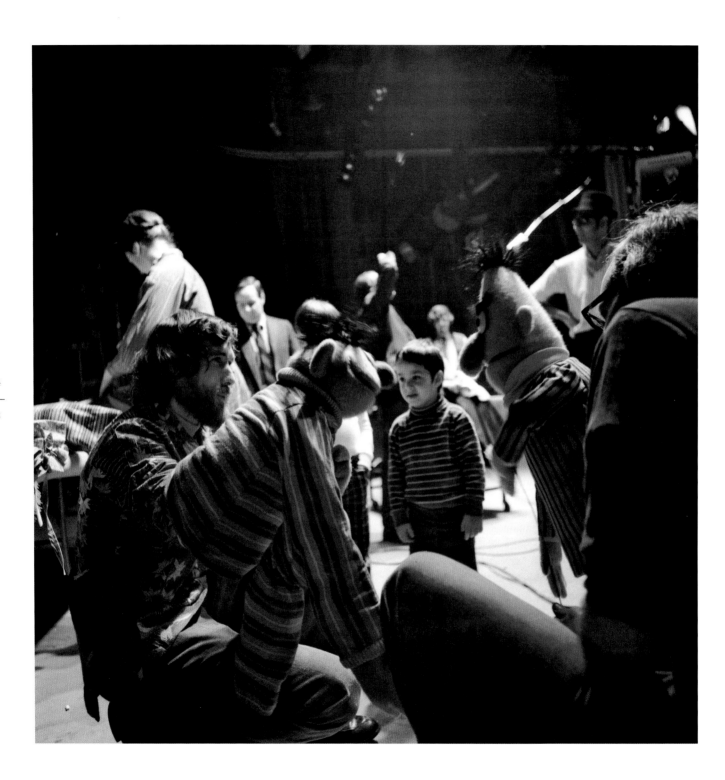

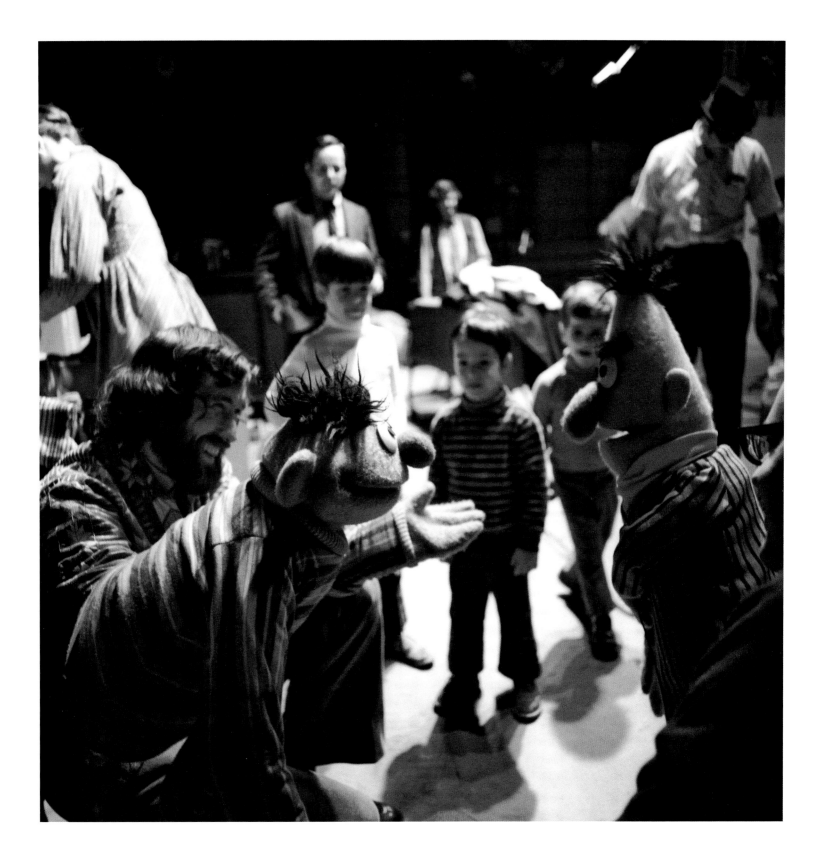

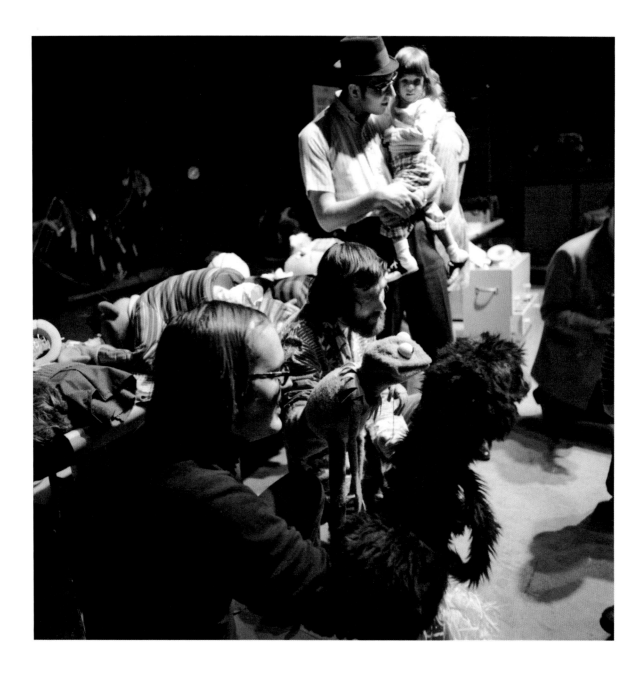

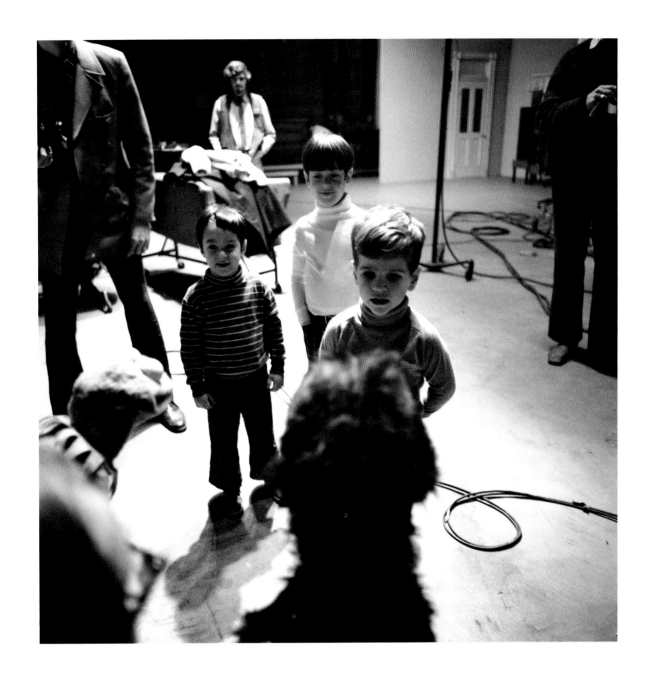

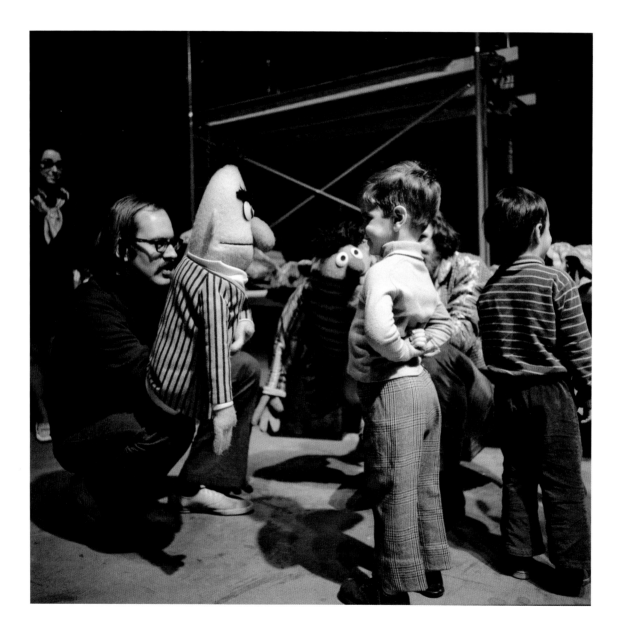

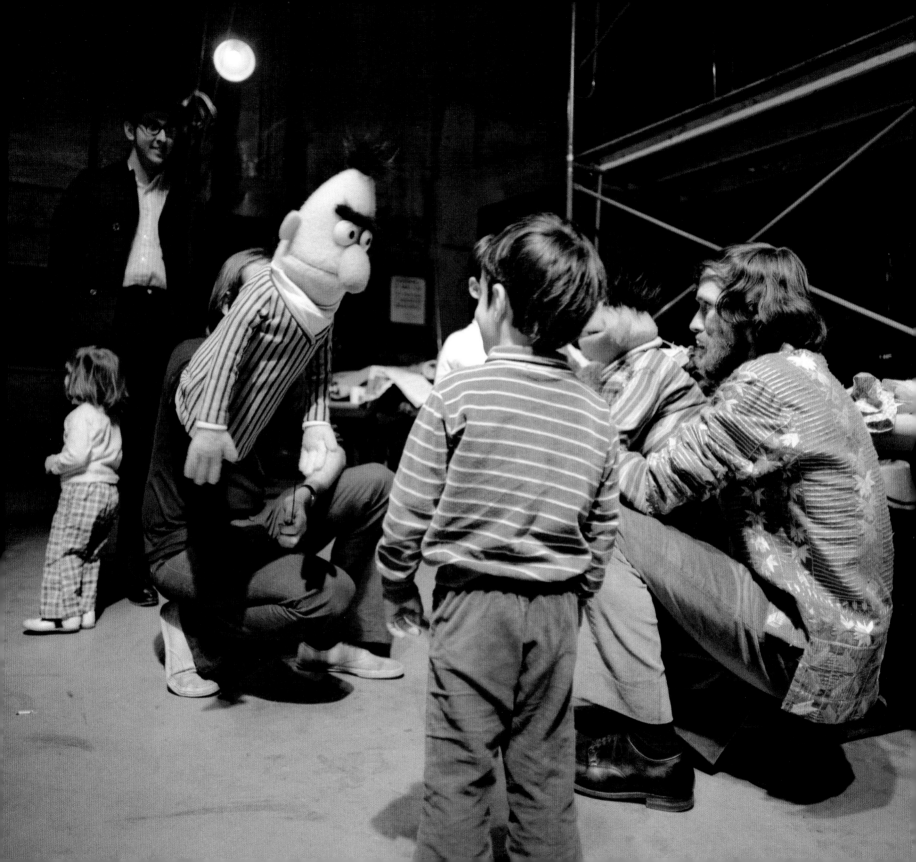

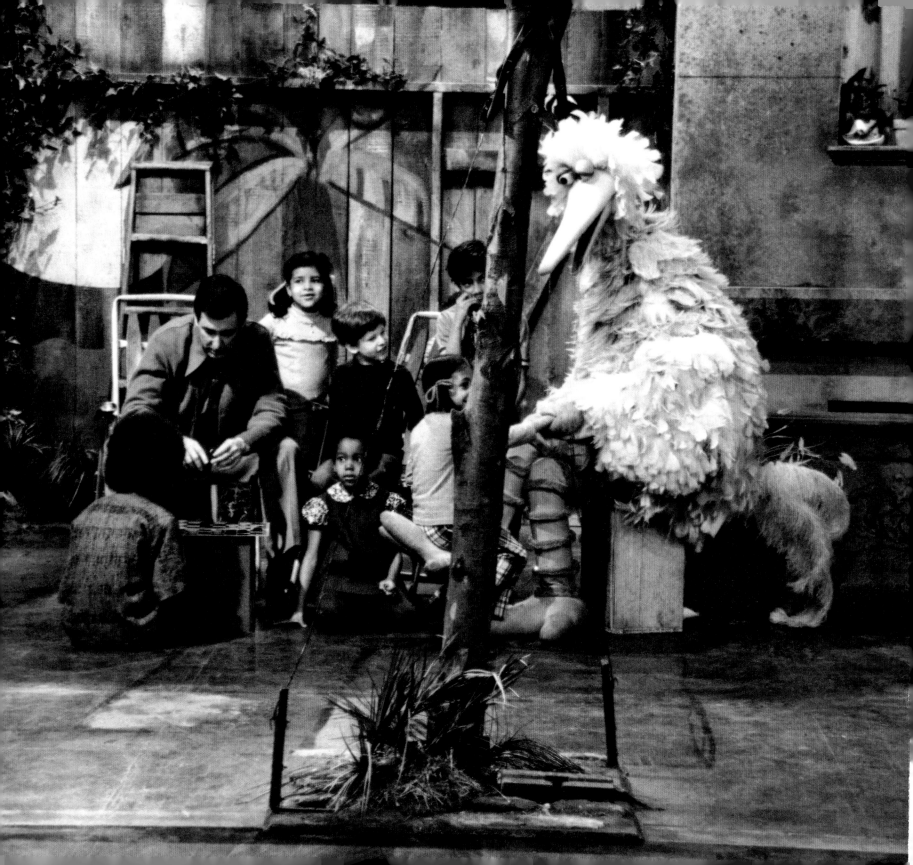

AFTERWORD

Sonia Manzano

Sesame Street was shot out a of a cannon in 1969, fueled by the social unrest of Black Americans tired of being treated as second-class citizens, young people marching on Washington to protest an unpopular war, farmworkers demanding decent labor conditions—the list of grievances that were being protested went on and on. It seemed everyone in the late sixties in America was in for a change.

By night I observed the goings-on from my home in the Bronx, and by day with my friends at the High School of Performing Arts. And just when I was beginning to think that Puerto Ricans like myself were doomed to watch from the sidelines, a group called the Young Lords protested the lack of garbage pickup in El Barrio by setting the trash on fire, finally getting the attention of New York City officials. That protest fired up my heart and mind as well, making me feel like a part of society. Perhaps even on some level also enabling me to feel enough a part of things to find my way to *Sesame Street*. Why not? *Sesame Street* grabbed me by the throat even before I was cast as Maria.

I first saw *Sesame Street* at the student union of Carnegie-Mellon University in Pittsburgh—and I was stunned. Were those *really* Black people on television? Were they *actually* talking to me from someplace in the city I was born? Everyone at the student union who watched the show with me that day was bemused and intrigued by what they saw. It was so funny, provocative, different, and smart.

But my white classmates couldn't have understood my own excitement at seeing Lorretta Long playing Susan and Matt Robinson playing Gordon. The thrill of seeing people of color on television was mine alone, except of course, for other people of color who happened to be watching somewhere else in America. All at once, I remembered that in all the television I had ever watched as a child, I never saw anyone who looked like me or lived in a neighborhood similar to mine. In fact, I remembered aligning myself with *any* dark-haired character on television, including the Mexican actor who guest starred as a gardener on the popular fifties television show *Father Knows Best*. Trying to fit into a pre-made mold had been exhausting, and worse, it made me question where I stood in a society that refused to see me.

But here was *Sesame Street*. It was as if the producers took everything that was going on in American society, funneled it through a straw, and blasted it on television. And if the things on the screen excited me—imagine what diving into the thick of things felt like when I got cast as Maria? Behind the scenes I saw colliding forces of creative people. Everyday creative fervor spread like a fever. Passions ran amok. There was a feeling of being on the move, of riding high, of enjoying and seeking exhausting exuberance. What was I to do in this mix?

Matt Robinson gave me a clue as to how I would contribute when he pulled me aside saying, "You're not here to be the cute little Puerto Rican. You have to make sure the Puerto Rican content is on point!" At first, I was surprised and self-conscious. *Me?* I thought. *Who elected me mayor of Puerto Ricans?* But I used his point as a stepping-stone to get on board.

My part became clearer the day creator/producer Jon Stone furiously pulled me into the makeup room and scolded the makeup artist saying, "I go through all the trouble of hiring a real person, and you make her up to look like a Kewpie doll." He was angry, the makeup artist was chagrined, and I soberly began to look at the reflection of my face coming clear in the mirror as she removed my make-up. *I was not to play a part or be anyone's preconceived notion of a Puerto Rican. I was to be myself.*

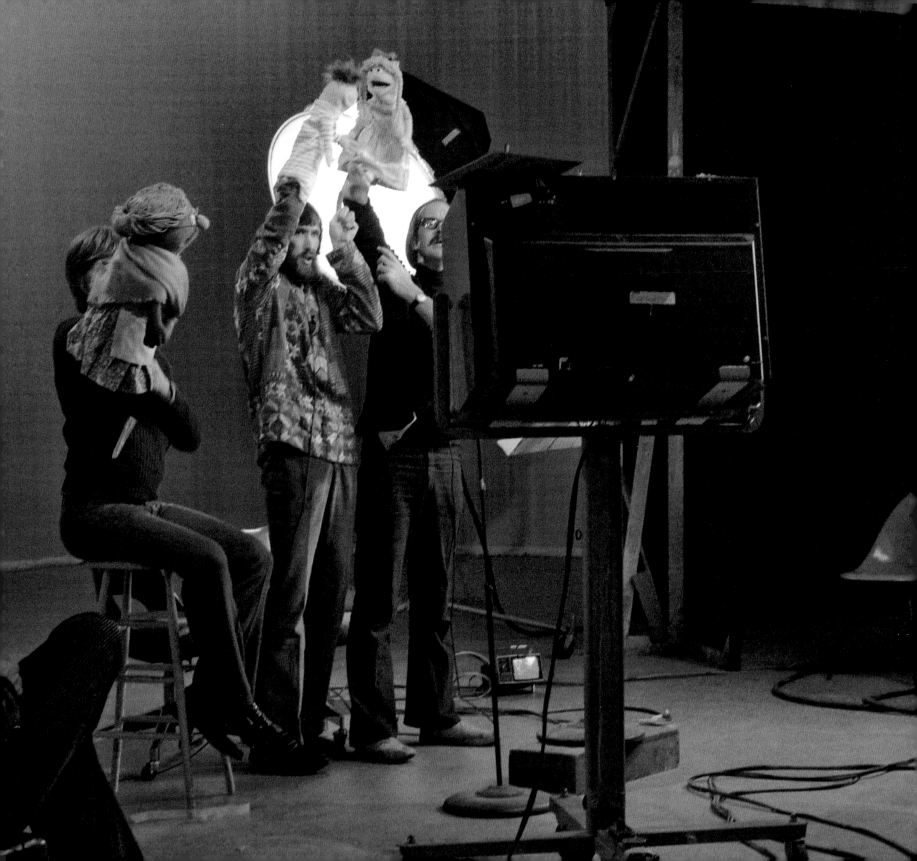

But I had one last hurdle to overcome. Puppeteers Frank Oz, Carroll Spinney, Jerry Nelson, and of course Jim Henson managed to radiate characters from their fingertips and through the furry fabric of the Muppets' faces. How could I put aside my own amazement of their talent long enough to perform with them? How was I going to act alongside handfuls of fur?

Once, while playing a scene with Grover, I continued to look at Frank Oz, the puppeteer down at my feet, instead of the Grover puppet Frank was holding close to my face. "Quit looking at that man down there," he quipped as Grover, bringing my attention up to the character emanating from his fingertips. Everyone laughed. The way to work with Muppets became obvious: I was to set up the joke and let the Muppet come in with the punch line. I became—what used to be called in old comic parlance—the straight man! I was on my way.

As the years went by, I began to see how *Sesame Street* gave us as opportunity to take a good look at ourselves. Television can help us celebrate our human universality. The medium wore me down when I wasn't represented on it, so it exalted me, and others like me, to be on the show.

So go back and take another peek at these images that suggest how *Sesame Street* celebrated us. Pour over these photos, skim over the images again with your fingers and guess, speculate, and fantasize about *Sesame Street*, as we've all done and always will—because I don't believe the phenomenon of *Sesame Street* will ever happen again.

Sonia Manzano is a mainland Puerto Rican, raised in the Bronx. After starring in Broadway show *Godspell*, she went on to create the role of Maria on *Sesame Street*, for which she received a Lifetime Achievement Emmy Award in 2016. Scholastic recently announced a four-book deal with Manzano. The first novel, *Coming Up Cuban*, will publish in 2022. Currently she is working on *Alma's Way*, an animated series with Fred Rogers Productions that will air on PBS. Sonia lives in New York City with her husband.

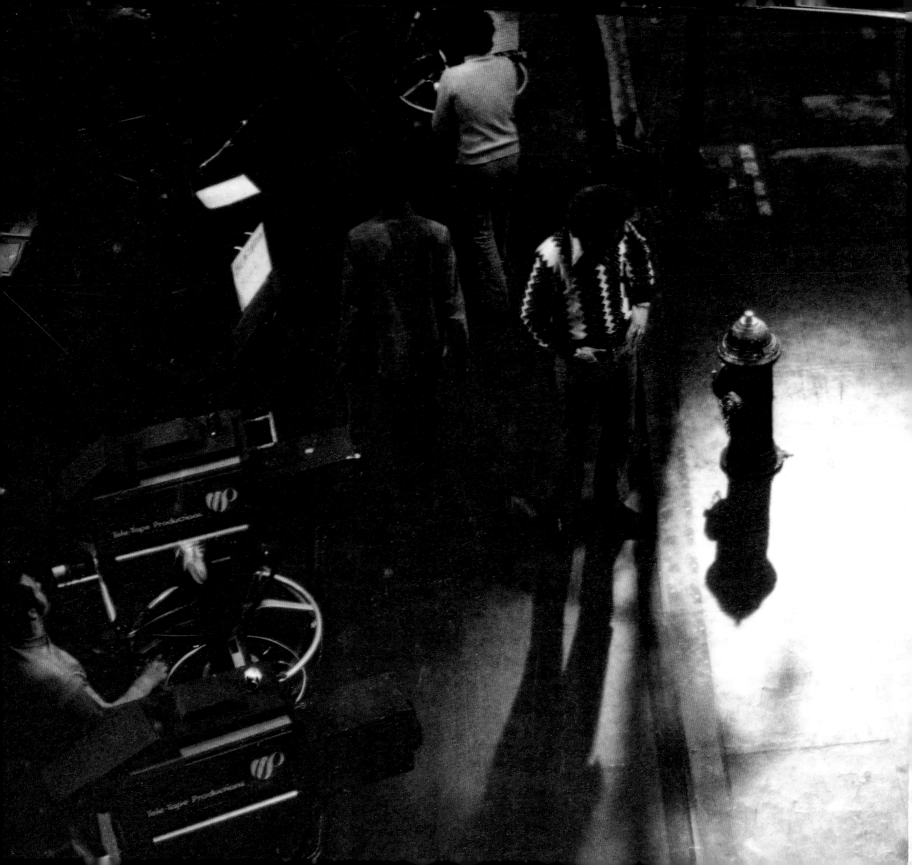

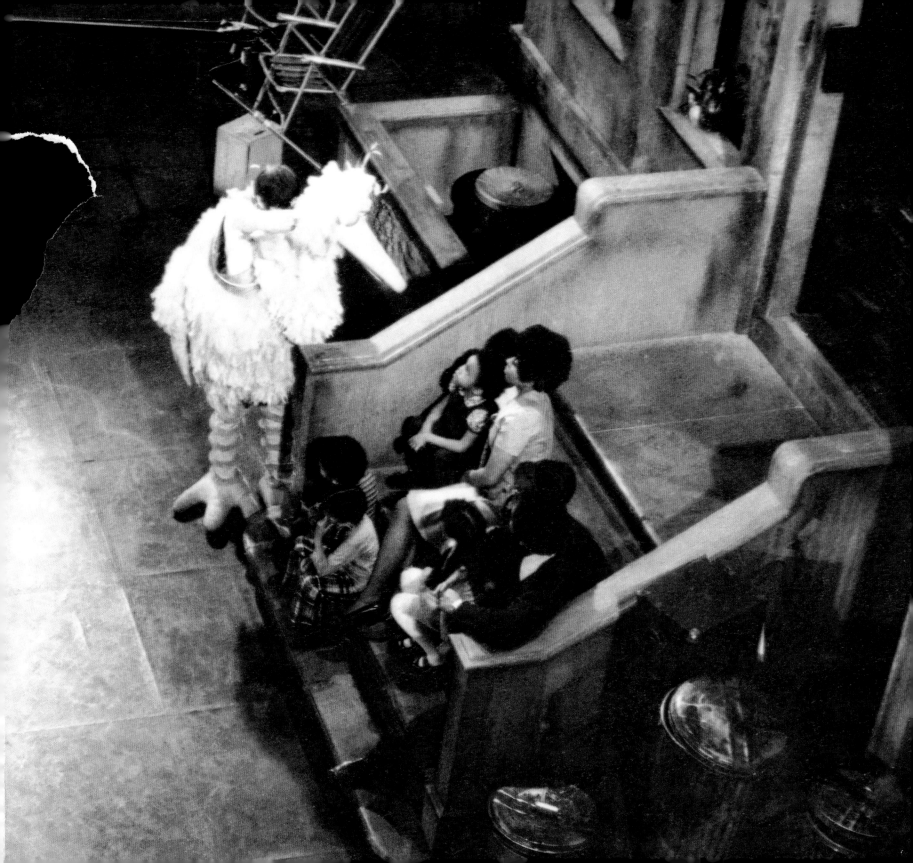

To Ellen, my all there is.

The author would like to thank Sesame Workshop
for its unwavering support of *Street Gang: How We
Got to Sesame Street*, and individually thank:

Steve Youngwood
Kay Wilson Stallings
Lili Lampasona
Meg Roth
Conrad Lochner
Taska Carrigan
and Jodi Nussbaum

Editor Eric Klopfer
Designer Liam Flanagan
Managing Editor Glenn Ramirez
Production Manager Denise LaCongo
Cover design Trevor Crafts

Library of Congress Control Number: 2021932673

ISBN: 978-1-4197-5840-9
eISBN: 978-1-64700-650-1

Text copyright © 2021 Macrocosm Entertainment
Illustrations/photographs copyright © 2021 David Attie Archive

For inquiries about the David Attie Archive, please contact
DavidAttiePhotos@gmail.com.

The David Attie Archive would like to thank Antony Blinken,
David Segal, Lisa Immordino Vreeland, Keith De Lellis, Stephen
Kuehler at the Harvard Library, and Andrea Zsubori at University
College London for their help in finding the materials for this book.

Sesame Street photos provided courtesy of Sesame Workshop,
New York, NY. ©1974, 2021 Sesame Workshop®, Sesame Street®,
and associated characters, trademarks, and design elements are
owned and licensed by Sesame Workshop. All rights reserved.

Cover © 2021 Abrams

Published in 2021 by Abrams, an imprint of ABRAMS.
All rights reserved. No portion of this book may be
reproduced, stored in a retrieval system, or transmitted
in any form or by any means, mechanical, electronic,
photocopying, recording, or otherwise, without written
permission from the publisher.

Printed and bound in the United States
10 9 8 7 6 5 4 3 2 1

Abrams books are available at special discounts when
purchased in quantity for premiums and promotions as
well as fundraising or educational use. Special editions
can also be created to specification. For details, contact
specialsales@abramsbooks.com or the address below.

Abrams® is a registered trademark of Harry N. Abrams, Inc.

ABRAMS The Art of Books
195 Broadway, New York, NY 10007
abramsbooks.com

MACROCOSM®
Macrocosm Entertainment
macrocosm.tv

To find out more about *Street Gang: How We Got
to Sesame Street* please visit streetgangmovie.com.